I hope you enjoy my
story

Marjorie Coens

Climb
That
Mountain

for Heaven's Sake

Printed in the United States of America 2018

This book is a true story; however, the names of Marjorie's children and grandchildren have been changed to protect their privacy.

Books may be ordered through Amazon stores

Or

by contacting:
Create Space at http://www.createspace.com

Or

by visiting Marjorie Coen's website
at http://www.marjoriecoens.com

ISBN: 13: 978-1721670895

Foreword

It isn't very often that an author is asked to edit a book that is not only a true story but is one that can literally change the lives of its readers because of the integrity of its truth. I will be forever grateful that I was chosen to be that one because, to me, this was not a job; this was a privilege.

I had watched Marjorie Coens' videos on YouTube and was impressed with her amazing testimony. The way she presented herself and the things that she said were very encouraging and convincing, and I really wanted to believe her. But like many others who hear these incredible stories that seem too good to be true, I questioned just how authentic this woman's story really was. However, my doubts all disappeared, and my appreciation and respect grew for her on that day when I met Marjorie Coens.

She is the same sweet woman in person as she appears in the videos. Her story is true. It's powerful, and it needs to be heard! So many people suffer from traumas of all sorts that are a result of many diverse kinds of accidents and diseases. Many will never regain their lives but will live in agony and torment for years afterward. Many others will die because they have no hope and will have lost their desire to go on.

Marjorie Coens is a brain injury survivor. After a car accident in 1999, she was left unable to walk, unable to talk, and with only a fragment of her memory. Much of her educated intellect had been locked away, but her emotions and her love never changed. Unfortunately, her family only saw the demoralized state of her body and never took the time to realize that Marjorie was still alive but trapped inside and unable to respond.

i

Regardless of what others thought of Marjorie, she could not accept that her life was over, and she fought hard to get it back. The doctors had told her that there was no hope for her and that she would never recover. But Marjorie had something that they didn't have and that they couldn't perceive. She had faith. She knew in her heart that God had something better for her, and He gave her the strength to climb that mountain and regain her life. Today, she's got more life in her and more energy than a person half her age.

It's heartbreaking, but she lost everything and almost everyone that was part of her life before the car accident. But miraculously, she gained back more than she ever dreamed was possible. Now Marjorie not only lives and enjoys the fullness of life, but she has a purpose, and that is to show others that when they have hope, they can rise up, too.

This book was written to give hope to those who suffer! Whether it's a brain injury like Marjorie endured, or another kind of trauma that has stricken your body, this book will encourage you to know that life can be good again.

I highly recommend *"Climb that Mountain"* to anyone who is suffering from anything that has made life seem as if it's not worth living. Life is very much worth living when the burdens are gone. Hopefully, Marjorie's story will witness to your own heart that you, too, can climb that mountain when all odds are stacked against you. When you have faith in God and believe in your heart that you can do it, you will be able to rise up and get the victory through that mountain that the world deems as impossible—just as Marjorie did!

...Ronnie Dauber

Inspirational Author and Editor

Acknowledgments

I want to thank Rick who has broken down the walls of my heart, and who is not only in love with me, but who accepts me for who I am, a brain injury survivor.

A special thank you to my editor, Ronnie Dauber, who captured the person I am today. I looked up to the heavens and asked for guidance to help me get an editor, and the moment I saw her, I knew, "You are the one."

Special thanks to all the doctors who believed in me, helped me and gave me the encouragement to beat the odds and overcome what most of the medical world said was impossible: Dr. Corless, Dr. Hamilton, and Dr. Adams. Also, to my Physiotherapist in Oshawa.

As well, thanks to Brandon Alleman, my Louisiana Osteopathic Manual Practioner.

A very special thanks to Lisa, my loyal friend who encouraged me to write this book.

Also, special thanks to the Amaze Brain Injury Support Group in Lafayette, Louisiana for inviting me to be a member of the soon-to-be Aspiring Speaker's Bureau.

Thank you to all my extended family for loving me, believing in me, and for being the foundation of my new life.

Lastly, very special thanks to the Heavens, where I look up every day and say, "Thank you for guiding me."

Dedication

In loving memories of:

My precious Mom who encouraged me to climb that mountain and not look down.

My sisters: Ruthie who gave me the courage to do what needed to be done, and Audrey whose faith in me allowed me to keep my promise.

For them, I climbed that mountain.

Table of Contents

Introduction

I wrote this book to inspire people to not give up and to keep the faith and the hope when they have suffered tragedies in life. While I especially want to encourage those who have suffered from brain injuries as I have, it really doesn't matter what the issues are when we are searching for help. This is a story of emotion, trials of life, and hope when there appears to be no hope.

This is about learning lessons of courage within your heart, and clinging to the love for your children, truth, and honesty, and not giving up on who you really are. I am a brain injury survivor, and I stayed true to myself. The brain can spin us out of control, but on the inside, we are all perfect humans with a heart, a soul, and a spirit. These may be buried deep inside, but miracles do happen. We can find ourselves again if we really want to.

One thing I can say after being lost in the darkness for almost 17 years is that when I finally got all of my memory back, it changed my life forever. I traveled to Louisiana, and I found the true me that had been hidden for so many years. I had built walls up around my heart to protect myself from the hurts and the torments that I couldn't understand during those dark years.

But then I slowly began to tear them down after my memory came back, and my heart and soul were filled with inner peace. It was not easy, but with my faith, I did it!

I hope this book will help people to find their own freedom. We are all so very different, and we all have different purposes, but one thing is for sure; we all have a heart, a soul, and a spirit.

. . . Marjorie Coens

Preface

Nothing shatters the heart into a million broken pieces more than betrayal. It torments the soul like a silent stalker and leaves it fragile and afraid. It wires the emotions into an unnerved tangle of fear and loneliness and consumes the mind with hatred and anger. In the end, it replaces the peace and joy of living with anguish and defeat. Yet, to give up is not an option.

Many of us have been there. Our worst fears became a reality when we least expected it; when life dealt us that one deadly blow. We bore the pain alone and tried to fight the giant that was determined to beat us. We were expected to pick up the pieces and move on as if it were just a slight inconvenience. A hiccup in life. A stubbed toe. Spilled milk.

Unfortunately, some of us have been dealt a double portion of torment that stopped us dead in our tracks. Dead because all of our resources were gone. Dead because our hope was left in the hands of those who turned on us. Dead because no one believed in us and told us that we didn't have to die. Yet, with God's help and our determination, we can rise above it all and live again!

In January of 1999, my life as I once knew it changed forever. Yet miraculously, out of this unexpected change in my life, a new me emerged. It took 17 years for my memory to come together, and through it all, I learned new things about who I was, and what I wanted in life—things that made me who I am today.

A head-on collision almost took my life. I was broken physically, mentally and emotionally, and needed constant care. I became totally dependent on others just to get through each day. It was humiliating, intimidating, frustrating, and at times hopeless; yet, in my heart, I knew that one day I'd become independent once again.

It was a painful struggle for me to try and regain my body movements. I could not walk. I could not talk. I was broken! What was amazing, though, was that I became the best of actresses to keep people from knowing the truth—that the reason I did things as I did was that I had lost my memory and forgotten how to do them.

It was a horrible and rude awakening! I felt worthless and uneducated because there were no memories that could bind me to my life and to who I was supposed to be. I couldn't even add two plus two, and I was ashamed that people might find out. I was locked in an unknown world all by myself, and it scared me beyond measure.

My physiotherapist was patient and always spoke softly to me. Yet, any physical touch hurt me so badly that I'd cry silently as the tears streamed down my face. We had no idea why the pain was so extreme until an MRI revealed a pool of fluid in an area of my brain. Then, to add to the trauma, I was told that it was inoperable. I was disappointed, and I felt so helpless. But I could not accept it!

So I set out to find a new doctor, and I found one who took me on right away and connected me with a specialist. Testing began that took three years to complete, and for several years after that, I saw Dr. Hamilton that specialized in brain injuries. However, I also struggled with issues in my personal life that added to my sorrow. Unfortunately, before I could do anything about them, I knew that I had to heal my body and my brain. I was on the road to recovery, but it was a road that I walked alone.

In the meantime, I had become an actress and played the role of "me" as I mimicked what I thought I should be, and disguised who I really was at that time. It was the only way I could be to survive in a world that I no longer knew or remembered.

One of my doctors told me that the brain is like a computer; the memory is in folders and each folder opens at different times, revealing what was known as bits and unexpected memories. Some were amazing; some were not. This was when I realized that there was hope for me. There was a chance that I could regain my memory. It was a very small chance, but the hope was there, and I wanted to get my memory back.

My plan was to follow my heart, my soul, and my spirit with my faith. It was the only way to move forward on my journey. I felt that my brain was messing with me so often, and trust me when I say that things happened in different modes. As I felt or thought something, I'd try to communicate that to others, but nobody understood, and I felt so alone.

It was a nightmare for me. I was able to think clearly and understand what others were saying, both to me and about me, but I could not get my words out so that they could understand *me*. I wanted to be able to write my thoughts on paper so that my family and my friends, and my doctors could know what I was saying. But that didn't work out because I couldn't hold the pencil, let alone write down anything intelligent.

So I had to learn how to spell and then how to type all over again, and that was not easy. It was a long process for me, but in time, I was able to type everything into my daytimer on the computer. That's where I recorded what I thought, what I did, and even what I ate.

As time went on, I saw the progress, and I was *proud* of each success. I regained my cognitive skills and improved my brain's immune system by taking Cod Liver Oil every day. I did all I could to get well.

Many times along the way, though, it felt as if my brain was in a lock-up. It was hard for me, but I knew that I had to keep working and focusing on healing. I made a habit of ending each day saying something positive about the day, and I'd write it down and read it to myself again.

Every day I'd climb that mountain, and every day I got closer to being healed. But it was a mighty task because every day also brought on new fears. It wasn't easy, but I overcame most of them even though I had little to no encouragement from family or doctors. When they'd say to me, "You can't do that," I'd say, "Oh yeah? Just watch me!"

It was a whole new world for me as I had to learn to do things differently; different from the way I'd done them before and different from the way that comes naturally to most people. It wasn't easy but I pushed myself every day, and I found that I could accomplish anything if I pushed myself hard enough. The key for me was to stay focused on each day that was getting brighter for me.

I was fortunate to have four professionals in my life who really helped me. They encouraged me, showed me compassion, and gave me unique ideas on how to overcome the obstacles that constantly popped up in front of me.

One year ago, while in Lafayette, I visited my friend Richard at his home and saw his puppies. I sat on the floor and looked at life in the spirit of those four puppies. They jumped around and barked and played so carefree, and came to me and licked my face and my hands. They lived a life of simplicity, of being purely happy. This is what I wanted in my life.

Bella, Annie, and Ringo snuggled up to me for a short time, and then Jolie came and licked my hand. Clearly, she let the others know that it was her turn to be with me. She was different from the other puppies, and that's when I realized that these puppies had individual personalities just like humans.

I look at life differently now. I had always loved life, but I love it even more now since the accident that caused my brain injury. It's strange because when I look up at the clouds and see different sizes and images, I can relate those clouds to a brain injury. They are similar even though they have different issues—they are different, yet they are free.

I realized that we have to work on our own issues, believe in ourselves and have love, hope, and faith in our heart. And inside my own heart I had to deal with these issues; issues that brought bitterness at first, but that soon brought answers of relief. Things like:

HOW: How did this happen to me?

WHY: Why me, God?

WHAT: What happened and what am I going to do?

WHEN: When will I heal? When will my memory come back? When will I be normal again?

WHERE: Where am I in this world? Where am I going now? Where will I be later on?

These questions flooded my mind constantly, but as I began to sort things out, I said, "I can do it." I got stronger in ways that even the doctors couldn't understand. I'd look at the joy around me and forget the bad things. In a way, I'm like those puppies who jump for happiness, treats, and love. Those things make them happy—and I am no different.

Each time I learned something new, I was proud of myself. Every little thing that I accomplished, although one step at a time, was another milestone that I'd overcome.

During the time of writing things down, I struggled— and I will always struggle with things, but I will always be blessed. There is one thing that I never lost, and that was the laws of the land, the Ten Commandments. I never questioned my morals. Truth was my power. I survived for a reason.

This is a journey of love for my children and for my family, and of life. Most of all, it's of the love of special friends, of Pastor Doug, and of all the special doctors who encouraged me to write my miracle story. I climbed that mountain but not without stumbling many times along the way. I got hurt often, but I kept going. I didn't give up.

When you look up at night and see the stars and the moon, and even the clouds on a sunny day, you call out to the universe, He hears you, and He answers your prayers. Trust me, God heard my prayers, and He helped me move mountains. There will always be struggles, but I take pride in helping others through their own journey now, by sharing my trials and tribulations….and my victories.

My mother told me one day as I was healing that I needed to climb that mountain. I knew that she was telling me to be strong and to keep going. I knew that I would and that I could. Soon after that, I was reminded that I always used to say, "Oh, for Heaven's sake" and since I knew that it would take Heaven's strength to help me climb, I took Mom's encouragement and my own expression, and I appropriately named this book…

Climb that Mountain….for Heaven's Sake!

My name is Marjorie Coens.

I am a brain injury survivor

…and this is my story.

Chapter 1

The Beginning of Sorrows

I could have started my book from the beginning of time when he was unfaithful to me, but there is no point in adding more pain to an already heartbreaking story. So to put in a nutshell the life that I lived with my husband, it seemed as if I was the only one married in our union.

He preferred to spend more of his time in bars with his friends than he did with me at home. When he was home, I was often the victim of his anger and brutality. Even after Lloyd, our first child was born, his affections and desires were drawn to outsiders, and not towards us. I learned early on in our marriage to be mindful of his words and of his actions. He was very quick to give his opinions and only too willing to enforce physical control over me as a reminder that he was the dominant one in our marriage.

Learning the sad fact that his allegiance could not be confined to one woman was also very painful for me. But I never gave up hope because I loved him. We'd started a home together, and I wanted more than anything for him to just come back and be part of it. Lloyd was such a treasure to be around, and he filled my heart with love and joy.

However, for my husband, being a full-time father and doing all those fatherly things with his son was just not part of who he was. So, unfortunately, he spent very little time with Lloyd.

While Lloyd and I were visiting my sister in Niagara Falls one day, I got a phone call from a nearby hospital. My husband, who I'd prefer to just call Ex from now on, had been involved in a car accident. The caller wanted me to come and get him as he was being released with only very minor injuries.

So, being a loyal wife I left Lloyd with my sister and drove to the hospital. I could never prove it, but I knew that Ex had spent the evening with another woman. But the time wasn't right to argue, so I brought him home and tried to forget my suspicions.

It wasn't too long after that when I discovered that I was pregnant with our second child. I was ecstatic; Ex not so much. Unfortunately for me, just as it was with Lloyd, this pregnancy kept me in a constant state of nausea. My husband was rarely home, as usual, and if it wasn't for my in-laws, I don't know how I would have made it. They were always there for me, and they helped take care of Lloyd in those times when I was totally vile from morning sickness.

It seemed that Ex was gone from home even more then than ever at that point. He showed very little concern for my ability to function while being so sick. On top of that, it didn't bother him in the least to just do whatever he wanted to do—as if I wasn't even there. He'd go hunting whenever he chose, and he'd spend his evenings with his friends at whim. I felt so alone; so forsaken.

To help support our family financially, I worked at a factory during the day. I'd drawn up schedules and plans to budget our money so that we could live as well as possible with what we had. But that didn't stop Ex. He bought whatever he desired at the time the thought hit his mind. He didn't care about the family budget. He wasn't bothered if our child had everything he needed. The family just wasn't important to him.

He was big into buying cars at that time, and he was caught up with buying and trading vehicles. He even bought snowmobiles; anything he wanted he just bought without giving any consideration as to whether or not we could even afford it, or if we even needed it. In fact, he never discussed any of his outrageous spendings with me. He just did whatever he desired to do, and he showed no concern for our needs at home.

It was during that time when I was pregnant with our daughter—although I didn't know it was a girl at the time—that I begged Ex to spend more time around the house and to help out with caring for Lloyd. Then when our little girl was born, I needed his help even more. So Ex—perhaps out of guilt for his own lack of interest in our family, I'm not sure why—agreed that he'd be home more often to help me. That was a good thing until I was absolutely shocked one day when he decided to discipline our little toddler.

We were visiting my mother-in-law shortly after our little daughter had been born. Lloyd wasn't quite two yet, and he got into some mischief, as toddlers do. Ex said that he would take care of it, and again, I was impressed that he was even there, let alone taking on any kind of responsibility. But then we heard our little boy scream and cry in a way that I'd never heard him cry before. Both my mother-in-law and I ran to Lloyd's defense, and we both gasped! There was my husband, beating little Lloyd with a belt! I was horrified!

His mother dove right in and tried to grab the belt out of Ex's hand, while I screamed at him to stop. Then he stopped, threw the belt on the floor and stomped out of the room. I whisked Lloyd up into my arms and held him close as we both wept. His cries were heartbreaking. He was scared and shaking. How could his father do this to him?

Never again would that monster touch my son!

Ex was long gone, off doing his own selfish thing somewhere, and my mother-in-law left Lloyd and me alone. As gently as possible, I put cream on his red skin and then carefully dressed him. I held him close to me and then curled up in a bed with him. He was finally at peace in my arms, and he soon drifted off to sleep. I prayed that the memories of this heartless beating would never stay in his mind.

A while later, we were back home, and Lloyd was asleep in his own bed. I watched him as he breathed so peacefully, and my thoughts drifted off. First to a horrifying event that had happened to my sister, and then to the birth of our new baby. It began about three months earlier, on January 7th, 1975 to be exact.

Ruthie had called me that evening, and we'd talked about abuse—wife abuse. She had suffered greatly at the hand of a cruel and abusive husband, and she had become terrified of him and was crying to me for help. There were no women's shelters or support groups at that time, and so when women endured this kind of cruelty, most of them just took it. It wasn't talked about, and there was no one you could tell. Abuse back then was hidden and covered up because of the shame. Therefore, it was never stopped because no one outside the home even knew about it.

But I knew! I also knew that she had to get away from him right then and there. So I told her to leave him, to get out of there while she could and to go to our mother's for safety. I knew about the abuse she was going through, and I knew that she couldn't take anymore.

Ruthie left her home that night, and then the next day she went to the police station to get help. She'd left her son with another family member and then returned to her home alone on the 9th to get her things. Later that evening, I got a phone call from the hospital that took my breath away; Ruthie had been shot!

They were taking her by ambulance to the Kingston Hospital. When I heard that, I fell back into a chair and cried out loud, "No!" A million thoughts flooded my mind, and I was sick with worry. *Why? Why?*

I couldn't go to Ruthie, but I prayed and prayed that she would be okay. The anxiety and the fear for my sister were so overwhelming that it stole my ability to think or to relax. I shook with distress from head to toe. Tears poured uncontrollably down my face. I had to do something, so I ran into the laundry room and started doing laundry with the old wringer washing machine.

My father-in-law kept asking me if I was okay. No, I wasn't okay! My sister had been shot, and she was in surgery in a hospital miles away. I didn't know what was going on and it made me sick inside. I begged God to save her.

Then, at around 1:30 in the morning, which was then January 10th, the phone rang again. No news is good news at that dark hour of the night. I held my breath and tried to comprehend the words. My sister had died. Ruthie was gone. I thought I was going to die with her. This couldn't be. It just couldn't be!

Chapter 2

Death, Life, and Heartbreak

Ruthie was gone, and I was devastated. Ex was too lost in his own world of sleeping to even care enough to get out of bed and comfort me. But his father was there, and he wrapped his arms around me and held me tightly as I sobbed like a baby into his chest. I don't know how I would have got through that night without him.

Then came the day of the funeral, and that was really hard for me. I was numb. We had the funeral reception, but Ruthie couldn't be buried until spring because it was winter at the time and the ground was still frozen. So her body was taken to cold storage where she'd stay until she could be placed into the ground. I was heartbroken. It was all just too much to cope with, and I started pre-mature labor pains.

They took me to Belleville Hospital, and after a while, the pains actually subsided. Since the baby wasn't due until March 10th, the doctors were concerned, and so they kept me there for five days under their watchful eye. We didn't know the sex of the baby at that time because they didn't have ultrasounds for pregnant women back then.

When I returned home, my orders from the doctor had been to get lots of bed rest and to try and relax. But that just wasn't possible. Visions of Ruthie and what happened to her flooded my mind, and I couldn't stop grieving for her. Millions of thoughts pounded at my brain as I pondered over this useless and horrendous attack on such a precious woman.

It was about a week later that I was scheduled to see a specialist about my pregnancy, and he showed little to no compassion at all for what I was going through. In fact, he scolded me and told me that I had to get a hold of myself and just turn off my feelings. It was a very cold and heartless prognosis, and it caused me to grieve even more. How do you just get over the murder of your sister?

When I returned home, however, I thought about it and realized that I did need to relax and calm down for the sake of the baby. But on February 2nd, my little girl wanted to come anyway, and so I was rushed to the hospital and given the epidural. Sadly, complications set in and somehow the freezing shot up my spine instead of going down. Within seconds, I couldn't move my arm.

The next thing I knew, the intervenous was being ripped off of me, and a whole staff of doctors had gathered around. Then one of the doctors said anxiously, "We are losing her!" Gripped with fear, I closed my eyes and begged God to save my baby.

So much was going on that I couldn't even see, and it made me feel so helpless! My heart raced with anticipation, and I wanted desperately to do something. One of the nurses sensed my panic and continued to hold my hand and tell me to relax. I tried, but it was an absolutely horrifying feeling to hear the doctors talking like that, while at the same time struggling to breathe and worried if I'd even get through it.

Then the labor pains began to pierce my insides, and my little baby was ready to be born. Unfortunately, though, there was nothing available to me that would numb the pain. The freezing I'd had was doing a number on the top half of my body, while the bottom half was feeling every sting of labor. Then the doctor said to me, "I can't give you anything more for the pain, and I'm sorry, but I have to cut you." That added to my anxiety, but I told him to go ahead.

They told me not to move, not even blink, or there could be severe damage caused by the misguided epidural. I wanted to scream, but the dangers that would come from moving had me paralyzed with fear. Then thoughts of Ruthie flickered in, and my heart ached for her. Confusion and anxiety quickly took over because I was no longer in control of my body. My life and baby's life were totally in the hands of the doctors, and I was terrified.

Seconds later, little Beatrice was born. She was quickly whisked into the incubator and had all kinds of tubes put in her. I began to panic, "What's going on? What's wrong with my baby?" The nurse said that she had a cleft pallet and that they were cleaning out her lungs. I wanted to die. No roof in her mouth meant that she could choke and get fluids into her lungs easily. How could this happen to my baby? I wanted to hold her, but I couldn't move. I couldn't even see her. Because of that wayward epidural, I was forced to lay in an absolutely still position for the next 48 hours. All I could do was think about everything that was going on in my life as the tears flowed silently from my eyes.

My brother Leon came in to see me the next day with the minister, and they asked if I was okay. My impulsive response was that I would welcome the devil right now and we laughed. Of course, I didn't realize at the time that just maybe the devil had already been there and had caused all of this. Yet, regardless of all that had happened, her birth was very special because our little baby had been born exactly three weeks after the death of my sister.

Finally, I got to hold her, and it was such a special moment. She was so tiny and so precious. But then it came time to feed her, and I had to learn it all over because feeding her was very different from feeding Lloyd. Milk would come out of her nose as she was drinking, and the first few times it happened, I got really scared. My fear was that she would choke and that I wouldn't be able to save her.

The first many feedings were somewhat stressful, but we made it through each one. At those times when I didn't hear her breathing, I knew she was choking, and my heart would race with fear. Then after the feeding, I'd look at her and smile. God had given me a beautiful little girl, and I loved her. My work was cut out for me, though, and it wouldn't be easy, but I knew that with God's help, I could do it. It didn't take long for a special bonding to develop between my little girl and me. Regardless of what her special needs were, I promised her that I'd always be there for her.

For a long time after that, for the next couple of years, in fact, I was always afraid that the fluids would go into her lungs and that she'd die from choking. That fear is what turned me into that over-protective mother hen, but it was only because I loved her so much. I dared not lie her down in her cradle for fear that she'd choke, and so I sat in a chair and held her in an upright position while she slept. This went on for about two years, day and night.

My only wish at the time was that her father could have felt the same way. Unfortunately, he saw her as more of an outcast and refused to even hold her, let alone spend any time with her. It was heartbreaking to see him reject his own daughter, and I hated him for it. I knew when she was born that I'd have to give her all the love because she wouldn't get any from him. He saw her as something disgusting, and not as a child—his child—that needed his love and protection.

About two months after Beatrice was born, a parcel came in the mail, and it was an outfit for her. When I first saw it, like any new mother who was given a gift for her baby, I was happy and excited. The outfit was adorable. But then I read the card and saw that it was from the very man that had shot my sister! How dare he! I was so angry that I sent it back and told him that I would never forgive him or the people like him. Did he really think that this gift would soften my heart for what he did? He was very wrong.

9

It was around this time when I first began to put up walls all around me, and I determined that they'd stay up for as long as it took me to protect my children. They, too, had an abusive father, and I was always afraid for them. My sister had died while she tried to protect her child from his father, and I would protect my children from their father, as well.

I had worked out a system so that when I was around people, my smile would always make me appear confident. But the truth is that underneath it all, I was terrified and worried for my children. It would be a lifetime job to protect them, but I learned to just deal with things. Perhaps that's because I never lost my faith in God, and kept my hope in Him and trusted that things would get better.

Over the years, I was always there for my children, for all their sports events and their school celebrations. Their father rarely ever showed up as he had no interest in his own children or how they progressed or what they accomplished. But they were everything to me, and I wanted them to know that I loved them and that I was proud of them.

Our financial situation forced me to return to work, and I was able to resume a job at Cadburys. However, that was short-lived because they closed soon after that, and so I decided that it was time to return to school and aim for a better quality job. However, Ex never complimented me or encouraged me for trying to improve myself. Instead, he made sly remarks to try and intimidate me and humiliate me. Fortunately, I was able to overcome them and press forward.

Things continued to grow intense between Ex and me, and when the kids were old enough and when I thought that I could support them on my own, I told my husband to get out; I'd had enough. Surprisingly, he said that he was fine with that. However, what really cut to the heart was what he said about taking the kids.

He made it clear that when it was his turn to take the children for visits, he didn't want Beatrice, just Lloyd. He said that he didn't want to deal with a child with a handicap, not because of the challenge of caring for her, but because he was embarrassed and didn't want her around him.

His words tore my heart out. It was bad enough that he avoided Beatrice at home, but how could I tell her that her dad didn't want her because of her appearance? I was so angry that I screamed for him to get out. But then I calmed down when I realized that we would have to stay together for the sake of our children. So, we stayed together. No one knows what went on behind our closed doors, but as with my sister, it was a price that I had to pay to keep my family together.

Stressed and unhappy, I'd sometimes ask my children who it was that was always there for them, and they both would say, "Mom." That made all of my hard work worth it. My greatest concern was to make sure that they were both loved and cared for, and because of that love, the three of us had a very strong bonding. Their father lived with us, but he was never part of our little family.

It was their smiles and their love for me that filled my heart with joy and kept me going. It made everything that I had to endure in the horrible marriage worth it. But sadly, it wasn't something that would last forever, and I'd soon learn how easily their hearts could turn away.

Chapter 3

The Day of Tragedy

Life had dealt me many painful challenges, but over the years and with God's help, I was getting through them all. I had spent the rearing years trying to ignore the abuse of my husband and focusing on the love of my children. But time flew by, and my kids had grown up and were married, and their children had become the apples in my eye. I loved and spoiled each of them and spent much of my spare time helping Beatrice keep her house in order.

Perhaps, I'd spoiled her out of constant worry for her over the years. Perhaps I'd spoiled Lloyd out of fear that his father would abuse him. Regardless, my two children and my grandkids were my life.

But on this night, my focus was on my sister Audrey. It was January 3rd, 1999. The time was approximately 5 p.m. Ex was driving, and we were heading to Teddy's Restaurant to celebrate Audrey's last chemotherapy treatment after a nasty bout with cancer. I was in the front passenger seat, and Audrey was sitting right behind me. The two of us were chatting and laughing and carrying on, and just so happy that Audrey was finally done with it. We had waited for this time for so long when she would be free and able to get back to enjoying life again.

But then suddenly, our joy was turned into a tragedy!

The car abruptly slowed down as Ex slammed his foot on the brake. I turned my head to the front just in time to see lights coming at us. I can't remember much else about it, except that it went very dark at first, and then everything lit up with a beautiful soft light. A voice awakened me from the trance that said that Ex was okay. It took all my strength, but when my eyes opened, panic set in because I realized that I was injured and inside a hospital.

I couldn't really feel anything, but there was a lot of blood everywhere. Apparently, my head had cracked through the windshield at the impact of the collision. Everything seemed to happen so fast after that.

The next thing I knew, it was around midnight, and the doctor was stitching me up, and I had this overwhelming sensation to go to the bathroom. Then it seemed that only seconds later I was lying in the hallway and that's where I stayed all night. My sister Audrey was with me, and she kept talking to me and telling me everything would be okay. Her being there really helped me because I wasn't clear on what all was happening, and it was very confusing, not to mention rather frightening.

Poor Audrey! She'd gone through so much with that cancer, and now she had broken ribs and a black and blue eye. It was hard to focus on her because blood kept pouring around my eye and down my face. That terrified me! I wanted to try and stop the bleeding or at least wipe it away, so I asked one of the staff for a facecloth to clean myself up with. But she said that they didn't do that there.

Shortly after that, a doctor said that I may need more stitches around my eye. I had no idea at that time what had happened or what was going on, and it was all still quite scary. It was during this time, as I lay there trying to figure things out that I realized my entire body was in shattering pain!

13

Sometime later, my oldest brother Leon came and picked Audrey and me up from the hospital. I was in a wheelchair and Audrey was struggling to walk with a cane beside me. I looked as if I'd been in a boxing ring and lost. I had stitches around my right eye and all up my forehead and onto the top of my head, in between the strands of hair. To make things even more painful, both of my eyes were black and blue and so swollen that I could hardly open them.

My face was one big bruise. I tried to smile but it hurt too much, so I gave up. All I wanted to do was go home.

When we finally got home, my mom wanted to wash my hair, my face, and my neck because they were covered in blood. She helped me to lie across the bed with my head hanging over the edge, then she poured water gently over my hair to wash the blood out. I didn't have the strength to hold my own head up, so Beatrice, my mom and Leon's wife Shirley held my head as it hung over the edge of the bed.

They managed to get a lot of the blood out, and of course, they had to do this. Yet, every time they touched my head, I wanted to scream for them to stop. There was intense pain that rattled through my head every time that water touched it.

Over the next four days, I was constantly throwing up, and slowly, my speech began to slur until it got to the point where I couldn't talk at all. That was bad enough, but the noise of someone simply shifting a piece of paper made my head shake. It was a horrible feeling of entrapment, and I was scared.

The nurse came each day and noticed that my brain was a bit more swollen at each visit. She wanted the doctor to send me to Sunnybrook but the general practitioner at that time, in my opinion, was useless and didn't think it was necessary. So, he did nothing as my brain continued to swell.

However, my PSW (personal support worker) was an angel. She was kind, gentle, and very soft-spoken. When she washed my hair, she did it so cautiously and so gently, and I knew she was trying to be as careful as she could be so that she wouldn't hurt me. But just touching my hair made me want to scream.

Unfortunately, there was still so much blood in my hair that I knew it would take many more efforts yet to wash it all out. I dreaded it each time they mentioned that they needed to do another rinse. How long would this go on?

During that time, I lost control of my faculties, and of course, along with that went my dignity. I had to have help with a bath from head to toe, and with going to the bathroom, a chore that required someone to clean me afterward. There were times when I couldn't control my bladder and had lost the sense to know when I was going. I'd think that I was finished, but I wasn't, and it just poured out everywhere.

Then my bowels stopped working properly, so when they did work, the nurses had to help clean me up. I'd get this shooting pain in my abdomen because I was pushing to have a bowel movement, and the nurses would tell me to stop pushing. But I didn't know what that word meant until they explained it to me. It was so frustrating! How could I not know what they meant?

While all this was happening, my head was spinning in circles. I desperately wanted to know when things would start working again—when this torture would stop. I couldn't understand what was going on. I remember trying to scream out, "What is wrong with me?" But it seemed that after a minute of desperately wiggling around and taking a deep breath and screaming at the top of my lungs, that I hadn't really moved at all.

I remember looking into my mother's eyes, and the words she spoke on this one particular day will forever be engraved in my mind. She said, "Marjorie, climb that mountain!" She had such a sad look on her face as if I was not going to make it. I tried to smile at her and struggled so hard to tell her, "I can do it, Mom." The truth is, though, that I don't know if I actually said the words or grunted them, or perhaps just thought them.

The hours went by one at a time as I lay alone in my bed, and my only consolation after each one was to say to myself, "Well, I have made it through another hour." I tried so hard to get up, but my left leg wouldn't move. That's when my heart began crying out to God, "Dear Lord, what is happening to me?" Then I realized that nothing had come out of my mouth, but I knew I was crying them out in my heart, and that God could hear my heart.

My body was not working, and it scared me. I could barely talk, if at all most of the time. Words had become like jumbled marbles in my throat that made no sense at all. No one could figure out what I was trying to say, and sadly, no one seemed to have the time to listen. On top of that, it was a struggle for me to understand what others were saying to me. It's not that I couldn't comprehend the words that they were speaking; it was that their voices were so very loud that they literally rattled my head with excruciating and uncontrollable pain.

At first, when I was able to move my arms and hands, they tore around wildly like loose live wires. When it seemed to me that I'd regained the control over my hands, the next thing should be to be able to hold something, like a cup. So with my arms stretched out and touching the cup, I tried to get hold of it, but that didn't happen. Then, when the cup was put into my hand, it fell right out. I felt trapped and helpless in my own body that I couldn't control.

My oldest grandson Jacob was just a little boy then, and when he saw me for the first time after the accident, he ran away and hid in the closet. It hurt so badly to have him afraid of me, and I tried to call for him to come and talk to me. No one could blame him for his response. His Nana had changed her appearance and her physical abilities, and he could likely have dealt with that initially, but it was my words and my voice that made him very leery of me. No wonder he hid.

I closed my eyes and begged God to help me see him. Then Jacob came out, and I reached for his hand and tried to put it on my face. "It's okay Honey. Nana will be fine." At least, I think I told him that, but I'm not sure if any words even came out of my mouth. Somehow though, he knew what I meant, and he relaxed a bit. My heart was glad, and tears of joy trickled out of my eyes.

However, little did either of us know then that "fine" would be sometime in the distant future. Or that this was just the beginning of an unknown world that I was about to embark upon.

Testimony #1

Every now and then in life, you meet a true champion. You know, someone who proves to you and to others that nothing can stop you, all things are possible, and that you can make tasty lemonade out of lemons. I have met such a person. Her name is Marjorie Coens.

When I first met Marjorie, her life was fun, carefree and totally positive. It looked like she had it all. However, not all good things last forever; and thankfully, not all bad things do, either. In this riveting personal story of Marjorie, you will see yourself and others. Often times, life deals us things that aren't fair, and at times, totally unexpected. This is NOT a negative story or a super positive one.

It's real life—the real life of Marjorie Coens. Her life gives hope to us all. I'm her pastor and friend and can tell you that this is a true story. It's filled with genuine miracles of grace because of God's love for her. And also, know this, there are miracles waiting to be released over your life, too. Marjorie is one of my favorite people—and she'll quickly become yours, as well.

. . . Pastor Doug A. Schneider

The Embassy Church

Chapter 4

The Humiliation of Trying

Physio started sometime later, and the lady was really good to me. She spoke softly, and even though she was so gentle when she touched me, I would cry. The noise hurt my head so badly, and the tears would just pour down my face. The pain was unbelievable.

Fortunately for me, the physiotherapist was able to come to my house three times a week. I did my best to listen to her when she'd say, "Marjorie, I don't care how much it hurts, you need to keep your back straight." It was my first challenge. I tried very hard to do it the best way that I knew how. That task alone was a major undertaking for me.

Then they scheduled me for massages which should have been relaxing, but were more like, "Don't touch me here, there or anywhere." I knew, though, that I needed the massages, and was hoping they'd give me some relief. Mirka was very good to me there, but we had to postpone massage therapy until I could get the pain under control.

In the beginning, and for a long time after that, the therapists helped me to sit up. They'd hang on to me because I couldn't keep my balance and wasn't able to do what was expected of me. So this is when it was decided to wait for a while before I would get involved with massage therapy, and this while turned out to be about five years.

I struggled with many things, and one of the greatest struggles was my speech. It was as if there was a creature inside me that just stopped working. I needed the patience to focus on everything, and although they were trying to teach me how to overcome a lot of things, I had to do everything my way. I knew what I could and couldn't do, and I am sure that they didn't realize what my true abilities were. My injury was totally extreme to what any of them were used to.

Getting dressed after therapy was another challenge. Often, I'd just fling my bra into my pocket as it took too much effort to try and get it back on. Then, of course, I'd always have to use the bathroom when I was there. That became another stressful challenge for me to get back to the receptionist's desk where the nearby washroom was located.

Then going outside after that was just another big headache—literally. The sun hurt my eyes quite badly, and it gave me tremendous headaches. I had to wear sunglasses as soon as I approached the outdoors, and then walking down those stairs to the truck was the next major stress point.

Thank God, I was independent, though, as Ex would just sit in the truck smoking and watch me struggle down the stairs. He never offered to help me, and sometimes as I was climbing into the truck, I'd say, "It would be nice if just sometimes you could help me and open the door for me." But he didn't respond; he'd just shift in his seat and get ready to drive. Then I'd mutter, "What did I do to deserve this?" But as trying as that was, it was really the least of my problems.

Eating became a real battle for me. I was never hungry, and my stomach and head were going wacky. I lost my ability to sense when I was hungry, and I couldn't taste anything anyway, so it wasn't a concern for me to find food and eat it. After a while, I thought, "Well who cares anyway." The desire or need to eat wasn't there, and so for a long time, I really didn't eat much at all.

It wasn't long until I was engaged in many tests, and in some of them, I would be asked what this smelled like or what that smelled like. I had no idea, so I just guessed at most of them. It could have been doggie doodles for all I knew; I couldn't smell or taste a thing. I told them that in my own way, but they didn't listen or even try to listen, and that really made me angry.

These tests made me quite angry because I couldn't respond the way they wanted me to. I couldn't taste anything, but they insisted that I could, and that made me even more confused. That's when things began to move too fast.

I'd have to repeat myself as I struggled to tell them, and all that did was cause them to treat me like a child. To say that I was humiliated was a gross understatement. I knew everything before, but my brain just wouldn't connect anymore. It seemed that the harder I tried to make sense of things, the worse it got.

This was a battle that blazed inside my head, and I was determined to win it somehow. I wanted to scream, but nothing would come out. The words were simply not there for me to be able to respond to many of their questions, and I'd get lost in this muffle of sounds. That's how it began, and then after a while, it was as if someone just shut off the switch and I couldn't understand a thing they were saying.

Not only were the mental switches shutting off, but occasionally the physical ones were, as well. One time I had been in the bathroom and was heading back to my bed when suddenly, the power went out. It was horrible, almost as if my body had been turned off with it. The room went dark, and the only light came from the moon that shone through the window. It was humbling to see that the manmade lights were out, but what God made was still shining bright and showing me the way.

Unfortunately, though, I had just lifted my leg to take the next step back to bed when the lights went out. I had no way to prevent the fall, and so down I went!

There's no way for me to know how long I laid there, but I remember yelling inside at myself to get up. "Okay, come on! I can do this. Come on! Scream for help so someone will come." But nothing would come out. I yelled at myself a lot and called myself unkind names because of the anger that riddled me for not being able to get up. I hated that I couldn't do the things that had come so naturally to me just a short while ago.

After that, I pushed myself to the limits. To quit or give in was something that was just not going to happen. I was tired and frustrated, and yes, ready to quit, but I couldn't. That frustrated me even more. "Why was I doing this to myself?"

I didn't know why, just that I had to do it. It didn't dawn on me at the time that I had angels around me that were there to encourage me and inspire me to keep trying. I kept trying, no matter what it took, and eventually learned to feel my way through everything with my hands. It was a technique that got me to where I was going, and it didn't matter to me what it looked like because it taught me that I could do it!

I realized at the onset of my healing process that any achievements made would come because I was determined to regain control of my body. That included the ability to feed myself. Mealtimes had become an issue for me because no sensor inside me said it was mealtime, and with no ability to feel hunger, I simply stopped eating. Because of that, I was forced to endure the humiliation of being fed like a baby. That really got to me. If I couldn't remember to feed myself naturally, then I'd have to figure out a way so that I could do it myself.

It didn't take me long to realize that if I watched the clock and wrote down the times when meals were served, that my problem was over. I knew I needed to eat, so I'd eat when those times came around. It didn't matter what I ate because I couldn't taste it anyway. Then after a while, I relied on my chart to determine when I should eat. It worked.

I know that I'm an adult, but I'd lost my ability to chew food properly, and so my food had to be cut into small pieces so that I wouldn't choke. This also frustrated me! Why didn't I know how to do this? I became angry over this, as well, and unfortunately, some of those cuss words did slip out. It's funny how I struggled to speak, and yet, every once in a while, a cuss word came out loud and clear.

As time went on, I learned to talk again, and my words started to make sense. Unfortunately, my ability to put emphasis on the different words or to use a friendly tone wasn't there. I was stuck on a solid, harsh tone. No matter what I said, it sounded as if I was angry. This, of course, led different family members to tell me that I needed to attend anger management classes.

However, it wasn't because I was angry—although sometimes I was—it was because I couldn't control the way the words came out. My voice somehow lacked enthusiasm or emphasis, and my family would give me hateful looks that were very demoralizing, to say the least.

One instance was when I was trying to protect my grandson from stepping on some broken glass. He didn't see it, and so I yelled, "Stop! No!" I didn't want him to get cut, and it seemed to me that the right thing to do was to tell him to stop. However, Beatrice didn't see it that way, and instead of respecting my intentions to protect him, she accused me of speaking too her son with that tone and then told me to not ever speak to him again.

If I could have spoken what was in my heart and in my brain, I would have told her to watch her kids, please. But no words came out, and this was what I had to look forward to after that. I would tell myself, "No way!"

The looks of disgust that were aimed at me from my children were heartbreaking. I couldn't explain what I was going through, or how I'd lost my ability to use different tones. I thought I was doing a good thing by stopping my grandson from getting cut on the glass. To this day, I don't understand how they could think that I was doing anything but protecting the boy.

The look from my partner frustrated me the most. He should have known what I was going through; he should have had the patience and the heart to help me. Instead, he gave me an appalling glare, and it bothered me because I was trying! But he had no sympathy, and it was very clear in his eyes—and it was clear in the eyes of my two children.

It tore at my insides, but I couldn't allow that hurt to destroy me. I'd look up to the heavens often for help because it was my sanctuary. Many times I asked God why, but never got an answer, not then anyway. But what I knew was that He'd given me determination and willpower. Because of these, I would discover different ways of doing things that no doctor and no family member could know.

My dear friend Doreen came to visit me with her mother one day. It was nice to see these two friendly faces; faces that were different from those of my family as they were anything but friendly, and from those of the medical staff. It was such a joy to be able to talk to them and have them tell me things that weren't demeaning or criticizing. For the first time in a while, I had a nice visit. But then after a few minutes, the look on their faces was not as promising as they'd been earlier. It seemed that the more I tried to talk to them, the sadder they became.

I know they thought that I was brain dead, and I watched their faces as I struggled to talk. But I wasn't brain dead! There was a person inside my body with a heart that had faith and a stomach that told me when things weren't right. I was thankful for their visit, but I was worried that they might not come back.

I did struggle with anger at times when things seemed so obvious but were so trying. I wanted to hang a cup on the hook, but I couldn't do it. My insides were screaming! No one was there to guide me, and the brain just wanted to go in circles so fast that it hurt. I kept trying, but couldn't grasp why it wouldn't work. It seemed so easy, as many things did. But I knew that there were so many changes to accept and so many new things to learn that I'd once taken for granted.

On the inside of me, I kept saying that what people saw on the outside was not the real me. I wasn't going to let something as simple as a cup keep me from being who I was. So I grabbed the cup with both hands, and it took me a few tries and a lot of energy, but I finally hung that cup up. What an accomplishment it was, too! Something so simple took so much effort, but I did it, and I was proud of myself!

That's the way my accomplishments began to happen, literally one step at a time. It took a lot of focus and many repeated efforts at times, but I began to accomplish the little things that I'd once done with ease. I had learned how to do them all over again. It wasn't easy, and it wasn't without initial frustration, but I did them!

The biggest setback, though, was that my family just expected me to do it. They had no idea what I was going through or about the stress that I endured to fight this horrible battle within me so that I could actually do the things that I used to do. They didn't understand the seriousness of my situation, and so they couldn't appreciate the wonder of each of my accomplishments.

I'd given myself a goal of one year to get the left leg moving again, even if I dragged it behind me. That alone would be an accomplishment. I promised myself that if I did this, I'd go on a trip to celebrate. So I grabbed my walker and headed to Beatrice's house a block away. I was dizzy and in pain, but I made it with that left leg dragging.

So Heidi booked the four of us on a trip to Aruba, and then she arranged for a wheelchair for when we got there. She was a friend who would look after me, and I was so excited. The doctor gave me extra meds to knock me out during the flight. He warned me what might happen to my head during the flight, but his words were too confusing, and it didn't matter to me because I was going anyway.

We arrived at Pearson Airport, and I was wired to the hill. There was so much going on, and I was so thankful that I got a wheelchair and was able to go. I took the quick release morphine right away because my head and my body were in unbelievable pain.

We sat in the front row, and the flight was hell for me. The drugs should have knocked me out, but they didn't. The brain and body felt as if they were being thrown to the back of the plane. A total stranger looked at me and asked if I was okay as silent tears rolled down my face. When we landed, a wheelchair was waiting for me, and I sat in it, but I just wanted to crawl into a hole.

It was then that I realized I would spend the whole week in a strange place, being fed drugs and wearing my collar 24/7, while not knowing how to talk or walk or smell properly. Not to forget choking on food every time I ate that caused people to look at me as I was trying to stop choking and breathe again.

So, to prevent me from choking, they cut my food into small pieces; it was so embarrassing. The worst part was that Ex would look at me and say, "You okay?" Then he'd spend the next few minutes just criticizing me. I soon learned to ignore him when I'd choke, and I'd just look at him with a real dislike for him. I just wanted to yell at him; however, I still struggled with words.

Of course, the trip back home was no fun, either. To add more torment to an already unpleasant vacation, when we got back we discovered that thieves had broken into our home while we were gone. They'd stolen all of my drugs and my jewelry and had torn the place apart searching for other stuff. Our home was in ruins, and our things were strewn everywhere. I felt so invaded.

Then the kids came in with the grandkids, and they cleaned everything due to the police leaving their dust all over the place while checking for fingerprints. Then we hired people to clean the carpets and disinfect the walls, but it still didn't feel right. So we had the carpets replaced. All this just added more anxiety to me; yet, through it all and for some unknown reason, I could feel His presence there with me.

A few days later, I grabbed my walker and struggled with it, but got over to my neighbor's house. My left leg dragged behind me, and it hurt a lot, but I did it with a smile. I was determined that even if it took everything I had, that independent Marjorie who smiled and had laughter and faith in her heart and soul was going to come back.

Through it all, Dr. Corless, who became my family doctor down the road, became my greatest encourager. He'd say to me, "Marjorie, you may have to do the same thing over and over a thousand times until it finally connects." His words encouraged me because I knew that he meant that if I kept at it, I *could* do it. He made me believe that I really could do it.

There were many times when I begged him to stick with me, and then I'd promise him that I would keep trying until I got it. Of course, my speech was very poor at that point, and he never rushed me when I tried to express what I was feeling in my heart. He would stand by patiently and watch me try and scribble my thoughts down onto paper.

The nurses were always concerned that the pupils in my eyes were two different sizes. Dr. Corless would joke about it and make me laugh. Then I'd try to look at them in a mirror to see the difference, and he'd tell me to quit looking as they weren't going to change. I'd whisper why and he'd say again, that I had a severe brain injury and that these pupils were the sure sign of it.

I'd always feel down when he said that, but then he'd come right back and tell me that we would both work hard to make life better for me. He knew that I would try anything, so my answer would always be, "Okay." As long as he was there to encourage me, I knew that I'd be able to keep going.

Yet, the things that we would tackle together up the road would be very difficult, and at times, almost impossible.

Chapter 5

Pain Indescribable

This brain injury affected everything in my body, and it changed the way I did all the big and little things in my life. I worried a lot in the beginning about how or even if I would ever overcome all of them. My life was busy going from one doctor to the other in those first three years, and I didn't seem to be gaining anything from them. At least, I didn't see any notable change in their attitude towards me.

Heidi was an angel, and I don't know what I'd have done if it weren't for this dear friend. She took me to see all the different doctors, and even on the occasional shopping trip. She took me wherever I needed to go and was my voice. I knew that with her I had the help I needed when I was going in and out of all the doctors' offices.

Whenever my husband would take me, he'd just sit in his car and do nothing like an unfeeling taxi driver. I'd have to get in and out of the vehicle by myself, and that was very painful and awkward for me to do alone. He never once helped me or even offered to help, not even after I'd mentioned how I could use his help. It angered me because he was so uncaring, but I kept feeling that I didn't want his help anyway. I had a deep resentment for him inside me, aside from his current attitude, and I had no idea why.

When we went to see the first family doctor, I had to climb a set of stairs, and I dragged that injured leg behind me and pulled myself up those stairs. After seeing the doctor, the receptionist helped me down the stairs, one step at a time. Ex did nothing but sit in the car and watch.

When I wasn't out seeing a doctor, I was at home trying to get some rest. My bedroom was at the back of our house, and just outside my window was the gate that led to the backyard. When people—and by people I mean Ex—would open it and slam it closed, the sharp sound would pierce my head with indescribable pain that would send me to hell and back. It felt as if someone were hitting me in the head with a hammer.

I asked Ex so many times to please stop slamming the gate closed, to shut it quietly because the noise hurt my head so much. But did he care? No. He did it anyway. He had no compassion for what I was going through. He acted as if I wasn't there most of the time.

My PSW explained to me that the intense migraines I suffered from were a result of the damaged part of my brain. She would give me cold compresses and keep me in the darkened room to help me cope with them, but unfortunately, nothing really worked.

However, whenever she was there, and Ex would slam the gate, she'd see me hanging onto my head and crying, and that bothered her. So, she would go to him each time and ask him to stop slamming the gate, and each time she'd explained to him what it did to my head. But he didn't respond to her pleas, and he didn't stop slamming the gate when he went through it. He either had no idea what I was going through, or he didn't care. That frustrated the PSW, and I remember hearing her mutter one time, "What an ass!"

Another two months passed by, and I had to have an MRI. If you've ever had one, you know the stress that goes with it, and so double that for me because, with all I endured from the brain injury, it truly was terrifying. However, it proved to be quite helpful because it showed that a pool of fluid was sitting in a certain area of the brain. When I met with the doctor for the results, he told me that it was inoperable, and that news just crushed me. I couldn't go on for the rest of my life with this horrible pain. This was not an acceptable prognosis for me. I had to do something to change it. So, I began by changing physicians.

In May of 1999, Dr. Kevin Corless took me on as his patient and became my family doctor. He studied the results of the tests that I'd had up until then, and he even put me through a few more, and then he gave us *his* prognosis. "Thank God," he said. "The spot of fluid landed in the right place." I couldn't believe it! Then he set me up with doctors in Kingston and Toronto and Hamilton in their brain injury facilities. I was filled with hope and encouragement.

Meanwhile, my left leg still wouldn't move, but I continued with my physio appointments at home anyway, and the woman who came was so patient with me. She knew my issues, and always spoke very softly and continued to be very gentle with me. I remember looking at my left leg and saying to it in my head, "Move!" Then I prayed, "Oh God, help me to make it move forward and lift it up." That's when I tried again, and slowly, it started to move.

I was so excited! Day after day I kept at it, and the leg continued to move little by little. Then, after some time, I had learned to walk by watching my legs and making them move. This wasn't a natural movement. I couldn't just get up and walk naturally, the way I used to, or I'd fall over. Now I had to keep watching my leg and focusing because it moved slowly and awkwardly. But it moved when I watched and focused.

Marjorie Coens

However, the pain in my head was still unbearable, and Dr. Corless put me on morphine to help me deal with it. It dulled the pain, and I was grateful. But morphine is a narcotic drug, and you do become addicted when you use it all the time. Unfortunately, over the next few years, I had to have the dosage increased until I was taking it at maximum strength.

In the meantime, I required regular enemas for bowel movements, and the joke of the week was keeping the nurses guessing as to how long I could hold it. I think the longest was an hour. Sometimes you have to find a bit of humor in situations like this, or it can get the best of you.

My son was doing all he could to help me recover, and he set up a computer so that I could practice my typing. "Mom," he said, "you used to type 90 words a minute. It's time to do that again." He also gave me an exercise ball to sit on so that I could work on my balance.

The idea of learning the computer angered me at first because I didn't want to do it. I'd have to start from scratch to learn to type, not to mention to try and figure out how to work the computer. It was totally strange to me at that point, and I had no desire to learn something new amid all my other stresses.

Lloyd's intentions were good, of course, but he had no idea that I'd forgotten how to type. He just wanted me to get back at it so that I could use it to communicate with. I didn't want him to know the truth, and so I agreed to practice every day and learn to type out the things I couldn't say. My right hand worked fine, and I was able to type the words set out before me. The computer program would underline in red all the spelling errors, and there was a page full of them. I didn't care at first, but then after a while, it clued in that I really needed to do this. So I stopped being angry about it and started doing it to improve myself.

My speech was like that of a stroke patient to the point that no one understood what I was saying. This was very stressful for me. So learning to type and put my words on paper was the perfect way for me to communicate with people. I could talk to my physician and have him understand what I was saying. This turned out to help him tremendously because then he knew what was going on inside my head.

Meanwhile, physio continued, and I was making slow but sure progress. We had a heater installed in the pool, and I was able to do physio outside in the warm water. It really helped because it was easier for me to move in the water than it was out of the water, and so I was able to start working on my legs and arms. I thought I was doing very well until I let go of the side of the pool one day—and then down I went! Once I got over the shock of that, I quickly learned to not let go of the side.

I'd go outside, usually by myself, and do as much pool therapy as I could. It was a struggle for me, though, because there was no one around to help me. Yet, I knew I had to do it to improve and so in the pool I'd go, wearing my neck collar and walking with my cane. Then I'd grab the noodle, and I'd work until I couldn't do anymore.

Sometimes my daughter would come over with her kids and her two dogs, and the dogs would stress me out. I'd ask her to please leave her dogs at home because they were fast and I was terrified of tripping over them and falling. But she didn't listen. It seemed that nobody listened to what I wanted.

I'd brought them up to know respect, to help others, to use manners and good work ethics, to be caring and to live by the law and with faith. What happened? I didn't see any of these values in the way they treated me. But what I did hear Beatrice say was that she had no mother anymore.

Her words cut deep, but I had to force myself to ignore them and keep going. There was no doubt that I was a mother and a grandmother first and foremost, and my heart and soul confirmed it regardless of how I appeared on the outside. I couldn't walk, and I couldn't talk properly, but I really expected my kids to understand and even help me. I remember crying out silently in my heart, "Why Lord? I need your help."

I had to do what I could do to get into the pool as often as possible, but it was so very frustrating at times. I was aware that I knew how to swim before, and yet there I was, in a pool of water with no clue at all about how to swim then. Getting out of the pool was another great challenge for me. I had to pull myself up with my right side and crawl like a worm. It showed me just how much people, including myself, take their motor skills for granted, and that the brain is the real motor for the whole body from head to toe. But we don't realize it until it stops working.

I pushed myself to do the exercises in the water. My grandkids loved to come in with me because the water was heated like a 90-degree bath. They'd do the exercises with me, and we'd have a lot of fun. They were also a great help to me when it was time to get in or out. Unfortunately, they weren't always there, and most of the time there was no one to help me. It was hard for me because I was tired and weak. Yet, it actually helped to make me strong because I *had* to get out anyway. I knew I could do anything if I tried; if I used the part of the brain that still worked. It took hundreds of neurons to do it, but I did it, one little step at a time.

My grandsons were the ones who encouraged me the most, even though they didn't know it at the time. Jacob, Karl, and Marky had written up a list for me, of what they wanted me to be able to do again. I looked at it, and the emotions made my head and stomach want to run away. But I saw the hope and the promise in their eyes.

They wanted me to skate again. I used to teach children to skate, and they remembered that. They wanted me to do it again. They wanted me to ride a bike again, a four-wheeler, and they wanted me to play road hockey with them.

Talk about encouragement! My boys believed in me, and I would not let them down. I promised them that their Nana would never give up and that one day I *would* do all these things again. I promised to try extra hard just for them.

The love for my boys was very strong, and I wasn't going to disappoint them. Their Nana was going to climb that mountain with faith! It was very encouraging for me to see the hope in their eyes. Because they believed me, they helped me to believe in myself!

Chapter 6

Learning All Over Again

During that first six months after the accident, my daughter Beatrice had taken charge of the bills and paid them all at the bank. This had been my responsibility and one that I had done so easily before the accident. But afterward, it was impossible. She was pregnant, though, and she struggled with sickness and moods, and my partner was better at spending money than he was at helping to pay my bills. So I wasn't too surprised when she said she couldn't handle it anymore; however, I was a bit shocked when she said that she'd given it all to her father to deal with.

Ex had never dealt with the bills before—ever, and it concerned me a lot as to how he would handle them now. Unfortunately, I couldn't do it myself anymore, so it was out of my hands. He took over the task for the next many months, and I had no idea at that time that he wasn't doing it properly.

Then one day, when my cognitive skills were beginning to return to me, I asked about the bills. I wanted to know if they were paid and how things were going. That's when the truth came out that many bills were not getting paid. For example, the hydro bill was very high because it was often not paid.

Ex had a reason for everything, or so he tried to tell me. Things were still a struggle for me to fully understand, so I kept trying to ask. Memories of how to do it and the details of the finances still weren't registering; yet, I somehow knew that bills were paid on time when it was me doing them.

After a while, he stopped giving me excuses and just answered with a smirk. It angered me that he thought I was too incapable of realizing what was really happening. I was aware that we had bills, and that they had to be paid. I just couldn't remember how to pay them.

Then it occurred to me that I might not know how to do it myself, but an accountant would know. So, then came my next greatest challenge in life and that was to get all of the papers and bills together for the accountant. Yet, I did it and somehow managed to bring them all to the accountant's office. I stumbled through my movements and tried to explain things to him in my own way, ignoring all pride in how I appeared. He was very kind, though, and he smiled and told me not to worry and that he'd go through them all and sort things out—and he did. This would become something that I'd end up doing every year after that.

The accountant was a big help, which is more than can be said for Ex who did nothing at all except to drive me to the accountant's office. He was no support to me in any way, and I was embarrassed each time I had to go there. He would just sit in the car and leave me alone to struggle with getting around in a walker by myself. That was bad enough, but then trying to talk intelligently so the people there could understand me was another thing.

It would have been so much easier if Ex had been there with me to help me walk, and to carry all those papers, and to talk to the accountant. But that never happened.

37

Regardless, I wrestled with these handicaps for the next few years. For whatever reason, it didn't fizz on my family to help me. Not once! Whenever I complained, they'd just tell me that I used to be an office manager and that I should know all of this. That would just rattle me! I was aware that I used to do it, but they were *not* aware that I couldn't do it now! Yes, it had to be done, but I had no recollection at all of *how* I did it before, and it frustrated me to the core that they didn't get that.

I asked my family for help many times and always hoped that they'd eventually understand what I was going through. However, neither Ex nor my daughter offered to help me. Lloyd helped, though. He'd set the computer up for me so I could pick up on my typing, and then he said that when I was ready, he'd show me how to do the online banking, just as I used to do it. This way, I could pay the bills myself. He wrote the instructions down on paper for me, and they were simple step-by-step instructions—simple for someone who wasn't dealing with a brain injury, that is.

But I practiced over and over, and eventually learned how to do it. The people at the bank were really helpful, as well. One of the reps there helped me to set up automatic bill payments. That was so helpful to me. Then I learned how to print the payments and staple them to the bills, and that alone was a major accomplishment for me. It was as if I had taken the first step up that mountain that I had to climb. What a great feeling that was!

However, that first step took me many, many tries to get it right. Learning to use the computer was a big challenge, and I was actually afraid of it at first. I knew that before the accident I could use the computer with ease, but that was all gone, and now it was time to start all over. I was terrified of making a mistake, especially when paying the bills, and so my focus was to practice and do it right.

Every day I'd open the financial files on the computer to see all the numbers, but they didn't mean much to me at the time. I guess my one reprieve was that Lloyd would help me if I needed help. As well, my homemaker was very sweet and helped me often. She would encourage me with her soft voice and tell me to keep going because I could do it. Little did either of them know that trying to do this made me very tired, and my brain became like a blank page covered in scrambled dots when I got tired.

It didn't take much for me to get stressed over things so that the skin would tighten around my head and that hammer would start to bang inside. I felt as if I was in hell when that started. That's when I'd take some quick release morphine and force myself to rest before the twitching would start. That always scared me when I came close to that point because after the twitching was when the seizures would come, and they were horrible.

The next thing for me to learn was the filing system— another challenging task. After I'd paid the bills and stapled them to the receipts, I had to learn what to do with them. I worked hard to get to the next step in the process.

The filing cabinet was nearby, and I knew that they went in there. It didn't occur to me to put the papers in any particular order, though. My thoughts were to just open one of the drawers and drop them into whatever folder I saw first. Sometimes, I'd accidentally collect the unpaid bills and file them in the drawers, as well. I didn't realize the difference. If it was paper with a staple in it, then it got filed.

This was my filing system for the next couple of years. Nothing was in order, and whenever I needed to find a bill or a receipt, I couldn't find it because I didn't know where in that cabinet anything was. In truth, it was one big mess.

It seemed odd to me that no one in my family was interested enough in the bills to even check and see if I was doing it right. No one questioned if a bill was paid or not. No one asked if I needed any help. No one seemed to care.

There were papers and bills and bank statements in all of the drawers. Some days, I would get so confused that I just wanted to give up. It was a constant learning process to remember how to do it, and it took all of my strength to focus and keep going. I could only hope that I was doing it right.

After a long while, the filing cabinet was full and a big mess. One day I was stressing over it when Lloyd's boys came over and saw how upset I was. One of them asked me if I remembered the A, B, C's. After shaking my head, I sighed and said, "No, I don't."

So they decided to teach me. Of course, learning the A, B, C's was done best by singing it. So we all sang, and I used my computer and wrote the alphabet down so that I could study it. Slowly, I began to understand. I not only mastered the alphabet, but I had so much fun with the boys learning it. They had no idea at the time just how special they were to me. They were my teachers, and I learned so much from them.

My homemaker helped me to set up the filing system in the file drawer, and soon they were set up in order. About every six months after that, I would redo the filing cabinet, and try to make sense of it. It took a while, but I saw a pattern, and I began to figure things out.

In the second year of my recovery, we had to redo our mortgage a couple of times. I had no idea why or what was going on and to try and understand was too overwhelming. I had to simply trust my husband and sign on the dotted line. But I soon discovered what was going on.

Fast forwarding for a minute to around 2003, we sold our home because it was just too expensive for us to live there anymore. I felt as if I had been fighting an endless battle trying to keep ahead of the bills that just kept piling up. Every month they were paid, yet, they were still so high.

At the time of the accident, our mortgage was about $48,000. When we sold the house, it had grown to $165,000. What happened? There was no logical reason to me why it went up, but I was still struggling to balance the checkbook and thought it was something I just hadn't figured out yet.

There was no more room in my life for more stress. However, the financial issues were overwhelming and they were getting me down. I just wanted to move on with my life and get a fresh start—and for me, that meant a fresh financial start as well as a fresh emotional one.

We moved to an apartment and lived there only for a short time, and then moved into Lloyd's house into a few rooms in his basement. His boys would come over every other week since they lived with their mother after Lloyd's and her divorce. They were a huge help to me. I'd look at their homework and try to help them, and it was this that really helped me to learn the basic academic subjects again.

None of them knew it, though. They just thought that it was fun to do homework with Nana—and it was fun! However, it was also a struggle for me because I was learning new things right along with them. But it was the smiles and the laughter from these boys that actually rocked the joy in my heart.

Beatrice's kids would come over, as well, but they never stayed long. They'd come after school, and I'd give them some ice cream, and they were happy. We had a lot of fun together, too, and I really looked forward to their visits as we shared things and laughed together.

Little did any of the grandkids know that they kept me going. At the same time, I wanted to help them to do the right things in life. I wanted to teach them things like honesty, respect, work ethics, love, trust, and the rules of the land such as the Ten Commandments.

Sometimes they would laugh at me, but I got them in line quickly, especially when I would say, "For Heaven's sake, Kids." One thing I can say about the kids is that they knew I would never lie to them. Even if the truth hurt them or me, I always spoke the truth.

While the relationship between my grandkids and me was getting stronger, I felt as if my two children were drifting away from me as each day passed by. We didn't chat or laugh together anymore. We didn't share things the way children are supposed to share with their mother. In fact, it was quite the opposite, and that hurt.

I'm so thankful, though, that the grandkids were there because they kept me on the right track. They inspired me to not give up and to keep pressing on. They believed that I could do all the things I used to do, and that really blessed my heart. I treasured their unconditional love for me, and their smiles, and their hugs and how they held my hand and said, "I love you, Nana. You can do it." My grandkids were my greatest encouragement. They gave me all the reason I needed to keep going.

Chapter 7

Life, Death, and Learning

Going back again, it was November 28th of 1999. I was walking with the aid of a walker, but on this particular day, I was using a wheelchair. My first granddaughter was born that day, and I was so happy to be in the delivery room to greet her. I held this precious new baby in my arms within minutes of her birth. My heart rejoiced, and I promised her that I would work hard to help guide her and to be there for her while she was growing up. I loved her. She gave me another reason to keep pushing forward.

But then, in October of 2000, Audrey took a sudden turn for the worse, and at a time that I least expected it. I immediately went to her home and spent some time with her, and I remember that when it was time for me to go, she begged me not to leave her. I was hoping that she was just the protective sister that she'd always been due to my health issues. But we both knew that she was dying, that this was the end. In my heart, I knew this was our final goodbye.

This was very hard for me to deal with, and I was absolutely sick inside over it. There was no way that I'd be capable of attending her funeral, so I planned a trip to Myrtle Beach for a week with some friends. This enabled me to get away and deal with the reality of losing Audrey, and at the same time, helped me to recover a bit more.

Audrey died during my trip back home. The pain and torment were almost too much for me. I was broken over losing her, and I didn't want to talk to anyone.

However, Ex talked to me about Audrey, and what he said cut to the core! He was absolutely nasty and heartless, and I'm still not able to repeat what he said without dying inside all over again. How could anyone say such things? How uncaring it was to say them to the grieving sister who was in tears over her death! This man had no compassion, and all I could think of at the time was, "God will get you for this."

Finally, I got settled in at home, and a neighbor there came over to visit me, as she often did. Each time she would ask why I was there alone, and I'd always have to give an excuse such as, "He had to go to the movies," or something. Then I'd say, "I'm okay. I'm getting used to being alone." But inside, I couldn't understand, either, why my husband wasn't there to help me. He seemed so distant, and I didn't know why. Slowly, I began to realize that it was because he had outside interests.

Then in November of 2001, Beatrice was supposed to move into her new home, but it wasn't ready. She asked me if she and the kids could live with us, and the hardest thing I've ever had to do was tell her no. I knew that I couldn't handle the congestion of people or the noise. Oh, I wanted her to come, though, because I really wanted her company so that I wouldn't have to deal with her father.

By then, Ex had admitted to me that he had been messing around with other women—and not just a few, either. He didn't seem remorseful or even guilty about what he'd done to me or to our marriage. To make things even worse, he justified his evil actions by blaming me for them. He said that it was because I was always pushing him away that he was forced to find pleasure in other women.

Ex had betrayed me. I could barely look at him let alone talk to him. All of my love and trust for him were lost after that, and there was no desire in me to ever reconcile.

I couldn't explain any of this to my daughter, and so she didn't understand the obvious tension between Ex and me. Even more, she didn't understand why she could not come and stay with me even though I tried to explain it to her. So that just added tension between her and me, as well.

Beatrice needed to realize that I wasn't able to be the Nana I used to be to her kids. I couldn't talk or walk or even react to things properly, and on top of that, her father didn't want anyone around, not even his own daughter and grandkids. She was mad at me, and I knew that if they went somewhere else, I'd likely never see her or the kids again. The thoughts of that were heartbreaking.

One time when they were at our house visiting, her son apparently spilled some milk, and Ex screamed at him for it. This had nothing to do with me; yet, Beatrice took it out on me, and there was a look of hate in her eyes that shot out at me—not at her father who did it. I couldn't understand why she did this, but it put so much stress and hurt on me that my head began to throb and go 5000 miles an hour. Why was she accusing me like this? I didn't know what to do, so I called the Hamilton Brain Injury Hospital and asked for help.

Since I'd been diagnosed with a severe brain injury, I had been forced to endure many harsh tests. So, while all of my waking hours were spent visiting every kind of doctor imaginable to help me recover, I also had to see doctors for the insurance company regarding the lawsuit. They put me through more tests and examinations, and it was hard for me. It didn't make sense. Why couldn't they use the test results from *my* doctors? They insisted on doing their own tests because they needed proof that I actually had a brain injury.

In 2000, one of their doctors said that I had MS. How did she get that from the tests? She was useless, and the tests I endured for her and the others were not fair. I should never have had to be put through them twice.

Then I went to Kingston to see Dr. Adams, a brain specialist, and I was terrified as he put me through the wringer with one test after the other. I didn't know up from down. I even tried to write my name with my good arm on a sheet of paper, but it was impossible as the arm and hand just swung all over the page.

He tested me to the max, and then I cried and could not stop crying. That was the last straw, and while crying and hanging onto my head, the pain was unbelievable! He knew I was on morphine, and he increased the dosage and with a quick release. He said that I had migraines caused by the damaged areas.

Dr. Adams arranged for me to have a brain mapping done and then an MRI. Afterward, he sent me to a Hamilton hospital for a month. It was harsh, and I only got through it because I focused on the outcome and not on what I was going through to get there. I had to take it one day at a time.

The first three years after the accident put me through more pain and heartbreak than most people go through in a lifetime. While the physical and mental pain was tormenting, it didn't come close to the emotional trauma that came with it. I was aware that Lloyd and Beatrice were my children, but the memories of the relationship that I'd had with them were gone. There was no recollection in my mind of how or why it was necessary to protect them. What I got from them after the accident, what I knew of them then was resentment and disgust, and it bothered me. Had it always been like this?

My children didn't know me anymore because I couldn't move or communicate with them. I couldn't help my daughter with her family in her home as I had apparently always done for her. I couldn't do things with my son; not because I didn't want to, but because I couldn't. They looked at me as someone who had become a totally different person. So, they treated me as if I wasn't there, as if I was a mentally disturbed stranger that you keep at a distance as if I was the greatest burden to them; someone without feelings.

The truth is that I knew I loved them; I just couldn't remember much about my life. So, I pretended to know the life that I'd had, but in reality, it been erased by the accident. Sadly, I walked and talked in such a way that it offended them, and I saw my children withdraw from me and become more estranged to me as each day went on. I had forgotten a lot, but I had never forgotten how much they meant to me, how much I loved them. Yet, the way they hid from me tore at my heart and brought on so many questions.

I'm so thankful for my three grandsons, Jacob, Karl, and Marky, though. They were positive and so encouraging towards me. From the onset, they would come into my room and lie on the bed beside me and gently hold onto my hand. The nurse would come in, and they'd all remind her to not hurt their Nana. I swear it was the voice of God's children that gave me the faith and the strength to keep going.

Life was very difficult for me because I couldn't control my body. Many times I'd wake up and discover that I'd passed out on the bathroom floor and that there was urine all around me. Other times I'd be on the family room floor. Several times the physiotherapist found me that way, alone and on the floor. It seemed that none of my family wanted to help me. Yet, I kept going and kept learning, and after a lot of trying and stress, I learned to walk and talk and move.

It was a while later that Pastor Doug Schneider from the Embassy Church came into my life. I can't remember if I was still in the wheelchair or using the walker, but I was glad to meet him because I needed him. My speech was still very poor, yet he understood me. That made me happy.

He spoke to me, and we prayed together, and that's when I remembered that God doesn't give you any more than you can handle. I told Pastor Doug the verse from the Bible about that, and he looked it up and told me what it meant. This gave me the encouragement I needed to keep going.

Through all of this, I felt that God had given me a job to do. Both of my children were divorcing and, oddly, within the same timeframe. It was a lot to deal with emotionally. Meanwhile, I was living through my own horrible marriage with a man who was constantly committing adultery. The truth is that I wanted to divorce him, too! But the timing wasn't right because the grandchildren were going through enough and were crying over their own broken families, so I didn't want to add stress to them.

I didn't want to lose my grandchildren. Who would teach them about morals and the right and wrong ways of life? I needed to be there for them, to help them. As well, I needed them to be there for me. They were my angels who taught me the things that I once knew, but had forgotten.

My grandkids taught me simple math like two plus two. They also taught me how to use a calculator. I didn't want them to think that I didn't know how to count or how to use the calculator, so we made a game of it, and this way, we all learned. In the end, it appeared as if I was helping them with their multiplication tables, but I was really learning it myself. It took a lot of practice when I was alone to try and get the hang of it, but I did it!

Dr. Corless was also a blessing to me. He was very compassionate, and I was able to ask him anything without feeling foolish. One time I asked him what a massage parlor was, and when he explained it to me, it made me feel awkward, but not stupid. It was something that I'd forgotten, and it was like learning it new for the first time.

This doctor always gave me great encouragement, and I really looked forward to seeing No matter what was going on in my life, Dr. Corless spoke with authority and yet with compassion, and it was easy for me to talk to him. He was very friendly and very helpful to me. However, things weren't as kind back at home.

I knew that I couldn't have sex for years as I had no feeling in the pelvic area, not to mention my inability to move. Part of me felt guilty for that because it caused me to not want to be intimate with him, but part of me didn't feel bad about it at all. I knew that Ex was not faithful to me, and that made me feel so resentful. So, I really didn't want him near me anyway because of that.

As well, though, it was because I really didn't know who he was. I knew that he was my husband, but I didn't know how we were together before. Did he love me then? It was quite obvious to me by the way he treated me, that he wasn't madly in love with me now. But that was it. I didn't *know* him, and it scared me!

One night he came home late, and I had a knife under my pillow. I didn't know what I was going to do with it, but I felt safe with it there anyway. I didn't feel comfortable with Ex; it was as if I was sleeping with a stranger. We were like two very estranged people living in the same house and sharing the same bed. We weren't lovers—we weren't even friends, and from the way he treated me, I had no idea what we were before the accident, or why I had even married him.

However, there was a special friend that stayed by my side throughout this entire nightmare, and I treasure her friendship very much. I met Doreen before the accident when she was an employee at Rogers Cantel where I had been the office manager who hired her. We got along well, and we became like twins. We shared everything and did everything together. When she needed a friend, I would be there for her, and when I needed a friend, she was there for me.

Even after we had become separated by 1600 miles, our friendship stayed close. We'd phone each other and not lose a moment of precious time together. Ex didn't like me calling her, but sometimes I'd wake up in the night and feel as if my spirit was telling me to call her, and so I did.

My other friend, Heidi, had stepped in to drive me to all the places I needed to go when Doreen left. She was also a friend who stuck with me from the very beginning of this new life. We'd been friends since the mid-80's, and our husbands did everything together, including going to places that they shouldn't go. They were two of a kind.

I'm so thankful for my friends because they helped me through the dark hours—and I would continue to need them because there were many more dark hours yet to come.

Testimony #2

I was looking for a job, and after a week I called the office where I had applied, and I introduced myself. I got an interview with Marjorie. Little did I know that she had mistaken me for someone else. Marjorie introduced herself, and I found her to be quite professional as she stood with such straight posture. She was very direct and sure of herself.

The interview went from basic business to something right into the left field. By the time I got home, which was just ten minutes away, there was a message on my machine saying that I got the job. Little did I know that this was the beginning of a wonderful new friendship.

As a boss, Marjorie ran a tight ship. She was very strict and expected her employees' personal best at all times. She would always remind us to make sure every "I" was dotted and every "T" was crossed so that everything was done just right. Time went by, and training became less. Marjorie's watchful eye softened—not that we could slack off, but knowing that her training and strictness was playing a key roll in her employees' work.

Over my first year of working with her, I learned very quickly that she was first and foremost, a lady of great form, from her posture to her positive motivational attitude. You knew she was always on the straight and narrow. She had strong morals, and they were very apparent in her everyday life. She practiced what she preached!

51

All that said, there is just one thing that seems most important—her genuine kindness and concern for those who surrounded her, like that of a mother's touch. I not only had a boss, but also a new friend.

Then one day, she was no longer coming into work. Had she fallen ill? Something was just not right, so the kindness she had shown to me, I gave back in return. I now considered her to be my friend, as well as my boss. So off to her home I went for a visit to see how my boss was doing. Something was just not right, and I saw that she was in physical pain, not being able to turn her head. Stress? But from what?

Our part of the company had closed, and we all went our separate ways. But Marjorie and I kept in touch. Then the unforeseen happened—Marjorie had been in a head-on collision. She was home from the hospital in no time, and I had to see her. As I walked into her home, she lay face-down with her head hanging over the edge of her bed. Her daughter was pouring warm water over her head into a bucket on the floor. She was trying to loosen some of the dried blood that had formed a firm nesting in amongst the hair on her head.

Numerous visits over the years were painful to watch. This straight-postured, strong woman had become crippled and hunched over, and she struggled to get a single word out even to share a single thought. At times, there were months of gaps between our visits. I took my mom to see her on one of my visits as I was so proud of Marjorie's accomplishments and her strength to get better and rehabilitate herself.

Thinking back now, at each and every visit I had with her, she was alone in the house. No one was there to watch out for her, and nobody was there when I left.

Some of the words I will never forget were when she struggled to say, "I will get through this and be strong again!" To know Marjorie as the strong woman that she was is to know that she meant what she said. Marjorie had to work hard to get to the point where she could actually, as they say, "Walk and chew gum at the same time." Imagine, having to work for years to get to that point, knowing there was still so much more to overcome! But she managed to grow stronger every day.

A significant amount of time had passed, and I finally got over for another visit. My jaw hit the floor that day. Here we were, chatting at the table and Marjorie was in great spirits—chatting like I had not seen her do in many years. Words were coming more easily for her, yet still not without great struggle. Step by step, I watched her get up from the table, walk over to the sink, rinse her teacup out, put it in the dishwasher, turn around and look at me, all while continuing her conversation with me, and without a hitch!

My jaw was almost on the floor. I could barely believe it! She was "walking and chewing gum," or so I was thinking.

What an accomplishment! I was amazed at how she managed to do more than one thing at a time. You can't even imagine how much strength it took her to retrain herself to actually walk AND carry on a conversation at the same time.

The conversations I had with her daughter over the first few months after the accident were few as I just could not understand what she was saying to me. "This is not my mother anymore," she'd tell me. All I could think of was, "How can you say that? Do kids not have unconditional love for their parents as their parents have for them?"

Over the years, Marjorie shared private conversations of how she struggled to rehabilitate herself. Things such as not even being able to figure out how to get off the toilet and get back to her bed, to the complete loss of emotions and feelings her body should naturally have. It was amazing to hear how she let her grandsons (Lloyd's boys) teach her the basic schooling again. They would come home asking for her help with their homework and were still too young to comprehend what had happened to her post the accident.

Some time had passed by, and her speech had become much better, but still far from what it once was. The boys would say to her, "Nana, how do you do this?" And her response would be, "You know how. You just have to try."

Marjorie developed her own learning skills by getting her unknowing grandsons to teach her the basic schooling. Things that once came easy to her, like Math, were now things that she would have to learn all over again. And in the same way, she had to teach herself to walk and talk again.

I saw Marjorie as a lady who once seemed to have it all, to become someone buried alive with just a straw that went from the surface to six feet down. Now, over the years of the soil being packed down on top of her, she had managed to dig herself out—all alone, one finger shovel at a time.

It just seemed that everyone around her had given up hope on her. She became isolated from the rest of the world. Not being able to walk or talk for so long, she never really went out or shared with any of her friends what had become of her. Trapped in her own body and mind, she struggled to get out of her own shell. She was blinded and deafened by simple sounds and fast movements, and they would often leave her in a heap on the floor in paralyzing pain.

It was her sense of aloneness that truly gave her the motivation to pick herself back up, one piece at a time, and to get herself back to become the woman you see today. This woman stood strong and proud, was the loving mother and grandmother who cared and did more for her family than she ever considered doing for herself.

She has lived a hell most of us will never know, and she has self-rehabilitated——and not to what she was but to a new improved version with much stronger happiness that she has never known before. All this and also having to bear her own cross of physical and emotional scars, will remain with her for a lifetime.

Marjorie walked down roads with many pathways, but with it all, she has kept her faith in God, knowing that with His strength she can make it through just about anything. Not to say that she did not have times of lapse and moments of thoughts that she could no longer go anymore. This, I now believe, was just a time for her to recuperate and rest so that she could regain her strength and continue her struggle to a more "normal" life.

Going to church and just listening to the music gave her strength for the next day, and for the struggles, she saw that lay ahead of her. What you need to know is that it took years before she was even able to enter a church. The noises of just a car going down the street, or a cup falling off the counter onto the floor would drive her head into a fast spin and send her to the floor in a mound of indescribable pain. And the music during that time was too loud for her to bear.

Summing up Marjorie's life cannot be done in a sentence, in a paragraph, or even in a page. It's a book!

Marjorie Coens

A book about an incredibly God-fearing, courageous woman who has profound and unconditional love for her family; a book about a woman with amazingly strong morals for her life, and with the passion and the strength to accomplish whatever she puts her mind to.

Marjorie Coens, a daughter, a sister, a wife, a mother, an aunt, and someone I am privileged to call Friend.

*Doreen*

Chapter 8

Locked in a Cell

It was the year 2002, and the insurance doctors tried everything to rattle me, but they didn't want to accept that I was rattled. So, they sent me to rehab in Hamilton with others who suffered from similar injuries. We were all locked up in different rooms, and that was fine with me.

One of my greatest concerns at that time was to just be able to go to the bathroom. They didn't understand my issues, that my body had lost its ability to release because the Vega nerve that signals the bowels to move had been damaged. So, they gave me some stuff so I could have a bowel movement. This was not the answer to my problem.

Shortly after that, I had to go, and I just made it to the bathroom before it all poured out of me. Unfortunately, with it went my strength. Then my blood pressure dropped so low that I was on my hands and knees trying to get to my bed.

There was a young girl in the room with me, and she rang for the nurse. A few minutes later, this old and harsh woman came in and told me to get into my bed. My speech was gone, and I couldn't tell her anything, that I was really dizzy. So she grabbed me and forcefully walked me over to the bed. I just wanted to die at that moment, and my stomach wanted to throw up, but I was too weak.

The nurses had the drugs for pain at their station, and they wouldn't give me any then, so I was forced to suffer through it, one long hour at a time, right through to the next day.

Early the next morning, I rose and went to the nurse's station to get the meds, and then went for breakfast. They gave me baby food and were checking my swallowing. It was nasty! I just wanted to gag. On top of that, they put this huge bib on me, and that's where I lost all my dignity. But that was just the beginning.

After breakfast, I had to go down the hall to get to my room, and my head hurt so badly. The best way to explain it is that it felt as if my brain was being pulled into the tunnel with me running behind it. It was so confusing. The nurses were telling me to look up, but I couldn't because the long hallway drew me in and I wanted to fall over. So I did what I knew I had to do to get that long hallway, and that was to look at the floor that was close to me. Then I laid down.

Lunchtime came, and it was Caesar salad. Whoopy! I threw the bib off and started to cut the salad up so that I wouldn't choke on it. But then suddenly, a nurse grabbed my hand and said that I couldn't do that. They needed to watch me eat it whole so they could watch it go down. What? I tried to argue, and then I struggled with them, and finally, I just cut my salad up. Then I said, "No more!" I told them to leave me alone in a few words since I couldn't yet speak sentences.

Thank goodness I was able to rest in the afternoon as I was worn out, but I couldn't sleep. Then all I wanted to do was take a shower because I felt so dirty, and so I did. It felt so good, too. Of course, without thinking, I'd taken the cane into the shower with me, and it got wet. So naturally, when I walked back to my bed with the cane, it left a water trail on the floor. That did not make the nurses happy with me.

The pain was getting to me, though, and I couldn't keep my track going in one direction. The stretch between pain meds seemed long, and one time, after I finally got them, the doctor came in right afterward. I told him what I could, but then there was a loud noise, and my head shook!

Because of that, they wanted to do more tests on me; tests that I'd already endured from my own doctors. These were hearing tests, MRI, speech therapy, physiotherapy, and tests for social skills, to mention just a few of them.

They sat me in a room with them and then they all just stared at me as if they were watching TV. I said, "No!" Then I got up and went down the hall to my room. I felt as if I was running with my left leg dragging behind me. Then I stopped and cried, "No more!"

There was a male nurse there who was working with another patient, and he came to me and asked if I could tell him what I was feeling. He understood me and was interested in me because one of his other patients was just like me.

He said he'd talk to his doctor so I could explain my feelings to him. Sure enough, the next day this male nurse came with the doctor. So I explained things to him the best way I could about what I was feeling. I thought things were going well, but then the doctor put his hands on my shoulders, and with a cynical smile, he looked down at me and said, "Be a good girl and you'll get out of here."

I was furious! How humiliating! How deplorable! I could not understand why that doctor would even say such unfeeling words to me. He treated me as if I was some kind of a crazy person! Is that what he thought, that I was crazy? I had become speechless because of all the stress, that's all. I was probably saner than he was! He was really lucky that I couldn't speak just then because then he'd know just how sane I was.

Shortly after that, I was moved to a private room with a kitchen, and when mealtime came around, I brought my food into that room and ate it alone. Then I'd wash those dishes every day, whether they were used or not. It was good therapy for me, and so I did it anyway.

Then came the hearing test, and they said that I was sensitive and that it was strange. I felt like saying, "Well, excuse me! I feel strange." But nothing came out. They wanted me to join the groups to watch TV, and somehow the words, "No way," managed to escape my lips. I had no interest in sitting in there and watching TV! There were things in my own life that I had to work on, and that were actually more important.

Then they wanted me to wash my clothes in their washer, and so I was taken to their little laundry room. It was so dirty, and the machines were so disgustingly filthy, that there was no way my clothes were going near them. I gasped and stepped backward. "No way! It's dirty." Then I turned and walked away because seriously, it was disgusting.

Most of the nurses there were very good to me, and there was one in particular who was extremely helpful. She'd come in at midnight and talk to me about big words, as in three-syllable words. It hurt my head to hear her speak and to hear myself trying to say them, but I knew that I needed to learn to say them. So I practiced them as much as I could.

Thankfully, I was able to go home on the weekends, and that's the only time that Ex saw me. He picked me up on Fridays and brought me back on Sunday afternoons. I never saw him the rest of the weekend. After the first week of being there, though, I made arrangements with his sister, and she'd take me out to dinner three times a week. It was so nice to get out of that locked cell.

Then, my own two sisters and my sister-in-law would come during the week and take me out for dinner, as well. Even my brother Dylan his wife Charlotte came at times. These visits were my sanity breaks, and these people were like angels to me. I would smile inward and out, but I couldn't tell them how I really was because sadly, that was an emotion that I wasn't able to handle at that time.

I'd call home during the week to talk to Ex, but he rarely answered, and on those few occasions when he did, he was cold towards me. When I asked where he'd been, he'd respond with a tone of anger and say in so many words that it was none of my business. So much for his support!

Meanwhile, I had told my kids not to come and see me because to me, I lived in a hell hole, and I didn't want them to see me like that. I especially didn't want them to bring the grandkids there. I knew that it would really hurt them to see where I was and how I was treated. It was definitely not one of my better hospital stays.

Then one day, a lady came with a bunch of papers for me to fill out with straight yes or no answers. Simple, maybe, but not for me. I answered what I could understand, but the ones I couldn't understand I just left blank because I didn't know what they were saying. The lady returned the next day and mentioned that I hadn't filled everything in. So I explained why, and without saying anything more to me, she filled in all the blanks herself. She didn't even know me, so how could she do that?

It seemed that no one in this whole world understood me. Why was I there? I wasn't getting any help, just test after test, and then that dreadful MRI. I hated them, but I'd worked out a system in my brain, and I'd say to myself, "Please don't move." Of course, they had my head strapped down so tight that it hurt and was impossible to move anyway.

But it was the noise that got to me! It was so loud that even with the headphones on, my head hurt. So I counted the beeps, looked for different tones and kept my eyes closed, and then I prayed. I didn't open my eyes again until I was out of the tube. But I still couldn't walk or talk, so it was back in the wheelchair and back to my room.

Sleeping there was non-existent because there was so much going on that I had to learn to focus and put things in their perspective. I'd hear patients screaming, and I'd beg God to help them. Then I'd go outside to the smoking area that was surrounded by a tall chicken wire fence. It felt like a cage. But then, I'd look up and see the stars at night or the skies during the day, and I'd get a type of peace come over me. Although, I did do a lot of crying and praying at the same time.

One time another patient came out there and tried to escape by climbing the wire fence. He wanted out, and I understood how he felt. He looked at me, and I told him that it was okay, and I smiled at him and tried to comfort him. But the whole time I was hoping that the male nurse would come soon. The man was definitely frantic; yet, each time he looked at me, he became peaceful.

The next day, I was collecting my lunch to take back to my room, and I had my hand full with my plate of food. Just then, this same man walked by me with a nurse, and he remembered me. He stopped by my door and motioned for the male nurse to open the door for me. I smiled at him and said, "Thank you." The nurse was shocked and unlocked my door.

Then I went in and ate my lunch and smiled to myself because that man remembered me. Afterward, I washed the dishes and the cupboards and anything that looked dirty. I had to keep busy.

I felt as if I was living in a prison cell. Across the hall from my room was a sign that read, "Do not go in or touch door. Dangerous." The room next to me had a male patient in it that screamed all the time. Thankfully, during my last week there, he got sent to some hospital in the U.S. That was such a relief for me.

I couldn't go to the bathroom half the time when I was there, and I hated those enemas that they gave me.

One long night I couldn't sleep, but this was nothing unusual. The night nurse came in, and she noticed me getting ready to head out to the smoking area. She came in, and we talked, and I was so impressed. She understood me! I thought to myself, "Hallelujah! There is a human working here after all." She was so encouraging as she helped me work on big words. It hurt so bad to think, but I forced myself to do it. Apparently, her mother had a brain injury, as well, and she noticed the similarity between her mother and me.

She said that she could get into trouble for not making me take the sleeping pills, but then said not to worry about it. I asked her what was going on there. I wanted help, but all they were doing was testing me. Then I asked her to be in the meeting with me when I leave, and she said she would. What a nice nurse she was! She did it on her own time, too. She arranged for me to see this doctor that she knew, and I'll just call him Dr. Trunks.

Dr. Trunks said that there was a new med that has been successful in helping with seizures. He looked at me and with sadness in his eyes, told me that I would never walk again and that I would never talk right for the rest of my life. My head was filled with thoughts and words, but I could not get them out, and it was so very frustrating to me.

As I looked at him, in my heart, I said, "No one knows me, not even you. With my faith and the love of my grandkids, I will work hard, and I will walk, and I will talk again. Just watch me!"

Then I was given the pills that I was to take four times a day. After three days, a miracle happened! I was saying sentences. "Oh, thank you, God!" I was talking so much that it was an almost unbelievable feeling.

Chapter 9

New Frontiers

I was so excited, and at first, I couldn't help myself, and so I just rambled on. This was a normal response and a positive step in this therapy, and so, I rambled as often as I wanted to. However, Ex didn't appreciate my step forward or my rambling. I could see that it annoyed him, too. So, he called the doctor in Hamilton to complain, but the doctor told him that it's normal and not an issue. So, I kept rambling!

The medication was necessary to prevent seizures, and so I had to stay on it. As I practiced, my speech became more evidently clear, and I was able to get out two words at a time. So, with the ability to now speak two full words, I was able to speak them clearly to Ex; words that I will not repeat, and that are left up to the imagination.

There was so much bad going on in my life that it was very difficult for me to deal with most of it. Things seemed to get worse, not better. So, without really realizing it, I'd built walls around my heart so that no one could hurt me anymore. I wanted to deal with those hurts and tear the walls down, but I'd have to get well first and deal with that later.

When I had visited my sister Audrey shortly before she died, I had promised her that I would work hard and that one day, I would drive again. It would take a lot of work, but I fully intended to keep that promise.

I met Dr. Anna that year, who taught *inner smile healing* through sound practices and acupuncture. She was a beautiful lady and was very calm and patient with me. I was anxious to work with her; however, the needles scared me. I couldn't get my brain to understand what was happening and it made me very nervous. She assured me, though, that they wouldn't hurt, and she was right because I didn't feel a thing.

She wanted me to learn how to do the healing of my inner self. When the pain would come, I was to either focus on it and do something with it, or just learn to live with the pain and the hums that constantly echoed in my head. It's hard to explain, but it's almost like the spiritual part of my being would take over while I would focus on going straight to keep working. The doctor would hold my head and teach me the colors that I'd see. I was blessed to be able to do that.

The white ball is unusual, and I was to send that through my body for self-healing. To this day, I still practice the inner smile; it's like meditation only more calming. Sometimes it's hard to grasp how the heart, soul, and spirit are, and so I need to just be thankful that I'm alive. This is what keeps me focused.

Then finally, I got a scooter. I lived two blocks from the church, and so I'd scoot along the sidewalk until I saw the steeple. Then I'd stop, look at it and pray. Even then I could feel God's Spirit talking to me and encouraging me.

Four and a half years passed by, and I wanted my bowels back—on my terms. No more morphine! It was to blame for the three enemas I needed every week to keep my system going. So, I asked for one pill to be taken away.

Unfortunately, I didn't understand the remainder of his instructions, so the pain slowly crept back in. By the third day, the pain was so bad that it felt as if half of my body was ripping apart. He quickly set me straight so that I could go on, and not too long after that, I was able to deal with it.

I went from the pool to the tub, and I did not want to take any more of those addictive pills regardless of the withdrawals. I was slowly adjusting to the stabbing and ripping of the pain, and I knew that if I kept going, I could beat this, too. By Friday, I was able to have a coffee at the coffee shop, and the pain was so bad that I just wanted to scream! But rather than go back to the pill, I wanted to trust the higher power to help me get through this. And He did.

That didn't stop the enemas; they were just happening less often. I had to learn a different feeling of how the bowels worked. I didn't know the Vega nerve in your head actually controlled the bowels. Mine was in need of new wires to reroute it, so I began to understand the different sensations.

The timing isn't really that clear, but by the third or fourth year after the accident, I was able to walk more assuredly with the aid of a cane. It was such a wonderful feeling just to be able to move around and walk without using the walker. I started off by walking around the house, but then I managed to walk a couple times from the house.

This was so exciting, and I was ecstatic at first. But, what should have been one of the most exciting moments in my life, turned out to be very stressful. In fact, it actually became bad memories for me.

I don't think anything in life can bring more sorrow and heartache than being alone!

No one was ever there to share the joy with me, or to help me when I needed it. It had been this way since the accident. Ex was busy having affairs and spending money and had lost all loyalty toward me. My family was busy doing their own thing and had no idea what I was going through. They didn't know that I had a fear of emptiness for not knowing what was going on, or that I was afraid of what to expect, or that I worried about how to deal with things.

It was at this time, after suffering disasters with the finances and an unhappy marriage, that I decided we should sell our matrimonial home and move into an apartment. When that didn't work out, as I mentioned earlier, we moved in with my son Lloyd. I had a big moving sale, and it didn't bother me about selling all of my things. It was just stuff that had no sentiment and no value to me anymore. I had more important issues to deal with. I was determined to beat this!

I couldn't remember much of anything before the time of the accident, and I tried so hard to get it back. Sometimes I'd get a clue through the unconditional love of my grandchildren. They were God's gift to me. When I saw them, my heart would smile inside and out. They'd help me with the big words, and before long, I was helping them.

I also met some friends online a couple years later who really helped me through my struggles. It was in 2005, and even though I'd had my computer for a couple of years by then, I was still trying hard to learn it. So, while searching for something online one day, I ended up in a poker forum and met some wonderful friends from all across the States.

They became my teachers, and they were very patient with me. Sometimes I'd even talk to them on the telephone. They understood that word-finding was hard for me and that sometimes my sentences just came out backward. But we would laugh, and they'd help me to try it again.

There was Chuckie from Colorado who would pitch in, as well. I spoke with him on the phone several times during the last few years of his life. My heart always ached for him, and I tried hard to encourage him. There was also Velour from Texas, who I still talk to on the phone every now and then.

Some people were awesome to talk to even though I don't remember their names. There was a pilot and what a joker he was! I saw him in Memphis, and this poor man, who had only one leg, died of kidney failure, and that was so sad. But he was the cracker of jokes when he was alive.

This group of online friends became my learning tools. They made me laugh even when I messed up, and I did that so many times. But to them, it was no big deal. We had fun together, and that made me feel like I fitted back into the social world. It really encouraged me to keep going.

But it was Danna from New York who would become a dear friend and who I'd spend a lot of time with. When I first met her online, we chatted a lot, and we even talked on the phone. Then I met her and her husband Bill for the first time in 2011 when we went to New York. She was exactly how I pictured her to be, too.

She would soon become my smile with the *open arms welcoming committee.* We'd go for walks in the evening, and since I was still struggling with trying to walk at that time, she'd encourage me to stay focused and to keep trying. That wasn't easy for me because I had to concentrate to keep one foot in front of the other. I stumbled a few times, but I was proud of myself. We continued to talk and laugh together, and that in itself was a challenge since I was still learning to walk and talk at the same time.

I enjoyed being with Danna and Bill, and it didn't take long to feel as if we'd been friends all of our lives. I felt so comfortable when I was with them. Danna had told her family about Ex and me, and so, of course, they all wanted to meet their new Canadian friends. Danna's daughter Rachel is now called my foster daughter. On some visits, I would bring Canadian momentums like the Olympic shirt or MIT's. The newborn friendship of this family had started, and I was really happy.

Danna and Bill owned a small motel business, and so we parked our RV in their driveway and stayed for about five days. Chuckie was also there, and he fitted like a glove into our group. They gave us wine glasses that were very unusual, but very beautiful. They had deer antlers wrapped around the base, and I felt so special drinking from them.

But life can go by so fast, especially when you're ill. On August 29th of 2013, I called Danna to see how Chuckie was doing, and she said he wasn't doing well. She held the phone to his ear, and I told him that I loved him and that he would go to Heaven where God was waiting for him. This was a very hard phone call for me, and he died shortly after that. Another member of our little online group was gone.

Chapter 10

One Step and Coping

The years between 2001-2007 had been very trying for me. I was referred to Dr. Joanna Hamilton Peterborough. She had a Ph.d. in Psychology and had been referred to me by the doctors in Hamilton.

My first visit to her office began with a struggle as I had to climb stairs, and I had to do it one step at a time. I'd count the steps, and then tell myself to pull the leg up, and I'd use the railing and the cane to do it. I had to tell myself to keep focusing, "Just do it." Every time I climbed stairs, I'd count them. It was like a tool for my brain—and it worked. To this day, I still do these coping skills.

I sat on a chair in her waiting room, and I was tired. But when I saw her, I had a gut feeling that this was going to work out. I liked her, and I liked that she was honest, and so I knew that it would be easy to talk to her. However, trying to talk to her with Ex there was hell on earth. He came in only once with me, and I ended up throwing a water bottle at him.

He told the doctor that we weren't getting along before the accident, so what! Then he tried to justify his affairs. He never came with me again, and I didn't tell the kids what was going on because I didn't want them to know. So I'd just put a smile on my face and pretended that everything was okay.

Dr. Hamilton was honest with me about the results of the tests, too. I told her that the testing at the hospital was scary and that when I couldn't understand the questions, the nurse took it upon herself to just fill in the answers.

Then she told me that the outcome of those results was that I was *Schizophrenic* with a brain injury. I was horrified! But she told me to relax, and then she worded the questions for me so I could understand them and give my answers. When I didn't understand a question, she would reword it again and help me to understand it. Then I was able to answer her correctly.

Sometimes the words that had more than one syllable didn't come out right. I tried very hard to concentrate and say them properly, but the more I tried, the more it would hurt the inside of my head with the force of a hammer banging. Then the skin on my forehead would get tight, and it would hurt. After that, I'd get a ringing inside my head that would get louder, to the point that I was nauseated.

When the testing was done, the result was that I had a brain injury. Dah! Even I knew that much. Soon after that, she sent me to another specialist. He had seen the results of the brain mapping and said that it was the best he'd ever seen. He also agreed that I had a bad brain injury. I liked him because he was also easy to talk to.

I told him my head would go crazy at times, and that the thoughts made no sense. So, I would have to go with the feeling in my heart and my stomach—in other words, my gut feeling. He gave me some medical information regarding studies that were conducted in Britain, and the conclusions they made regarding a second brain. Things were looking up until he said that he wanted Ex to come with me next time. He asked if I minded. I said that I didn't care.

So, Ex came with me, and we talked a while as a group, and then he spoke with Ex privately. The doctor confronted Ex with what I'd told him earlier about my gut telling me that Ex was lying and not telling me everything. So the doctor told him that he should be honest with me. At that point, Ex stormed out of the office. But I didn't really care because he wasn't part of my life anymore. Only my kids were part of my life, and I needed to get better for them.

After Ex had left the office, and it was just the doctor and me again, the doctor asked me a question that made me livid. Was I a lesbian or did I want to be one? So needless to say, I soon returned to Dr. Hamilton, and I would stay with her for many years to come, and she would help me to grow and fight. I respected the other doctor for being upfront, but I didn't like his questions.

But what I disliked, even more, were the doctors who worked for the insurance companies. They were the most dishonest and cruel doctors that I have ever met. I tried to answer their questions as well as I could, but I often got things mixed up, and I didn't answer the questions the way *they* wanted me to answer them.

One of the questions seemed easy enough, "Who is the Prime Minister?" I answered, "Bush." The doctor looked at me as if I was mentally disturbed. Then another person asked me, "What are the three numbers that I told you to remember a minute ago?" I told him that I couldn't remember—because I really could not remember.

Then one of them stood up and said that I was lying. I looked at the doctor and said, "Don't say that! I have never lied in my life. This is who I am. I cannot remember things. I want help. I want my life back!"

Then another time, a speech therapist came to our house and asked me to count to ten. Again, it seemed like an easy enough quest, and I did my very best to answer. I said without hesitation, "1,2,3 GO." I thought that this was the right answer, but obviously, it wasn't.

After the therapist left, my husband looked at me with a disgusted expression on his face. I didn't say anything to him, but in my heart, I was rhyming off words of what he could do. He has no idea how lucky he was that he couldn't read my thoughts!

Every once in a while, Ex would try and show an attitude of caring towards me. I was never sure about him, and so I found it hard to accept. Since it didn't happen often, I tried not to focus on it because, in reality, I didn't have a husband, but I did have my own taxi driver. I think that in his own way, he had so much guilt to deal with that he knew I did not trust him at all.

There were family events that he did not want to go to, but he did go with me to my brother Dylan's house on a few occasions. Dylan and my sister-in-law Charlotte really helped me. We would play a board game, and it would be the guys against the girls. It was hard for me to focus, and of course, I messed up many times. But Charlotte was quick, and she'd pick up the slack and would cover for me and say, "That's how it's done." Then we'd win! She made those games fun for everyone—especially for me.

Charlotte knew that there was stress between Ex and me, and she always tried to pamper him and keep the peace. Whenever we'd stay overnight, she'd put a chocolate beside the bed for him, and she'd cook his favorite meal that was so tasty. I felt so at peace there. Charlotte understood me, and she went out of her way to be a friend to me and to make our whole visit with them a good one.

But then on our way home, Ex would complain and criticize everything about the visit, even though they'd gone out of their way to make it nice for him. He'd become adamant and say that we were never going back there again; however, we would go back, only it was more me who would go back as his visits became less and less.

I was trying to get better, and the lawsuit was closing, and so Ex took charge. Without really realizing what I was signing, I signed the money away. He took everything plus, but that really didn't bother me because, at the time, I had lost my value for money, and I thought that it was nothing compared to my health and the ability to remember. It wasn't until later when I needed the money for medications and therapy that I realized the agony of it being taken from me.

So, I buried all of Ex's garbage in the back of my mind and swore that I would never trust a man again in my life. It was time for me to move on. I buried all the hurts, and the wall around my heart got bigger and thicker.

So many hurts; so many losses; so many people that didn't know me anymore. I was determined, though, that one day I'd get my brothers and sisters back into my life. I had no idea when that would happen—I just had to keep hoping.

In 2007, we bought a new truck with a fifth wheel. Ex wanted to go to Florida, but I was adamant that we were going to Texas. I didn't know why I wanted to go there, but I knew that I did. I am a firm believer that things happen for a reason, and so we got in our new truck and drove to Texas.

It had seemed like such a long wait for me, but I'd been able to start driving again in 2006—finally! So, I was able to do some of the driving on our trip down to Texas.

When we arrived in Nashville, both the slide and the furnace weren't working. We discovered that the carriage dealer that could do the repairs was located in Georgetown, Texas. So we packed up the next morning and headed for Georgetown. The dealer was very nice, and he suggested that we go to Rockport in Texas and camp in the park there called *Lagoons*. So, we set off for Rockport as soon as we could.

Driving through Austin, Texas was a bit challenging because there were two highways and each was labeled as being "35". We didn't understand that one was a bypass and the other went through the heart of Austin. Fortunately, we took the right one and went through the city. Unfortunately, we had the 5th wheel and had to stay in the left lane to avoid hitting the overpass with the top of the RV. That took a while, but when it was time to go, at my suggestion, we followed a transport truck and made it through safely.

As we continued, Ex was driving, and I was holding the map, and we both saw on the map that there was a left-turn up ahead that would take us off the interstate. However, this didn't make any sense to Ex so he wouldn't take it. Instead, he pulled off to the side of the highway so he could get out and look at it and figure out which way to go.

I'd read up on maps and the rules of the road, and I'd worked very hard to educate myself on all the road signs. That was no easy task, either! It took a lot of reading and re-reading and focusing on getting it right. So when we passed a sign, I would look it up so that I'd know where we were and what we should to do.

I tried to learn about the GPS, but it was too stressful of a challenge for me. Everyone said that the Garman Bluetooth was the best, but it still screws up often. So I relied on my maps because they were always straightforward and easy to follow. I'd made up my mind for this trip; we were using the old-fashioned but faithful maps.

I'd been following this map precisely with my finger, and I knew where we were. I had told Ex that we needed to take the turn, but he didn't believe me. A minute later, after standing out there staring at the traffic, he returned and said that I was right. I was so angry with him for doubting me! In one of my nasty tones, I told him, "I am retired, *not stupid*!"

My brain was always rushing around, and when you add that stress on top, it would have been easy for me to lose focus. However, I was determined not to let anyone do that to me anymore. I'd progressed a lot over the last couple of years and was able to think and act on my thoughts. I wasn't going to let anyone intimidate me again. Especially not Ex.

Finally, we pulled into Lagoons RV Resort, and a beautiful elderly lady, who must have been about 80 years old, came out and greeted us. When I asked about aerobics classes, she said that they had a class scheduled for the next morning at 10 o'clock. I told her with my poor speech due to being so tired that I was trying not to use my cane anymore. She said with kindness, and I knew she was sincere, that I'd come to the right place.

I was anxious to attend the class, and was there and ready to go before it started. The instructor was leery at first, though, due to the insurance liability that could result from my disabilities should I have an injury while working out there. But then her eyes sparkled, and she smiled and said that I was welcome to join. I was so thankful for that!

I got the back corner of the big hall with a chair to hang on to. I was determined to get rid of the cane, and so naturally, fell flat on my fanny. Ed, who was in front of me and Harry, who was beside me stepped in and helped me move. It was so hard to keep going, but I told myself to not look up and to look only at the feet in front of me. So, if I got confused, I could stare at the walls to try and focus.

I was following my dream, and the song *The Power of the Dream* by Celine Dion began to echo through my thoughts. I felt so encouraged.

Rehab continued when vacation was over, and I was back to trying to perfect my walking and talking. There was a colonel named Cass, and a major, and they both dealt with brain injuries in soldiers. They helped me tremendously with my speech. The last part of long words ended up slurred; words like America. They worked with me and encouraged me to learn to say these words clearly.

Gradually, my speech began to improve, and I was able to say those longer words without the slur. Again, it took a lot of focus and continued practice, but I didn't give up. I was determined to get rid of that slur and speak normally.

However, loud noises would still shake my head. A helicopter would come by, and the Cornel would try to calm me down, and she'd tell me that it was okay. She would tell me to focus on the noise and take it to another part of the brain to quiet it down within myself.

This was a major effort at first, but after several tries, my head would quit shaking from the noises. Cass would tell me, "Have faith, Marjorie." She seemed honored to help me. She and all the others told me that there was a white glow around me, and many other people have told me that, as well—even in grocery stores. I knew God was helping me.

By 2010, there were noticeable improvements in my health. I would get up and read the news on the computer every morning, and when I didn't know what some of the words meant, which stopped me from understanding what I was reading, I'd look the words up and learn the meaning of them. My ability to read and understand began to improve greatly, and I felt good about myself.

Chapter 11

Chaos or Tranquility

We traveled to Texas several times over the next few years. I was getting stronger and stronger all the time, and doors were opening. Life was becoming good again in many ways, and hope was being restored, but nothing ever came easy. I always had to work hard for every success, but that was good because physical work was the best therapy for me.

In the fall of 2009, we bought two lots, side-by-side, in Cadmus, Ontario. It was so very peaceful there. One of the lots had a gorgeous stream running through it, and the other had an old cottage that had been bulldozed down and left as ruins. That needed to be removed but we could do it. The properties would be beautiful according to the vision I had for them, but they needed a lot of work to get them there.

I thought this would be a joint venture between Ex and me, but I didn't get any help from him at all—well, so little that it was as good as nothing. I don't know why I even thought that he'd help me because he had no interest in them at all. It required a lot of focus on my part, though, because I had never done anything like this before. But I did it.

There was a massive pile of wood and rubble that needed to be cut up and burned. That wasn't easy because of the noise and because the newness of the situation brought stress onto me and sent my head constantly spinning.

However, I focused and worked at it, and I was able to take control over it. Then I had to learn balance, and trust me, that was really hard! I had bought myself some steel-toed work boots that helped to not only strengthen my legs but to work on my balance.

I fell a few times, and one time I injured my ribs and they were very sore. I was alone with no one around to help me, but I couldn't let that stop me from working. Besides that, I'd look up to the sky and say, "Thank you. No broken bones." Then by the afternoon, my body hurt all over, but that was okay because, in my mind, it meant that the brain was feeling it. I was alive!

Whenever Ex decided to join in, he did it his way. He cut the brush and trimmed some of the trees, but only enough to say that he'd been there. I asked him to cut more so that I could haul it away and burn it with the wood from the house. That didn't happen, though. However, he did like the riding lawn mower because it was so easy, and so he cut the flat grass with that and left me to use the push one, which was very laborious. I hit the little stumps, and each one jolted my shoulders and did a lot of damage. It was physically challenging and something that I should not have been doing.

Then Lloyd brought in a backhoe and pulled those stumps out, and there were hundreds of them. His three sons were with him, and they were very helpful in the clean-up. They helped to drag the piles of brush that been there for 15 years to where they could be burned. Soon, my park area was beginning to look the way I had envisioned it.

During rest time, it was heavenly to just sit quietly and listen to the trickling waters of the stream. Neighbors came by and told us how beautiful the lots were. Little did anyone know except for one neighbor that this was just the beginning. The actual vision would take five years to develop it to where I wanted it. I don't even know why I told her that.

But I do know that there were angels there with me every step of the way. When the boys came, they would work hard, but they'd also laugh at me working like a man. I'd work with them side-by-side, and I even cussed when we were working. The laughter in my heart was huge with them.

One time, I was going to give them some money because they had all worked very hard and I felt that they deserved it, but Karl looked at me and said, "Nana, you just insulted us." That took me by surprise, and so I asked what he meant, and he said, "We do it 'cause you are our Nana and my family."

I hugged them and walked away with tears in my eyes. I sat on a rock and looked at the stream, and when they asked if I was okay, I told them that I just needed a break. I couldn't tell them what it did to my heart and soul. I was still missing so much of my past. Why wouldn't the rest come back to me?

Then I got up and said to myself, "Move on, Girl. Your day will come. Enjoy the boys and have fun doing it. I know that I'm lucky to be alive to enjoy them."

Within two years, we had 50 big tractor trailers full of soil come and fill in the foundation. Then we had a driveway put into the park-like lot with the stream. Lloyd was able to get a hold of a backhoe and a bulldozer again, and we all watched the boys run the machinery. It was like miracles happening right in front of me.

I kept pushing forward, and I was proud of myself. I had taken responsibility for this project, and I was succeeding at it even though Ex scoffed at me and others felt that I was a bit crazy. I even arranged for the electrical service to be hooked up, and then I learned how to work the generator. That was fun. I also learned how to use the special saw to cut up the wood.

I was worried about it at first because of the noise; it was a bit much for me at the start. In fact, sometimes it would just pound at my head, and I was sure that I wouldn't be able to finish the job. But then I put earplugs in and said to myself, "Marjorie, don't be such a wuss!" I'd even tell myself to just get used to it—and I did.

When I had enough wood chopped up, I'd pile it into the old bathtub that was in the corner of the foundation, and I'd burn it. No one was around to watch. It was just me, and I loved it. It was like a new world unfolding as things were done my and without any criticism. I would burn the sheets of paneling and the two-by-fours, and the flames just sparked into the air. Then I'd watch them and say, "This is freedom, up to the heavens."

During that first year of owning the lots, I'd begin at 6 a.m. and work until eleven. Within the first month, I had most of the ruins from old building burned including old sheets, garbage, wood, and just about anything that you can imagine would have been in that old house. It was a lot of work, but that work was more than just a job for me; it was very therapeutic for me.

I got into a lot of arguments with Ex at that point, and that put a lot of stress on me. He and Lloyd had bought a factory in Toronto with *my* money—and of course, without telling me about it at the time. For some reason, they felt that it was okay to do that, and so when I found out, I was quite upset, but I just accepted it after a while and let it go.

Ex and Lloyd worked there along with the boys, and to keep busy and help with finances, I worked in the factory for a few days, as well. I'd clean the bathrooms and the lunchroom with disgust—they were filthy! Then I'd work on the drill press machine, and sometimes I'd look around and think that this was not how a factory was supposed to work—but what did I know? I was just the owner.

When I wasn't working in the factory, I was on the lots working hard to fulfill my vision for them. I wanted to get them cleaned so that we could actually put the RV there and live there, and that eventually happened in late 2011.

For the next three years, Ex worked in the factory, and I was alone on the lots. I wanted to keep working hard because when I did, there were times when little things would pop into my head. I couldn't put them together, but each time, it was one more piece to that puzzle.

I was at peace because Ex was not there, and neither were my troubled kids. I was free, and I was able to walk outside and do my aerobics classes. Life was good. Within a couple of years, I'd planted flowers on the bridge, and it was so beautiful that it became a small tourist attraction for people walking by as they stopped and enjoyed the view. Some visitors even took graduation pictures by the stream. I knew that God was doing something wonderful there.

In 2011, we returned to Texas, and I met a lot of new friends there. Two of them were Lisa and her husband, Thomas. They were neighbors in the trailer park where we stayed in Marksville, Louisiana, next to the big casino. We got to know each other and even went to the casino together. It didn't take long for Lisa and Thomas and me to become dear friends.

As they were preparing to return to their home, Lisa told me that we would always be friends. I was very happy with that, but her husband was negative and said that when you meet people at a campground, you don't see them again. That was so disappointing to hear, and I hoped that it wasn't true—and it wasn't because Lisa and I became great friends. I think we were meant to meet. We may have been 1300 miles apart most of the time, but distance means nothing when you are friends.

We had a good vacation with Lisa and Thomas that first weekend. Little did I know, though, that there were angels all around me all the time and that Lisa was a friend I would never lose. We would talk on the phone during the summer, and also when each of us was going through hard or sad times. We were always there for each other. Sometimes, Thomas and I would even have long talks together. It seems that some friendships are just meant to be because those friends become part of your life. I firmly believe that it was no accident that Lisa and I met as we did.

Neither was learning to drive again. I was able to share in the driving during our different vacations, and that was a great help to both of us. But even more importantly, I had gained some independence because I would never have to depend on anyone to drive me around again. No words can describe that freedom!

Every year after 2011, we would meet in Louisiana with Lisa and Thomas, and we'd talk and laugh so much! I felt free and comfortable with them; I didn't have to become someone different for them. I could just be me. The joy of our friendship was amazing!

So much happened to me in those few years after the accident that it's impossible to tell it all. Much of it, though, is just too painful, and it's better for me to just leave it alone for now. I want to share what I can to inspire others, but sometimes going back to relive certain times of deep pain and emotional stress is not a good thing. So I push forward and hope that the accomplishments I am able to share will encourage others.

I knew that I was getting stronger as each day went on. I worked like a man, and it would hurt so badly, but I knew that I had to get stuff done, even though I didn't really know why. I believe that there is always a reason, even if we don't fully understand it.

Within five years, my hard work and determination had paid off because the lots were beautiful! They were just as I had envisioned they would be. I helped the neighbors clean up the lots beside us so that the entrance to our little community would look like we were in Heaven. People came and took pictures by the stream, and they took pictures of the flowers that I had planted by the bridge. It was so beautiful, and it was so peaceful. Life was opening up for me, and because of the success of these lots, I was beginning to realize that there was hope for even better things up ahead.

It often seemed, though, that every time I made a positive step forward, there was a black cloud out there trying to ruin my day. I remembered one in particular; it was a day shortly after I'd started driving again. I'd parked my truck in the designated handicap spot, which I was fully entitled to. However, when I came back out to my truck, there was a note left on my windshield:

> *You don't look handicapped to me except for your parking skills, but then again, it's all about "me"...*

I was furious! Some people can be so rude! They see a person from the outside who appears to look good to them, but they don't know what troubles or pain or hurts are on the inside or what parts of their body won't work. So they take it upon themselves to judge them and leave them a despairing note like this. As I like to say, you should never judge a book by its cover.

Disabled people are beautiful human beings; we were normal before our injury, and we are normal now. We just have different struggles and tougher challenges than other people have. That makes us just a bit different, but we still have hearts that need love and respect.

I saved the note, and I'm not sure why. Perhaps it's to remind me of the life that I once had. Obviously, I was never able to respond to the person who wrote the note, but I felt sorry for them. At least I could hold my head up high and know that I was alive and doing everything in my power and in God's timing.

It's all about forgiveness, and faith that gives me the strength to keep going. It's not about being judged by others. As I struggle to understand people, I realize that some are very caring and others are just plain ignorant!

My plan, though, was going to keep going forward because life was opening up to me once again. However, just as I thought the worst was behind me, little things began to happen. Nothing to do with the brain injury, but to do with the rest of my health. It seemed at times as if there was no end to things that could go wrong with me.

Testimony #3

It was the summer of 2011. The day that I opened my camper door was one of the happiest days of my life.

I had no idea that this little Canadian woman was going to be one of my best friends. When I came out of my camper door, she asked me if the boys riding their bikes were mine. I told her, "Heck, no!"

We were both upset with those boys, but we got over that real fast when we started talking. When it was time to leave and head back home, my husband told me that we would never hear from her again. Marge and I both looked at each other with sour puss faces and then at him. "You will see!" we said. And guess what! We never stop talking, laughing and crying.

Now she is a part of my whole family's life. We all make new memories together.

She is a blessing to me, and I thank God all the time for my strong, crazy, and beautiful Canadian miracle!

...*Lisa*

Chapter 12

If Brain Injury Wasn't Enough

I needed shoulder rotator cuff repair, and so I went to the hospital to have that taken care of. Again, it was nothing compared to what I had been through, or to what I was still going through with the brain injury. Yet, it was still very painful, and just another issue that I had to do all alone. Still, no family to give me love and support.

But it was the following summer when my life took yet another nosedive. I had to go in and see the doctor about my shoulders because they hurt so badly again. The hospital took more x-rays, another ultrasound, and a bone scan. I didn't like all the tests, and I dreaded doing some of them, but it was all necessary due to the seriousness of my brain injury. I was almost at the point where I stopped asking why they were doing another test. I just learned to grin and bear it.

Then it came time for the results from all the tests. I met with Dr. Corless, and he said, "Marjorie, did you know that you have a cracked rib and that both rotator cuffs are torn?" I didn't know that, but I suspected as much, so I wasn't really shocked by this report. It did explain all the pain that I had been suffering with.

But it was what he said afterward that made me choke. "And to top it off, Marjorie," he said in a quieter voice, "you have lumps on your right breast."

That was *not* the news that I wanted to hear. In fact, it terrified me! My sister Audrey had died of breast cancer just a few years earlier, and my mom had also had breast cancer. I had always worried about getting it, and so every spring for years I would have a mammogram, an ultrasound, and a biopsy. Yet, there I was: I had lumps in my right breast!

I told Ex how the tests had shown that I had lumps, foolishly hoping for some kind of empathy, but he wasn't too concerned. He told me to do whatever I wanted; it was my body. A little more comfort and support would have been nice during that really traumatic time, but then that would have been expecting too much from him.

I knew what my mom and my sister had said about it, and what they'd gone through, and I anticipated where it would take me down the road, as well. I didn't like it, and I cried a lot, but I made the decision to just have a double mastectomy and get it over with. But not right then. I needed some time to think.

So Ex and I went to Florida to get my mind off of all my pain issues and to try and enjoy life a bit so I could free up my mind and make the right decisions—because this latest one was still hard to bear. When I would return home, I'd get the MRI and see the top surgeon at Western Hospital in Toronto. Then I would have all the surgeries.

The pain grew intensely worse in my shoulders, and I knew that I couldn't survive it in the time I was there. So I went to an Orthopedic Hospital in Tampa, Florida and took with me the copies of the first MRI and the doctor's reports. The doctors there conferred with my doctors in Ontario, and the decision was to give me cortisone shots in both shoulders.

For a while, it felt so good because they were both frozen, due to the cortisone. I knew it wasn't the final solution to my problem, but it didn't matter because it was a relief that I so badly needed.

When I went to pay the bill, though, it became a very challenging argument. The clerk started by presenting me a bill for $5000. I asked her, "For what?" It was unbelievable! Between the confusion in my head and trying to get the words out right, it had caused a great mixup.

The doctor looked at me weird because my voice and speech began to go funny, and my head started to spin so that I wasn't able to even stand properly. After about half an hour, they finally understood what was going on with me, and they gave me a bill for only $1200. I told the receptionist that I wanted a receipt with the words "Paid in full" stamped on it. I'm not sure why I asked for that, but it made perfect sense at the time.

When I returned home, I saw my doctor, and very soon I was scheduled to have the double mastectomy. That in itself was a very traumatic experience, and I don't wish it on anyone. It was a horrifying and emotional time in my life, and the recovery was extremely painful—both physically and emotionally. The new implants were put in immediately and were supposed to help rebuild my feminine appearance. However, it's not as easy as we are made to believe. You don't just have breast implants and live happily ever after.

The year 2012 hit me hard. Every week I was going to St. Michael's Hospital in Toronto for something. Between the surgeries and the regular visits and the pain and the emotional trauma, my speech and balance took a few steps backward. The breast surgery was hard enough, but the implants were causing sharp pains in my right side, and so I was put on more drugs.

Finally, after about two and a half months of absolute agony, I said that I couldn't stand to live another day with the pain. So I was taken back to St. Michael's Hospital the next morning, which was Saturday.

I waited for five hours to see a doctor in the emergency waiting room, and then I went through several hours of extremely painful tests. Afterward, they put me into what is called an "infection room" with several other infected patients, and that's where I stayed while waiting for my surgery.

The procedure revealed that my breast cavity was filled with infection, and so that was cleaned out, and I was given antibiotics to get rid of the remaining infection in the wall of my chest. No wonder I had been in so much pain! According to the pharmacist, the medication I was to take while recovering from it all would kill everything—and trust me, it did. I couldn't eat anything but yogurt for the whole winter.

"Thank you, God. Another painful experience, but You saved me again."

My family thought I was crazy, and they didn't help me at all. Once again, I had to keep working and doing things for myself. It always amazed me that regardless of how much I struggled or stumbled or fell that not one of them showed any compassion or offered to help me. This has always weighed heavy on my heart.

There were times, though, when I was totally beat, and I'd ask Ex to do simple things such as pick up some groceries because I wasn't able to get out and do it. But he'd complain the whole time and then come back with only diet TV dinners.

One time, when I was finally able to go, Ex went with me to the grocery store. When the cart was full, I asked him to push it as it was too painful for me to push it. I told him that I just had to get some milk and a few other things and then we'd be finished. So, I sauntered over to get the things, but when I turned to put them in the buggy, he was nowhere in sight. My arms were aching from carrying the groceries, and so I had to grab another cart to put them in.

I found Ex at the checkout. He'd just left me there in the middle of the store. Would he have gone home without me? I lost it with him! He didn't seem to care, though. I knew he didn't want to do the grocery shopping any more than I did, but I really didn't think that it was too much to ask just this one time. Yet, as hurt and angry as I was, I knew in my heart that things were about to change. I didn't know how, but I kept my faith and prayed every day.

My little grandsons had grown into teenagers, and they came over often to help me. They worked with me in the gardens digging roots, and when we first got the lots, those boys ran the backhoes and bulldozers to help clear them. They loved to help me, and that was more than I can say for Ex. He wouldn't even help me in or out of our truck. He'd just sit and watch me struggle and do nothing to help me.

I strove with things that most people do in a breeze. Simple things like vacuuming or making the bed were very hard for me. It hurt, and it took a long time, but trust me, I did them. Changing sheets was a strenuous task for me, though, and my sister Patricia would drive for an hour and a half to visit me, and I'd get her to change the bedding for me.

The next winter I was in Texas again, doing aerobics and feeling great! It helped me walk and talk so much better. I kept busy and met many new friends. Things seemed to be getting better; they were changing for me.

However, I was very conscious of the fact that I had to wear a prosthesis. It was very embarrassing when Ex was with me because he was quick to tell me that the doctor had done an ugly job. He could be so cruel at times. I did my best to ignore him, though, because it was the only way I could get through these tasks without feeling too awkward. Yet, on the bright side, it was during my aerobics classes that bits kept trickling in from the past that made me quite curious.

The following summer, I had two more surgeries; one to fix the left breast and the second for carpel tunnel on my right hand. I had to keep that hand straight up for a week. Have you ever tried cooking and pulling up your pants or getting dressed with only one hand? It is difficult, but I did it.

The next winter was routine for me in Texas. Ex was never sociable, but that was good for me. I really preferred to spend time with friends or out shopping without him anyway. I also enjoyed talking because the words were coming forth so easily now. So, I kept learning and talking about everything, mainly because I could.

Unfortunately, I didn't have control over my voice tones. When I got excited, my words came out in rather sharp tones at times. This angered Ex, and he often told me to stop talking like that. I didn't do it on purpose, but it became another thing that I was very aware of, and so I had to work on it quietly so I could gain control over it. I didn't want anyone to be offended by the way that I spoke to them.

However, the ordeal with my breasts was not quite over yet. In 2013, I had to go back to the surgeon to have a balloon inserted into my right breast to get it ready for the implant. I got used to being alone at the hospitals during those times of waiting for surgery. However, I got over the loneliness by using that time to think, and I had a lot to think about, trust me.

Then, three weeks later, and at three-week intervals for a long time after that, I had to go back to the hospital to get fluid put into the balloons so that they could stretch the skin. However, I couldn't rest in between as they had suggested. Life goes on, and I had things to do. After all, it wasn't as if there was a husband, or even kids, there for me who was wanting to help!

I even used the whipper-snipper or the weed eater as some people call it. As well, there were times when I cooked and cleaned. The jobs were all mine to do alone, but at the same time, it seemed that the more I could do, the more I wanted to do.

I could not—I *would* not let this injury dictate who I was or what I could do. There was so much to life that I knew I could have, but it would take many more hardships to get to that place. The next hardship, however, was one of the worst for me to face and to get through.

Chapter 13

Saying Goodbye

In July, I got a phone call to say that my mom was dying. Fluid from her heart was going into her lungs, and she could choke to death at any time. It wasn't a total surprise to learn that she was coming to her end, but at the same time, it was horrifying to actually hear someone tell me that my mother was going to die soon. So I didn't waste any time. I packed up the 5th wheel right away and drove to my mom's, which was about an hour and a half drive from where I was living.

My mom hadn't been able to recognize me half the time for the last eight years. That didn't bother me too much because I knew the torment that she was going through. When she did connect and know that it was me, she'd be upset with herself and call herself stupid. I'd laugh and say it was okay because I do the same thing. On the other hand, I knew the intimidation she went through from not recognizing people or not remembering who they were. It really is a very sad feeling.

She had always been very particular when it came to my wardrobe, fashion, and class. This would be a special memory for me. But God gave me a gift because I was there for five weeks, and only once and for a second, did she not recognize me. I was so thankful for this. She couldn't get excited and talk a lot or laugh, so I made a deal with her. When she got tired, she was to do a thumbs down and then take a 20-minute nap. That was one thing she loved to do.

My mom knew that her time was coming to an end, and so I asked her if she had a wish. All she wanted was to see all her 120 grand, great, and great-great kids. Her last wish was that I would be there when it was time for her to go. I told her I would. "You're going up to Heaven to see Audrey, Ruthie, and Dad when it's your time to go." I tried to be strong, but I said this behind welled up tears.

Three days before I was to return home, I had to break from our visit and return to St. Michael's Hospital for the last ballooning fluid. Wow, did that hurt! I was so glad that it was over, and I guess stretching the skin for that last bit egged on the pain. When I returned to my mother, the first thing she asked was if I had cancer. I told that no, I didn't.

She didn't really believe me, so I told her that I had a preventative test done and that I was fine. I told her about the ballooning and then pulled my top down a bit to show her. She smiled and said, "They are beautiful; not like mine."

My mother never had implants put in after her mastectomy, and I told her that it was because of her that I made sure I had implants put in. She had never felt like herself after her surgery, and always said it was ugly. But I fooled her that day, "Mom, when you are in the casket, you will have boobs." She looked at me funny and said, "Really?" I said, "Yep," and then I showed her a set of foam ones that I'd bought, and a beautiful smile crossed her face.

The last few days of our visit went by fast, and soon it was time for me to return home. Mom was not happy that I was leaving and she began to swear at me in Dutch—and boy, could Mom give you the evil eye! "You promised!" she said. I smiled and choked back the tears, "I'll be here, Mom. I promise." Then I left.

During the whole time that I was visiting my mom, I struggled, but no one really knew. I tried to remain positive and happy, but my patients were running thin. Visits with my mom also meant a lot of work for me. When I was there, I had to really focus on my mom when she had to do things such as go to the bathroom. I didn't want her to fall or have problems that I could help prevent, so I went with her.

Needless to say, during those times I did not answer the phone when it rang. The family was angry at me because according to them, I should have just stopped everything and answered it. But little did they know how physically and mentally straining this was on me in the first place. It wasn't as easy for me as it was for them, and I gave it all I had to do what I did. I didn't have much left in me, and things were already starting to turn in my brain.

So my sister Nene got a portable phone so that I could carry it with me. That made me angry, and I told her where to stuff it. She didn't understand that I just could not do it all myself, but that I promised our mom that she would see everyone. Trust me, that was hard to handle, as well. The family just wasn't as tightly-knit together as my mom would have liked to believe it was.

The family was looking at me as if to say, "What are you doing?" I got into arguments with Ex because he took it upon himself to tell my sisters off for things he had no idea about. There were times when I felt as if I was doing this whole thing alone. I was still struggling with memories and abilities, and I felt that still, no one understood what I was going through. I was there to help my mom get through this difficult time in her life and to work with the family as a sister to support our mother.

I kept going and just lived each day around all the bull that was flying. All this was dumped on me on top of my own personal struggles. It was becoming hard to deal with.

Something was going on inside me, and I couldn't figure it out. Little things were happening, and I would tell Doreen, but she didn't help me. I was looking at rental units in Ontario as far north or south as it took. I didn't care. I wanted to be someplace where I could call it home and know that it was home for me. Little things would pop into my head, but they didn't make any sense to me at all.

Soon, I was back home and helping to work on the lots. Then it was Friday morning around 5 a.m., and I woke up crying and feeling pain all over, yet it wasn't physical pain. I got up and made myself a cup of coffee and then sat outside to listen to the peaceful sound of the stream. At 7 a.m., my sister called and said that our mom was not doing well. She had to give her a needle, and I said, "Yes, you gave that to her at 5 a.m." She kept asking me how I knew that.

We arrived at my mother's a few hours later, just as the nurse was hooking her up with a morphine splint. They said that my mother wouldn't know that I was there, and I said, "Oh yeah? Watch!" Then I moved closer to my mother, and with a loud voice, I said, "Hi, Mom. I'm here. Told you I would come. Now let's move this pillow a bit, so you are comfy."

My mother struggled but couldn't open her eyes, and then she moved her arm through the railing of the hospital bed. I reached for her hand, and she clung to my mine when it touched hers. I knew it was time, so I held her hand tightly, and I felt her squeeze. She knew that I would be strong and tell her it's time to go.

Later that day, the minister came, and he was holding onto her hand. I told the minister to watch this, and then I opened my cell phone. I told him, "I You-Tubed *How Great Thou Art* by Elvis Presley in Hawaii." It had spunky music to it, and I put it by my mother's ear. The minister said, "You know how to get to her, don't you?"

While I was holding her hand, I began to think back to a week ago. We all used to say that mom was a spiritual psychic because she could look right into your soul. She had put both her hands on my cheeks and said that I would be happy and that she loved me. I was so thankful for her words of inspiration, and for her encouragement.

I felt that I'd been given the best gift of all. Later that day, after holding Mom's hand in mine for a while, I knew the time had come. So, I let go of her hand and gently brought her arm through the railing and rested her fragile hand on her chest. My insides ached, and I took one step backward and then blinked the tears away as I watched her.

My brother and sister were about to move her, and I motioned for them to stop. "Mom is gone." I had felt her last heartbeat and counted for two minutes. There was no more pulse. Mom had left us.

Losing my mom was a very big adjustment for me. I know we all have to go sometime, but I wished it could have been just a little bit later. She had always been there to encourage me and give me the confidence I needed to keep going. So much had happened in the last few years—in the last few weeks, and I felt as if I'd have to face them alone because she was gone. Yet, she had left me with her words of encouragement and hope, and I clung on to them. I believed her. Mom had helped me build up my self-confidence, and I knew that I could get through it all, especially once things would begin to settle down.

However, things were always changing, sometimes for the good and sometimes for the bad. This time, I noticed the beginning of another very big change that was looming on the horizon. This one would have a great impact on my entire life.

Ex and I were getting ready to head out to Texas again in October. This was another year that we couldn't get the kids together for Thanksgiving. So my attitude became, "So what else is new?" Years ago, things like this would have really bothered me, but I was changing, and they didn't bother me now. I didn't know why. I wasn't surprised that they happened, but they didn't affect me that much anymore.

We arrived in Texas, and I drove part of the way. Ex was tired and blamed me for it. I thought to myself, "Go to sleep. I don't care." I had no problem driving a truck that pulled a 37-foot fifth wheel. However, he did. He'd sit there and criticize me, and say that I had a heavy foot. I ignored him and just turned the music up louder. He didn't intimidate anymore; he just annoyed me.

We finally arrived in Texas, but Ex decided that he only wanted to stay one month because it was too cold. So, we packed up again, and I had to lift stuff with a torn left shoulder and a new implant that was put in, in September. So we headed to Florida. In the meantime, I was trying to find a spot. Largo, it is, for two months and then we'd move again. I was beginning to hate it, but I just kept going. It wasn't easy for me, either, because I had been so sick once again. I blamed it on yeast infections that I got at least twice every winter. Those darn drugs were killing me!

After two months, we were in Myrtle Beach. I knew a lot of people there, and it was easy to escape from the dark world that I lived in. On top of that, I knew where the shops were. I felt free once again, and I enjoyed that freedom.

I was lucky to receive two calls from my daughter, every winter. My insides would burn with excitement to hear how the grandkids were doing, so I really looked forward to those calls. They were so rare, though. Even on Christmas day when I knew they'd all be together, I'd phone, but there would be no answer. No one returned my calls.

I knew that something was up, but I had no clue as to what it was. I'd spent so much of my time during my many months of healing at Beatrice's house. She was not a good housekeeper, and so I'd clean her house from top to bottom on a regular basis. But as time went on, my time at her house became less and less because I was tired and fed up with it. Besides that, I never even got one thank you for all the work I did to make her home clean. Not one!

So after a few years, I got to the point where I just didn't want to go anymore. When the grandgirls would call to ask for help, I would say that I was sorry, but I was tired. In truth, my body and my brain were getting worn out easier all the time.

I was getting tired of a lot of things, and of helping others and not being appreciated, especially when I was doing it at the same time that I was undergoing so much stress and pain in my own life. But more than that, I was tired of being the only person in the marriage relationship with Ex.

Chapter 14

Breaking the Bank

The winter of 2013 sparked some very bad memories for me. My mind was slowly getting snapshots of things of the past, and often I couldn't put the pieces together so they could make sense. I got a major snapshot when I was looking at my bills online one day. Things didn't add up, and it puzzled me.

I had loaned my son my Master Card so he could buy some new tires for his vehicle, and that was fine. But when I saw what was owing on my account, I knew something was wrong because tires didn't cost that much money. Lloyd had maxed out my card! There I was, and I knew that soon I would need to make some rash decisions, but how?

I phoned for the statement and then printed it off, and as I was looking at it, a strange thing happened to me. I got a flash of the job at the head office where I had once worked. The brain began to spin out of control, and I saw accounting pages in my head. What was going on? I was so confused. After a few minutes it stopped, and I was back to being what was my normal self.

When I returned home in April, I asked Lloyd about the financials of the factory. It was a loss all the way around. So I said, "Shut it down. Shut the factory down. I don't care, you are not getting any more from me!" Of course, that was because there was no more to get.

Bills had piled up high, and that's when I found out that I was responsible for them all because I had co-signed Ex's loan. Lloyd got a lawyer to negotiate what was left owing and what had to be paid. Now what I had left for me was gone. I was furious!

Yet, as angry as I was, my health was far more important to me. I prayed and said, "God, please give me my life back." The love of money can be the root of all evil. I knew then that my children and my partner didn't care about me or about getting my life back, or about what would be needed for the future of any of us.

That year, Lloyd sold his lot that was near ours in Cadmus, Ontario. He'd had his trailer on it and had been trying to sell that, as well. But it didn't get sold right away, so he had it towed to my lot. I thought to myself, "Look out! Marjorie will clean it up and sell it."

I spoke to one of the men at the garage on the highway where I stopped for fuel, and I told him that I'd make him a deal with him. I explained that I had a trailer on my lot, and I gave him the year and some details about it. The deal was, as I told him, that if he could sell it, I would pay him $500 in cash. He seemed interested and hopeful and so he agreed.

Then I went to my lot and cleaned Lloyd's trailer and threw out all kinds of stuff. Cleaning seemed to be an outlet for me. No one ever bothers me when I'm cleaning. So, I scrubbed—and I mean scrubbed—from one end of the trailer to the other. I must have thrown out at least ten garbage bags of clothes, dishes, and whatever else. But I didn't stop until that trailer was spotless.

During this time, Lloyd was separating from his second partner, and so there was no way that I was going to let either of them off from abusing my Master Card. I had the trailer towed to the garage where the man had agreed to sell it, and within one week it was sold. I collected the money and paid off my card. Lloyd was upset with me and said that he could have got a lot more for the trailer than what I got. But I told him that I didn't care; it was gone. I never screamed or yelled because I knew that if I did, then the words would get mixed up and not come out right. So I spoke calmly.

I knew that when I had a lot to say or that when I got upset or angry, I could not control my tones. It was during these times, apparently, that the family always complained or criticized me and said that I was an angry mother or wife. I tried to explain it to them that when there are a lot of words to say that are important, the brain goes fast and I can't help it. So I told them to suck it up because this is me.

Did I like myself for that? No, I did not. I did not like that I couldn't speak with a natural emphasis on words. How could I improve my tones? I thought I was doing so good, but I still had a ways to go. I was determined that I would climb that mountain with the help of the higher powers.

Whenever I would be on a walk or even just standing alone, I would look up and into the clouds or into the stars, or the sun or moon, the universe that God had created, and I would say, "Please help me through the next step. Keep me calm."

Chapter 15

Healing Means Hard Work

The summer of 2014 was another very difficult time for me. Beatrice was diagnosed with Lyme's Disease, and I felt terrible for her. I knew that if she were going to get through this, everything in her house would have to be cleaned and disinfected. Everything! This was something that was very badly needed anyway. I stayed at her house for over a week and just cleaned every floor of that house until every one of them was spotless. I bleached everything, and not sparingly, either.

My daughter was not a good housekeeper at all, and I told Beatrice that she was a pig and didn't deserve a beautiful home like that. She didn't seem concerned, though. But of course, she had a son who was on drugs and who punched holes in the walls, and that just added to the dilemma. On top of that, she had taken into her home another boy that made her house even worse.

I knew that he would be trouble. But they wouldn't listen to me when I warned them that there was trouble coming that she would regret. I don't know why I said that, but I did. Then I warned that kid that if he hurt my girl, he better look out. But, who was I in my daughter's eyes anymore? I don't think she even cared.

Beatrice and I had become quite distant by then, but at least I could still talk to her daughters. One day, as I was getting ready to head back home, I spoke with the girls, and one of them said, "You know, Nana, when you call, Mom tells us not to answer the phone and says, 'It's only Nana'." I was upset with this, and so I confronted Beatrice about it, and she said that it was true, but it was because she was busy.

That made me even more upset, and I argued that maybe I was calling to speak with the girls and not her and that she should answer so that I could talk to them. But it didn't fizz on her, and she just passed it off as not important. But oh, when she wanted something from me, that was okay to call regardless of how I was feeling.

She called a lot when she and her partner split up, and their trailer was parked on one of our lots where she wanted him to stay. I didn't like the idea of getting involved, but Beatrice's partner would call and tell me his side of the story, and she'd call about him. So, I ended up telling them both that they would have to be honest with each other and work this thing out themselves.

I was a great one to tell them to be honest with each other. I knew that at that time, being honest was far away from our household. The walls around my own heart were so thick at that point that I think I was triple layering them. Hurtful words never stopped coming at me.

When I returned home, I had to face more work and more surgeries. I saw several more surgeons, and those visits resulted in me having two more surgeries scheduled for the summer. I had to undergo more breast surgeries that were necessary as a result of the infections I'd had earlier. The doctor said that they would do one at a time—so more pain to go through.

The summer was a tough one on the body. That year was the 50th anniversary of our community in Cadmus, and it was going to celebrate. So, out came the small chainsaw and the lawnmower. I wanted the property across the road where the stream continued on to look perfect. There were a lot of over-grown trees that were removed, and that's when I saw the pattern that the green spruce trees was planted in. The trees were in a straight row.

One of the original owners had planned to return for the celebration. He was a WW2 German war vet who had been held in the prison camp for eight years during the war. He had come to live in Canada but had since moved from this property. When he saw what I had done to it, tears of gratitude rolled down his face. He stayed close to me, and as we walked through the property, he told me many stories.

When he learned that I was Dutch, he bragged about how the Dutch Red Cross had helped everyone during the war, whether they were a friend or the enemy. Then he told me how this property had been his dream home. It looked beautiful, almost like coming to a golf resort; beautiful and clean. He was filled with memories and joy that day for all I'd done, but what he didn't really understand was that doing this hard work was not all about beautifying the property; it was actually a kind of therapy to help me get stronger.

I was proud of my heritage, and when the World Soccer Games were being played, I would fly the Dutch flag right below the Canadian flag. My mom really loved that I did that.

Not too long after that, Ex decided that he wanted to build a windmill. It was huge and beautiful, and it could be seen from a long distance away. There was always a breeze blowing, and so it was always turning. Oh, how I wished that my mom could have seen it!

Meanwhile, I kept myself busy and didn't really see anyone. There was so much to think about and to try and understand. So, I spent my time walking alone and reading, and of course, visiting doctors. In fact, doctors' visits just seemed to become part of my regular life routine. Strange things began to happen, though, and I knew that someone was watching out for me. I didn't understand it at first, but I began to remember what I did a month ago—even a year ago.

I still faced a lot of ongoing health issues, but it was those horrible yeast infections that I got every year that really got to me. With those infections came cold sores that were extremely painful. I'd have to stop and ask myself, "Okay, Marjorie, your immune system is down again. So okay, how do I improve it?"

I thought that I'd been doing all the right things as in eating healthy and exercising, but I also knew that anesthetic takes a toll on the body, regardless. I had to find a way to overcome this issue, as well.

Chapter 16

Getting Braver

It was the winter of 2014-15, and I knew that this would be the last year for RV'ing with Ex. Don't ask me how I knew; I just knew. Danna and Bill, my two really special friends, came for a visit and stayed at the Holiday Sands that I had booked for them while I was in Florida. When I arrived in Myrtle Beach, South Carolina, the first thing I did was check out the motel, and I liked the owners' grandsons who were at the front desk.

While checking out the top floor, I met this sweet lady, and we chatted for a while. That woman had spunk! I told her that I wanted to do aerobics, and she told me to just tell them what I wanted. Then later on, while speaking with the young men at the front desk, I told them that I'd met this sweet elderly lady on the top floor and that she reminded me of my own mother. That's when they told me that she was their grandmother.

When they joked that she was getting old, I told them, "Listen, we are all getting old, and that if I can look like that at her age, then I'll be really blessed."

That was the beginning of Myrtle Beach in the fall, and I was looking forward to coming back again. It felt right, and even though there was a lot of noise, as well as dirt that came from the working construction, it didn't bother me. This was the first time that something was happening, and I didn't have a clue as to what it was.

The summer of 2015 was a tough on one my body. There was a lot of physical work to be done, and I was part of that labor force. I dug into the ground to build cement forms for the RV to go on. We needed something that would be strong and reliable. Marky and Lloyd had come to help, and they both worked hard, as well. The cement truck came and poured the cement into the spots, and of course, I was there using a shovel to pound the air out of the cement mixture while Lloyd and Marky smoothed it out.

So the RV was set on jacks because I had made up my mind that when we would go to Myrtle Beach later that year, we would be staying in a motel called the Holiday Sands. We would not be taking the RV. Ex didn't like that we would stay in the motel, but I didn't care what he liked. I was tired, and I didn't want to work anymore. So, when we got there, I had a great time! Lots of walking and looking at the stars, and praying. I asked God for strength because it seemed to me that I was getting tired earlier and earlier.

Meanwhile, Lloyd was going through his own problems, and he would try to tell me what was going on with him, but I didn't want to hear it. Bits and pieces were swirling around in my brain, and on top of that, I found that the energy just wasn't there. Something was draining me, and I had to find out what it was. So I went to see Dr. Corless, and he upped my thyroid meds. Yet, the confusion part was taking effect, like a puzzle. I had to get answers.

By July, things were really crazy. I was working hard to get myself up to par. There was a family reunion planned, but I could not go because it was raining so hard. At that point, it was still very challenging for me to drive in bad weather, so I knew it would be better for me to stay at home. My sister-in-law Charlotte was in charge of coordinating it, and she put together a wonderful family tree booklet. The children of my brothers and sisters were to write something about their parents in it. What a sweet gesture!

On another occasion, which was my older brother Leon's birthday, he was on his way to my place. What would I give Leon as a gift? I had no idea, but I knew that I wanted it to be something really special. That's when I got another small miracle. I woke up at about 4:30 in the morning and began to type about my brother from bits and pieces of my memory that began to trickle in. I wrote how, when we were kids, he had picked me up when we were playing hockey after I'd fallen through the ice, and how he ran and carried me to the warmth of a wood stove.

Then I wrote about another incident where we were playing football, and how because I was the youngest, I had to grab his legs and hang on. These new memories excited me, and I thought they'd do the same for him.

However, the only response that I got from Leon was when I asked him if he had picked Audrey and me up from the hospital when I was in a wheelchair. He replied that he had and then said that I had been in really bad shape.

For a long time there, clues had been popping into my head, but no one noticed. Whenever I tried to reach out and tell others what I had remembered or what I'd learned, no one seemed to notice. No one seemed to care. I asked myself, "Why?" I realized then that you can make the outside of your body look normal, and that even though the inside is so messed up, people and even family don't notice anything. I remember sitting down and trying to encourage myself that in time they'd notice—but in whose time?

I only saw my daughter Beatrice once that summer and that was at the park. I would drive by her house quietly most often, but things had really changed. I stopped myself from being so concerned about her. I didn't care anymore about how they lived. I had tried my best and had given her and her family all of my energy for years, but that time was over. Now I felt nothing. I was empty.

I had surgery on my breast again in the spring of 2015, and this time they transferred fat cells, but since I didn't have much fat on me, I was left black and blue from my private area to the top of my breast. Then I was out of it again! I wasn't allowed to do much, and I actually didn't do much this time because I was too tired. Normally, I would have been forcing myself to move around, but this time I didn't care like I should have. I had too many other things to deal with.

One of those "things" was Ex. I was tired of hearing him criticize how my breasts looked, and I got to the point where I stopped caring what he thought. Then he was hardly around much after that—and I actually enjoyed it because then I could walk over and talk to my neighbors. But on those occasions when Ex was home, and he'd fire one of his snide remarks at me, I'd just think, "So what?"

In August of that year, we had a bad storm, almost like a tornado, and it went through the back of the properties and broke trees and did a lot of damage. One of the huge trees that snapped landed on top of the shed on our property. I knew that it had to be cut down and cleaned away, and so Lloyd came the next day to check it out when everything was still wet.

He wanted to grab the chainsaw and clean it up, but as usual, his father argued about it. Ex said not to do it because the roof was too slippery and that it could be done later. I knew exactly what he meant.

He meant that it should be left to me because I was the worker! So, I used the saws-all and the small chainsaw, and I cut the branches off the big tree and then loaded them into the back of the truck by myself. That's when Ex decided to help me, and he drove the truck with all of the tree branches in it to the dumping area.

By the time he got back, I had enough cut for the next load. Hauling those heavy branches with a torn left rotator cuff, and having had breast surgery about six weeks earlier made me very tired. So if I needed a break, I would dull the chainsaw blade on purpose so he'd have to sharpen it.

I knew that Ex was struggling with his breathing, but he wouldn't get help for it or even try to help himself. I had lost all sympathy for him since the accident, and I felt that there was more going on with him, but I couldn't figure it out.

When clean-up was done, I got the same response from Lloyd's kids as I had got from him. They also laced into me for not waiting for others to come and do the cleanup. Sometimes I felt as if they were all just waiting to dump on me, and over the summer, I had become more verbal with my responses to them. Often though, they were the same two words that clearly told them what I thought of them. Then I'd turn and walk away. No one said anything after that.

There were a few times when I felt as if the whole family was coming down on me. Yet, inside me, I knew that things were opening up. Something was coming back to me, and I had no clue as to what it was. But there was an overwhelming sensation that told me I would not like it.

Chapter 17

Eye Shock

September rolled around, and I had to start the winter clean-up. Packing was going to be different this year. I had to figure out what was needed in a motel as in clothes. I always liked to start early so that I wouldn't forget anything, and of course, the inside of the RV had to be winterized. My brain felt as if an overload was setting in—or a burnout. I wasn't sure what was going on, so I just kept working.

I didn't have time to think as I had to do it all myself. There was so much to be done; medical bills, insurance, food, clothes, and cleaning the inside of the RV, not to mention cooking and everyday stuff. I had to do it all.

Something inside my heart—or perhaps it was my spirit—was different, though. I felt as if I was going to be hit with a bombshell; yet, I had no idea why. I was confused about a lot of things that should have been normal for me, but September 15th became the exception. I will never forget that day, as it was the day that I saw my personal eye doctor for an appointment.

I'd been having problems with my right eye since February of that year. I couldn't see out of it properly and assumed that it was the result of being tired. It had never really been right since the accident. But what did I know? I had been knocked down verbally so many times that I just ignored everything and kept going. I just figured that one day something would happen because I had my faith.

So I had my eyes examined, and the doctor used a different machine and called my issue by a name that I didn't understand. I told her that I'd get it fixed when I got back home in April. Her response was, "No, you're not leaving the country. You need surgery now, or you could go blind at any time." I tried to humor that away and say that that's not going to happen to me. The truth is that it scared the life out of me.

The temperature got cold early that year, and my heart was not into staying in the RV. It had become our home in Cadmus where we lived during the summer. Then Ex's sister offered their home to us for October 1st as they were going to be away for two weeks. That was perfect because by the time they got back we would have left for Myrtle Beach.

We were on our way home just before we were to leave for his sister's when EX said something that really upset me. I can't remember exactly what it was that he said, but I know that something really changed that day!

I screamed at him, and I sobbed and cried as if my soul had been ripped apart. When we got home, I didn't say much, but I started the packing procedure. I was going to my sister-in-law's with or without Ex. I really didn't care.

On the following Monday, I was at the laundry mat washing all the blankets to be packed away for the winter. My phone rang, and it was the eye surgeon's office telling me about my appointment next day in Toronto. I was scared as I didn't like anyone touching my right eye. It was always so sensitive, and I was conscious of my eyelid drooping.

I'd had issues with my eyes since the accident, and I hated going out in the sun because it hurt them so much. On top of that, I had never been able to stop my right eyelid from drooping. It was embarrassing. I'd look in the mirror, and I'd feel so ugly inside. I wondered where my beauty had gone. This eye really made me feel and look horrible.

I'd gone from one doctor to the next, constantly having my vision checked. When they'd shine the light in my eye, I'd always close it because it hurt so much. The doctors insisted, though, because they needed to check for drama behind the eyes.

My eyes were often checked after the accident. It was so hard to see at times as the vision would come and go in the right eye. I'd been given different glasses every six months to help, but nothing did. Some of the eye doctors seemed to be really harsh because they'd work fast and they'd ask if I could see this or that, or if this was better or maybe that was better. Finally, there was a time that I got two words out. This time, those two words were, "Too fast."

However, this would be the first surgery on my eye. So, I went to Toronto and began another painful procedure. First I got eyedrops, and then more eyedrops and I had to sit in the waiting room with my eyes closed half the time. Then it started. I had to sit in the chair and not move my head. My eye was then frozen, and the lights from the laser began playing in my head. Little fine red wires were floating and connecting. When I mentioned it to the doctor, his only response was to tell me not to move.

So all I could do was sit and focus to keep on track. I'd tell myself, "Don't start a seizure, no twitching, control your mind and body. Oh, God, please help me!"

One eye was done twice, and then the other. I thought to myself, "Just keep smiling. Soon I'll be seeing better than ever." When it was over, I had more drops. Then came the disturbing news—I had Angle Glaucoma. I was shocked! The doctor told me that it would explode and that I would be permanently blind, and that there was no way of fixing it. One eye was really bad, and he said I was lucky to get it done. The timeframe for it bursting was unknown, and so my eye doctor was right—it could happen anytime.

Seven hours later I had returned home, but while in the truck ride back, I told God, "Thank you for keeping my eyesight."

Then the eyedrops started, three times a day. I had to keep my eyes closed for ten minutes each time, and I did this for a week. However, after the first few days of lying on the bed for those supposedly ten-minute periods, I began to realize that I was actually lying there for a lot longer than ten minutes each time.

Some days, Ex was back outside after the drops went in; other times I'd check the clock myself to know when the time was up, and I'd do this by counting the seconds and minutes. When I figured that my time was up, I'd wait and wait for Ex to return. Then finally, he'd open the door and tell me that I could open my eyes now. But 20 minutes had passed by, not ten. I was so angry with him that I'd swear at him.

After that, he'd put the drops in, and I'd just do the timing myself. As it turned out, sometimes I went over the ten minutes a little bit, too, but that was my choice. So after a few days, I just set the timer on my phone and was stunned as to why I hadn't thought of that in the first place.

The most startling part of this whole procedure was that the laser had sent red flashes like lightning strikes through my head. They scared me a lot at first, but soon I began to realize that more and more of my memory was coming back. These shocks actually woke up parts of my brain that had been in a dormant stage for so long.

The greatest thing that happened to me and that helped me regain my memory was when my brain was shocked by the eye laser treatment. So, what began as a procedure that terrified me, turned out to be one that actually triggered my brain and released all the hidden memories.

At first, I was thrilled because what I had longed for all those years had finally come to pass. My memory was coming back! However, what I had never anticipated was that along with those recovered memories would come many forgotten hurts that I wished I had never brought back.

Chapter 18

Going Forward on My Terms

On October 1st, we were living at Ex's sister's home. I got to know my nephews a bit better, and it was exciting to get up early in the morning and enjoy breakfast with them. Then, during the day, I cooked their meals and spent time with them. It had been quite a while since we'd really talked, and one of my nephews and I would reminisce what it was like for me then and how I was doing now. The other one talked to me, as well. They both told me about their problems and their concerns. All I could do was listen, and give them a bit of advice on some of their issues.

I told one of them that he and his mother needed to talk about things. I told them that whenever he felt troubled or in need of help, he should look up at the sky and tell the One up above and that when he was done, he should always say, "Thank you." I told him that it really works and that I am testimonial proof that miracles do happen.

During those ten days, I tried to arrange a family Thanksgiving Day dinner, but no one seemed to want to get together. So finally, I just said, "Forget it. We're going to a restaurant." So Lloyd and his partner and his boys met us at the Swiss Chalet, and we enjoyed our dinner together. I even gave the boys their Christmas and birthday gifts. We had a good time laughing with them.

In October of 2015, just before I was to leave for Myrtle Beach again, I felt something inside nudge me that I should go and see Pastor Doug at the Embassy Church. It had been about ten years since our last visit, even though I thought of him every time I saw the billboard at the church where he'd put a Scripture.

He was amazed when he saw me. "Miracles do happen!" Then he hugged me, and I told him that yes, they do. I had promised Pastor Doug that I would never give up, and it was uplifting to see him again. We had a wonderful visit together that day.

Shortly after that, it was arranged for Beatrice and her family to come on the 9th. On our way to the restaurant, I decided to phone her and see where she was. But guess what? She had forgotten! That hit a nerve. The apple doesn't fall far from the tree with that one. I always said that she and her father were alike in so many ways, and here's proof again. I told her to meet us there and whoever comes, comes. I was beyond caring anymore.

Only two of my granddaughters came; the other two weren't there. But I didn't let it bother me. Years ago, I would have made an issue about family being together on special occasions and that excuses weren't accepted because everyone knows the holidays, and they have calendars. But not anymore. I enjoyed the dinner with those who came, and I gave them their gifts. But inside it felt useless, and so I determined that this would never happen again.

We returned to his sister's home, and I loaded up the truck. Those bins were heavy, but I knew that he would wake up one day and say, "Let's go." So, I wanted to be organized and ready. I wanted to wait until after Thanksgiving to give me a few more days, but he didn't like staying at his sister's, and I knew that he'd be on my case about it soon enough.

On October 9th, we were at my brother Dylan's home. Ex didn't want to go, but I won that argument. I told him that we are staying there, not paying for a motel and that I wanted to see them. He muttered words, and I just used that two-word phrase at him again. I was getting myself back together and decided to just ignore the digs about how I was.

I had a good time visiting Dylan, and then we woke up early in the morning and headed to Myrtle Beach. I had flutters in my stomach, and I couldn't understand why. I noticed at our first fill-up with fuel that we had to pay before we could fuel-up, so I paid and just talked to this stranger about nothing. Where had this boldness come from?

Soon we were off again! I had phoned the motel and told them that we were coming in on Sunday, and the grandson said, "No problem. It will be all ready for you, even the aerobics room." That part really excited me. I was always trying to be civil, and finally, my voice tones were changing. I did not have a fear of Ex anymore, either, nor did I feel held down. We stayed overnight in North Carolina, and I was tired but happy inside. I would look at the stars and feel as if someone was watching me. It was so peaceful.

We arrived at the Holiday Sands, and wow! I felt something. We checked in, and the office was upset that the room had been used and not cleaned. The owner's son sent four people up there to start cleaning immediately. I told them not to worry, and that I'd just unload and leave my stuff in the hallway.

Then I went to the top floor and hit it off with the staff. I told them to leave the bathroom for me and that I'd help them to clean it. So, there we were with bleach and vinegar; the staff was cleaning the jacuzzi tub, and I was cleaning the toilet, the sink, and the floor. I often felt at home when I was cleaning.

Jan, the chambermaid, and I hit it off instantly as I joined in and actually told them what they should clean and what I would clean. We were laughing, and then she told everyone to look out, that the poor working man was giving orders left, right and center. Get the garbage out! I knew this is where I belonged.

While waiting for our room to be finished, I left them for a while and saw that Ex was not breathing very well as he tried to help lift the stuff I had already put in the truck. We went downstairs, and I left him standing there to have his smoke. Meanwhile, I walked over to the office and asked for a key to the aerobics room.

When I left the office and went outside, I stood and looked at the ocean. But when I turned around to walk back in, I was shocked!

I saw a vision of my mom and other spirits around me. I thought to myself, "What is this?" Then I looked up at the atmosphere, and the sky was so beautiful. I guessed I was in for a beautiful winter, the feeling of someone around me was weird, but they say God moves in mysterious ways. I guess this was a sign of the peace and quiet that I'd find there.

Danna and Bill were coming in January, and I was looking forward to seeing them. I had to get in shape, though. Every winter it seemed as if it was catch up with me. But I knew I could do it.

Chapter 19

Big Changes Ahead

I worked diligently to get the room all set up. After a while, it was basically done, and as well, I had managed to get some groceries. Then I sat on the balcony and listened to the ocean. Between the tranquility of the water and the serenity of the sky, I was at peace as I sat alone and enjoyed the beauty of it all.

The first few days were just getting familiar with everything. I tried talking to Ex about quitting smoking and doing more walking. I told him that I was going to quit smoking because I had to get in shape. I found a coffee shop up the street so we would walk there. I was trying to be happy, nice and encouraging, but it seemed to go on deaf ears. I enjoyed the simple things of life now, like a full-sized fridge and stove. Some people would think that I'd lost my mind, but to me, life was great.

By then, Ex was often choking and short of breath. I tried talking him into going to see the doctor, but he'd get nasty with his words, so I'd just mutter a few words back at him and leave. Being with Ex brought the worst of words out of me, and so I decided that when he'd get that way, I would just go for walks or go shopping and get away from him.

That wasn't all bad because while I was out there, I'd say good morning to everyone. If the people were friendly back then, there was joy, and if they were grumpy, then I'd think that they were the losers, not me.

Within a month, I was comfy with all of the staff. Jan would bring a big bag of towels, and she'd tell me that if I wanted anything, I was to just ask and then she'd get it for me. I had quit smoking and was working out to get through that change. That was tough, though, and after aerobics, I started trying to jog to the pier. That was not easy for me. But tackling it for a month, I finally made it to the pier by jogging, but I could only do a fast walk back.

It was during this time of being alone while out for my short walks and jogs that the pieces started to come together. I would sit on the bench along the boardwalk, and say, "I can't believe it! That did happen!" Every day would bring more and more clues. My brain seemed to be in overdrive, but one thing was sure; I didn't want to talk to any man. I began to hate them more and more, especially when I went back into the room and looked at Ex.

I tried to put happy times together, but there seemed to be a block of that at first. I would just go out and walk in between the two buildings and look at the sky. It was so beautiful with its glittering stars. It was peaceful.

There was a barge out there in the water, and I found that interesting, as well. It would take my mind off of my issues of the new things I was remembering. I would sit on the balcony with my binoculars and look for dolphins, and watch the barge pull the poles out. Strangely, I found that interesting.

Ex would ask what I was looking at, and I would tell him that I was watching the dolphins and the workers who were doing their job out there with the crane. His response was always the same, "Oh yeah, just looking at the men." Finally, I said to him, "Yeah I am, so what?" He knew I never wanted another man again, but he seemed to enjoy throwing the snide remarks at me anyway.

A month had passed by, and just as I was leaving the office one day, a man stopped me while still in his car. He said he was in bad need of a haircut and asked me if I knew where this particular barber shop was located. The only one I could think of was one that had, what I call, an old-fashioned candy cane style sign. But I didn't know exactly where it was, just that I'd seen it. So I told him that I wasn't sure where it was, but that it wasn't too far away.

Just then, Ja the grandson came out to help, and the man repeated that he needed a haircut and wanted to get cleaned up. I wanted to say "Yes, you do need a haircut," but instead, I just stayed with them until the man drove away.

Then I was in shock! What had just happened? The first time my heart or something changed and I was talking to a man! This was something that I had ignored and didn't want anything to do with, but yet somehow, this man was different. I shook my head and went into the elevator where I could be alone, but I felt weird. So I came back out and went to the boardwalk where I sat on the bench and asked God what was going on.

I closed my eyes, and it was as if my mom and Audrey and Dan, and the soft light of guidance or whatever it was, was there with me. Tears streamed down my face. So much was going on and I didn't understand any of it. I could not make any sense of so many of these new feelings and emotions or of my own responses. I needed to do something, so I took a walk along the ocean.

So much of my past was beginning to trickle in. "Where are you, Dan? What happened and when?" I had more questions than answers or visions at that time. So much was coming at me and I struggled to put it all into the proper perspective. How did this all fit together?

Meeting that man touched something inside me. He had a charming smile that just drew me to him and that I couldn't get out of my mind. I felt something. I was sure that I was losing my mind, though. I didn't own such feelings towards anyone, let alone to strangers. I called my minister and told him, and he said that I have a gift and that God is preparing me for things in life.

None of it made any sense to me, and so I just shook it off. I thought that whatever it was really didn't matter anyway because I truly doubted that I would ever see that man again. With so much going on inside my thoughts, it was sometimes easier for me to just put things on a shelf and walk away for a while.

But regardless, it had started a feeling in a different part of my brain. I thought that maybe a friendship part of my brain had come back. Yet, I had a lot of friends, both singles, and couples, so what was this? "Just put it away, Marjorie," I told myself. I would talk to men, but that was it—talk. My walls were very thick, and no one was going there again.

My weekly workouts were getting easier, but dealing with Ex wasn't. He was always asking me how, why, when, and where was I going. He would even sneak into the aerobics room to see if I was there. I saw him peek in once, and so I told him, "Quit looking and do something for a change."

Yes, men were history for me. I had no intention of ever getting involved with a man again. I had been through so much, and I never planned to go there again. However, while going for a walk on the boardwalk a few days later, I saw that man again. This time, my heart fluttered.

What was this?

Chapter 20

Downhill for Ex

I'd just been enjoying the peace and quiet of the day when I saw him again. He came right up to me, and so I talked to him, and this time because I wanted to. He said his name was Richard and asked if I was married. I told him that I had been for almost 45 years. He threw back his head a bit in surprise. Then I said, "Trust me, it has its ups and downs."

I wanted to say so much more, but I held myself back. Something was intriguing about Richard, and I had no idea what it was—or why. I told him a bit about my injury, and then he asked me how I learned to walk, or something like that. So, I told him that I just learned to walk with a smile.

This man was something else! I tried to read his body language, but I couldn't see his eyes through those darn sunglasses. But his smile; it was doing it to me again. What was going on? Then he said something, and I guess I looked stunned, so he said he usually wasn't so direct.

It was as if we were meant to meet. Richard told me about his knee, and that he'd built a deck and didn't give in to pain. So I told him that I was a brain injury survivor and that I didn't want to meet anyone just now. I said that I had to find myself and that the memories were beginning to come full-force at me. So we parted that day, but we met up a few times after that, either on the boardwalk or during my walks.

Ex began to complain that his back was so sore and that he wanted to try out these massage people that were there. I said sure and then reminded him to get a receipt so that we could claim it on our income tax. When he came back, I asked for the receipt, and he said they don't give receipts.

Dah! Did he think that I was really that stupid? I remembered that he'd been seeing hookers again, and in fact, I don't think he'd ever stopped. But I didn't care as long as he never touched me again. He did try once last year, but that was it. Never again!

Christmas came and went, and for the first time, Ex bought me a gift, an Apple watch. What a waste of money! I was not happy with it, and so I took it back. Unfortunately, I started smoking again because of the stress that I was getting from him. I would go for walks, and I'd notice him up there with his binoculars watching me, and it looked so foolish. Ex would go from one side to the other. It was priceless!

Danna and Bill arrived, and I was so happy that I had someone to talk to and to do aerobics with. They stayed for a bit but then went on down to Florida during the time that it was cold in Myrtle Beach. It was during that time that I got very sick. I was so sore down below that I couldn't breathe. I hurt all over, and it seemed as if my tongue was on fire. My throat hurt, and I got so many cold sores.

I asked Ex where the medical cards were just in case I needed to go to the hospital. He said that he had no idea since I'd been in control of those things. I was angry with him and told him to look in his wallet. He did, and there they were! So I told him that if I had to live like this, I would do myself in and that I understood how his brother felt when he couldn't breathe. Then Ex said, "Now you know how I feel."

I turned to him and shouted, "If you don't want to go to the doctor's, then that's not my problem, and if he ended it, then don't let me stop you from ending it. Go for it. It's over between the two of us anyway."

For the next week, I wasn't able to go to aerobics. I had to take Monistat like crazy, plus antibiotics because I was so ill. During that week, I asked Ex if he had any regrets about his life or our marriage, and his response was, "Just spending or losing all the money." I just looked at him and said to myself, "Wrong answer!" My memory was back, and I knew what he had done all his life.

I was finally able to get back to aerobics class and to get back to walking again. While I was returning from one of my walks, I was shocked to see my friend. I was coated in sweat and out of shape, and he looked at me and asked if I was okay. I told him that I was and that it was so nice to see a friend with a smile. I loved his smile.

Danna and Bill came back, and I was so happy to see them again. We talked, and Danna said that she noticed that Ex was really miserable to me, and I told her that it was over and that I couldn't stand him touching me. She said that was obvious. I couldn't tell her why, though. I was putting so many pieces together, and it was driving me crazy at times. Fortunately for me, since they were back, they occupied Ex's attention with playing board games and tiring him out, so he had to take naps.

While he was napping, Danna and I would go for walks and sit out on the boardwalk and talk to everybody. We had so many laughs out there. Seeing people smile was a gift from Heaven above. I knew I was never alone. At night I'd wake up between 3-4:00 o'clock, and so I would pick up a cup of coffee and then go down to the truck and just sit there and listen to music.

As February went on, Ex got continually worse. He couldn't walk 20 feet without practically passing out, so I asked a friend what I should do. He said to call our son because Ex looked so awful that if anything should happen to him, our son would never forgive me. So, in the meantime, I called Doreen, and she was awesome. She got a plot for him, looked at all the details of the funeral and the cost, and I ran everything by Ex, and he agreed to it all. He even agreed to the service. He did not want a long, drawn-out funeral; just a simple, short one. So I called Pastor Doug, and he was very helpful.

A couple days passed by and I thought of what my friend had said, so I called Lloyd and told him, and he said he'd come right away. I asked him not to tell Beatrice or the kids because I wanted him to see his dad first. I knew Ex was in a dark place, and possibly going to end it. But, when I told Ex that Lloyd was coming, all hell broke loose with looks to kill. It was so bad that I didn't even want to be there by myself until Lloyd arrived the next day. Relief at last!

When Lloyd saw his father, it didn't take him long to figure things out, but surprisingly, the next thing I knew, Beatrice and her family were there, along with Lloyd's boys except for Jacob. He planned to come the next day, and of course, when Jacob arrived, Ex lit up like a light bulb. That made his day or weeks. Jacob was very attached to his Papa, which was nice to see. I saw the love of the grandkids, but inside I knew it was going to hurt them. But I didn't know how, what, when or where.

I had reserved some rooms for my dear friends from Lafayette. Lisa and Kayla were coming, and I told Lisa some things because she'd been a friend for several years, but she had recently lost her husband to cancer, and I had lost a good friend when Thomas died. It was so sad. Now we were getting ready to say goodbye to someone else.

Chapter 21

A Small Crack in the Wall

Beatrice knew how to stir up the pot. She said I was a social butterfly because I was out talking to everyone. So, of course, Ex agreed with her and said that it was what I did best. I responded by saying that it's called social skills. How soon he forgets that it's what I do all the time so that I don't have to spend time with him.

This time, though, he knew it was over between us. He had blamed me for all of his affairs over the years, and he reminded me of that again with his recent visit to the local hookers. My daughter didn't know any of what went on, but I remembered, trust me, and he reminded me again before the kids came.

I thought that now Lloyd was there, I could get some rest, but Lloyd got up the same time that I did, so the both of us would get some coffee. Some nights he'd wake up first; some nights I'd wake up first. He heard his father choking and gagging all night, as well, and he couldn't sleep.

When Ex would get on my nerves, Lloyd would tell me to go for a walk. Within one week, Lloyd and I tried to outdo each other; I walked 42 miles, and he walked 45 miles. I still think he cheated, but little did they all know that walking did not clear my head. In fact, it was filling up with more and more memories of the past. These memories were beginning to help me understand a lot of things.

I talked to the grandkids about when older people die, and I told them that we don't know when or what, but to enjoy the time they have with him, and to make it a farewell fun time. I had the best time of my life with the grandkids as I taught them about life. We walked along the ocean and got little trinkets, but the volleyball was the greatest thing. I surprised all of them with how athletic I was, and I could laugh. Seeing their faces warmed my heart. The people in the motel and along the beach said that I should be so proud of them, that their good manners and the respect for their Nana were unbelievable.

The week was getting hectic with the cooking and cleaning, and so I said, "Screw it. They can look after him." So I spent the time with the kids. Inside I knew what my life was about. I remembered the big kids and the grand ones.

Then came my birthday, and for the first time in ten years, I got to celebrate with the family as well as with Danna and Bill. The year was 2016, and Danna had recently retired, and so she and Bill came to Myrtle Beach for a vacation. But what a disaster it turned out to be! I wanted to choke my daughter.

I was sitting on the couch with Danna and Bill, and I opened the first gift. It was a beautiful necklace, and then the second gift was an eternity bracelet, which I assumed was also from the children. But then Beatrice quickly budded in and said that it was from Ex. Then she glared at me and with a sharp, nasty tone, asked me if I knew what eternity meant. I wanted to choke her.

"Yes," I said, "I do." I looked across the room, and Ex's evil eyes were just boring into me. Then Beatrice wanted me to give him a kiss as she was trying to take a picture. I gave him a quick smack, but that wasn't good enough for Beatrice. Danna saw my dislike but gave me a look as if to say, "Do it again."

So I had to do it again. I threw Danna a look that said, "Who asked you?" Then I said, "Okay, what are a few more moments of pretending." So, I threw my arms out and gave Ex a big kiss. Afterward, with a fake smile on my face, I asked, "Is that good enough for you, Beatrice?"

Immediately after that, I went outside for a smoke to get his disgusting lips off of mine. Beatrice's partner followed me out, but I didn't know at first. I just wanted to run and cry. So there I was, on the boardwalk and Beatrice's partner popped up behind me and said, "We have not been listening to you, Marjorie. Please don't give up."

Tears rolled down my face as I told him, "I can't do it anymore." I couldn't reveal things to him yet. I was putting more and more pieces of the puzzle together, and I felt as if all the angels were there protecting me, including a friend that I met who was telling me to call Lloyd. Angels and spirits have been with me all the time. It's hard to explain, but I can always feel it.

It was time for the kids to leave, and they were all crying. How could I comfort them? I did what I could, but I couldn't do anymore. Jacob said that he would be staying back for another week, and be with his Papa the whole time. That was great with me. So during I left them all alone as I did my aerobics and then went for a walk to be alone with Danna.

The day Jacob left, though, I was upset—really upset. I went running out when he left, crying my eyes out. My friend asked me if I was okay and I said yes. But then I ran out and walked. I had watched my oldest grandson cry, thinking that he'd never see his Papa again, and all this time that creep could have said, "I'll be okay" and "See you soon."

Watching my grandkids hurt was a stab in my heart and soul, and so to deal with it, I just walked. A few minutes later, as I walked alone, I got a phone call on the cell from Richard who asked if I was okay. I said I was and thanked him for caring.

After Jacob left, it was just Lloyd for a week. I was sitting on the bench on the boardwalk, looking at the sky and the ocean. My friend Richard came by and asked if it was okay to sit beside me, and I said, "Sure." I saw the expression of concern on his face, and after a minute, I said, "You know what? My job is done. My grandkids are old enough now to handle things."

When I said that, I felt as if the biggest load had been lifted from my heart, soul, and brain. Friends help to open the walls around your heart and soul, even if it's just a crack. But that crack was a new beginning of a new life that I knew I would have to deal with. To what extent, I was not sure.

Chapter 22

Breaking Down Walls

Lloyd stayed behind to spend some time with his dad, and everyone else returned home. However, during the March break, Lloyd's girlfriend and her two small children came for a week. I enjoyed their visit, and for a few more weeks I was happy because I could see her and the kids again. We spent time together in the ocean and in the pool, and sat around and talked. We had a good visit.

Soon it was time for us to pack up and head back home, and I wanted Ex away from me as soon as possible. So I told Lloyd to book him on a flight because it would be too strenuous for me to drive with him all the way home. On top of that, I said that it would likely not be safe for him to take that long drive. The truth is, I just didn't want that man around me anymore. I could barely stand to see him at times during our stay there, let alone tolerate being alone with him for that long drive back to Ontario.

So, Lloyd told his father that he'd book a flight for him, but Ex argued that he would drive. When he saw me, he said that I could drive until I was tired and then he'd drive. Well, that's when I blew up, and we were fighting again. As usual, Ex threw all kinds of garbage in my face about how it was my fault that he was the way he was. But his ugly words didn't bother me anymore. So I told him, "You will never drag me down to your level. You are history!" Then I turned and left him alone with his jaw dropped to the floor.

I was furious! I was not going to drive with that man, and that was final. I went to Lloyd and told him to book the first flight home now. "I don't care how much it costs, just get your father on the first flight out of here!" So, Lloyd booked the flight, but it wouldn't be for five days. So, I had to put up with Ex for five more days. Thankfully, though, Bill and Danna were still there. They helped me to stay sane and not explode.

Shortly after that, Lloyd left, and I slept in the spare bedroom where he'd been staying. It was so much more peaceful than being in the room with Ex. Yet, it still was too close to Ex, as far as I was concerned. I wanted way more distance between us.

I continued to rise early, get my coffee and sit in my truck. I loved to listen to the inspirational channel because it played beautiful Spiritual music, and that music soothed my soul. Some mornings, I would be all alone and then notice that Ex was standing about 30 feet away, leaning against a garbage can. He would be glaring at me with looks that the devil would just love. It creeped me out at first, but amazingly, it didn't take long for me to stop being terrified of him like I used to be. He didn't scare me anymore.

Things were changing. I was beginning to learn so much from the past, and I had to focus and put it all in order. I remembered that one doctor told me my brain was a computer and that my memories are all in storage. He said that maybe one day something would trigger them all to connect. I had clung for years to the hope that this would happen.

He was right because slowly things were coming out of that storage. When I went to church that week, I felt at peace. I felt God's Spirit all around me, and I felt stronger and more able to deal with whatever it was that was waiting up ahead for me in life.

Finally, with the help of God, and of Danna and Bill, I got through the week. I had survived it and made it to the day that I could get Ex on the plane. As we left him at the airport, I told him that he was staying with Beatrice, something that I knew he would not want to do. "Get to know your daughter and her kids because you never wanted to know her when she was growing up. Now is your chance."

His mouth dropped open, but he couldn't argue; he couldn't refuse. He was no longer in control. I was! So, I left him there stunned, and then turned and walked away. It felt so good. When we drove away from the airport, it felt as if Heaven had unwrapped my soul. Ex was out of my life, and I was free! The only burden I had then was trying to figure out how to spend the rest of my time there—without him.

I went out to dinner with Richard. He was such a good friend and a great support person for me. We talked and laughed. It was wonderful. He loved to listen to me as I went on about my memory coming back. I even told him things about before then, and his response was, "What a waste of all those years!" Yet, it really wasn't a waste, and I told Richard that. If it hadn't happened, then I wouldn't have met such good friends, but more importantly, I wouldn't have met him.

We spent a long time together that evening as we talked and shared. I felt good afterward because I could talk about things with a friend who didn't judge me; who wanted to be my friend in spite of it.

For the next few days, I enjoyed dinners out with different friends, and it was great being free to laugh and talk with them. But the one experience that got to me was that one of these friends could puncture a hole in the layers of the wall that I had built so high and so thick around my heart. I never dreamed that it could happen. It felt very strange, yet it gave me such hope and encouragement to keep going.

I phoned Pastor Doug and told him that I'd met this friend and that I believed I had some kind of spiritual connection with him. Then I asked him if this was normal. Pastor Doug said that God works in mysterious ways and that things happen in His timeframe. He said that God would send people or a special friend to show me the way. I told him that I had cried for three hours in the truck one morning because my heart, soul, and spirit had been touched. I needed to know if this was a real feeling or if it was just something messing with me due to all of the memories coming back.

But Pastor Doug assured me that God doesn't mess with unnatural feelings and that my feelings were very real. He said that I was struggling with them because I had kept my heart guarded for so many years. He said that His Spirit has hit the center of my heart, soul, and spirit and that it was because I had never given up my faith in Him.

Then Pastor Doug said, "God answers our prayers." That was a strong statement from him, and I told him that I was looking forward to seeing him when I got home.

Testimony #4

My name is Richard; some people call me Rich, others call me Rick. I wanted to write a few lines about how I met and came to know Marjorie.

I was working at Myrtle Beach in South Carolina last year, overseeing an ongoing Marine Project. One of my favorite places to view the work was from a beach that was across from the site, and that was between two motels. After a couple of weeks of me being on the boardwalk, I got to know many people. Most of them were just curious about what was going on, and some were just being friendly to strangers who wore hardhats on a beach.

I'd seen Marjorie a few times, often with a group of friends, but mostly by herself as she walked 90 mph along the paths. She was like the energizer bunny; she never seemed to get tired.

One day, I had just driven up and was talking to a couple of guys when Marjorie walked by. I stopped her and asked her if she knew of any barbers that were close by. Yes, I needed a haircut. I realized that I'd shocked her, so I introduced myself and then tried to convince her that I was not trying to pick her up. She laughed it off and then told me of one barber shop that she had noticed.

We continued to run into each other, but never really talked much, other than to exchange the friendly, "Hello." I left the project for about 40 days, and when I got back, Marjorie was one of the first people I ran into.

Most days, the project drove me crazy, and I found that her positive attitude really helped me. Plus, I was amazed at the questions she'd ask about the project and the reasons why we were doing things. Some of the things she talked about showed me the hidden intelligence that she had.

As the weeks and months went by, we talked more and more. In talking to Marjorie and getting to know her a little better, I noticed a few things about her that confused me a bit. Things like, when she was sometimes tired, she would slur some of her words. Or she would limp when she walked. Or how loud noises sometimes frightened her. She was always so reserved around me. I knew she was married, so I thought that perhaps she was feeling uncomfortable with me.

Our conversations were always about my work, or just about the beach in general. I know that sometimes I unloaded my work problems on her; I think because I found her to be a very good listener. As we talked more and more, we started talking more about our families. Soon, after that, she started to unwind a little and tell me a few of her problems. She also told me a bit about her accident.

When she described all she'd gone through and how broken she was, I was able to put together all the silent questions I had of the things that I'd noticed. One thing that impresses me is her "can do" attitude and how she is always going to improve herself. In the year that I've known her, it's hard to describe the personal things she's accomplished.

I've known friends with injuries like hers, but I'd never seen anyone that was able to overcome the physical problems with such determination, yet with so much grace. It's amazing that she had come to where she is today from where she was when she woke up from the accident. Like I said before, she never stops amazing me from day-to-day with her positive words. To have gone through so much and still have the heart for others just makes my brain spin.

One thing that I'm thankful for is that I was lucky to be around when some of her memories started to come back. We'd talk, and sometimes it was just flashes of something that didn't really make any sense to her or so I thought. She'd fight with her brain for days on end, bringing out all the dark things that had stayed hidden for so long.

And what was most impressive was that she didn't get down or cry or go back inside herself as most people would have done. She fought back within herself and could overcome the sadness and move on with her life. Her whole being is to improve her life and improve herself.

I am far from understanding her, and there is no way that I can compare her to anyone else I know, or have ever met. Her determination to look at the past and to improve her future is awesome. And those are her words, not mine.

She once told me, "I really want to remember all that I went through and all the bad things that happened, not so that I can get revenge, but to remember who my real friends were and are. And to use my bad past to improve my future." To me, that was one of the most powerful words that I have ever heard. And what made them so powerful was that I could see that she said it from the heart.

Marjorie is very blessed, and I'm blessed because I needed a haircut and asked a stranger if she knew of a barber.

...*Rick*

Chapter 23

Decisions

Then came the day when I had to leave Myrtle Beach and return home. Bill had gone with me the day before to get the U-Haul, and Richard loaded the motorbike onto it. Safety was important to him, and he even bought more chains to secure it so that my drive home would be a safe one.

I was going to miss my talks with Richard, and the whole time he was helping me, I kept thinking how much I really *would* miss him. He understood me. He understood about God and about God's Spirit around me. I knew that we were supposed to meet; just not the full purpose of it.

The day came to say goodbye to everyone, and it was very emotional for all of us. The motel staff was all teary-eyed as they hugged me, and the owner said that I was like family to them and had brought a bundle of joy to their place. That meant so much to me. So, without hesitation, I booked for the next year even though I had no idea what was ahead.

I left Myrtle Beach around 5:30 a.m., alone in my big truck, and pulling the motorbike on the U-Haul behind me. The kids at home thought that Danna would be going with me and driving, but I told them that I would do this myself. I needed to show my family that there was no more controlling me, that I was capable of making choices without them, which I had done all my life. They just didn't know it yet.

Leaving Myrtle Beach had been very emotional for me. For the first time in ten years, I felt it, and I just wanted to cry. I had to keep telling myself, "Get control of yourself, Marjorie! Look up at the stars and just go."

I had promised Richard that I would fuel up when I got to half a tank and that if I ran into bad weather, I would pull into a motel and wait for it to end before getting back on the road. I told him that I would be careful and drive safely. It felt so different and really great, actually, to have someone concerned about me.

The drive was good, and I made it to Pennsylvania. Looking back now, I remember that I had a blue tooth in my ear as I talked to friends who were calling and asking where I was. Whenever I got to rest areas, I would text them and keep them updated.

Finally, I booked into the Hampton Inn for the night. I was tired, but still going strong, and I was hungry, so I went to the restaurant. First I needed to get something to eat, and then I needed to get some rest so I could head out early the next morning. So far, things had worked out good for me.

As I was sitting and eating my dinner, I listened to some messages on my cell, and I was choked up with tears. So many friends were actually worried about me! I knew that emotions and exhaustion were causing a brain overload, so I went to my room to rest.

Doreen called. I didn't know what I was doing, but I told her that I was going to her place for my new beginnings. I thought that first I would stay a week or two with the kids to get them organized and help them deal with things. Then I cried and cried on the phone. My heart was opening up, and the tears would not stop for a good hour.

It was evening time in Pennsylvania, and when I went outside to have a smoke, I looked up at the moon and stars. It was such a beautiful night! That's when I found myself asking God how I was going to do this. "Please help me, Lord—and as always, thank you."

The next morning, I was driving north with the music playing loud as the sun came up. Then I turned the music off, and it hit me like a ton of bricks. "This is what you have to do, Marjorie. When you get to Niagara Falls, tell your brother the truth. Then when you get to Beatrice's, tell her the truth. Then when you see Ex, tell him it's over. Unload the bike. Jacob is leaving for Alberta, and he will need the help from his family. That's who you are, Marjorie. Do it for your grandkids; your last job of letting them go."

I put a smile on my face and said thank you to the higher powers.

Traveling up north the roads were good, but there was a snow warning out for the areas that were going through the mountains. I stopped at Corning and filled the truck with fuel, checked the bike and asked the serviceman how the roads were going into New York. He said they were good for now, but that a storm was brewing for the afternoon.

I wasn't too happy to know that I'd be driving into bad winter weather. But I took a few minutes anyway and answered some messages from friends who had called to find out how I was doing.

Twenty-five minutes later, I was back on the road, and it was almost instantly that I was driving into a heavy snowstorm. I could barely see two feet ahead of me, and before I knew it, I was right behind a snow plow. That was my guide, and I stayed with that plow, going 15 mph. I didn't care. People would pass me, and then I'd see them up the road in a ditch.

It was reassuring and comforting that Richard kept calling me. I reassured him that I was okay and that I was driving behind the snow plow. It was about a 15-20 mile stretch of blizzard-like conditions, driving with my four-ways on, constantly looking behind me for other car lights. But lights were barely visible on the other vehicles that were on the road. Yet, I felt safe because I knew that so many angels were watching over me on this journey.

Finally, I made it to the border. Welcome to Canada! After showing my receipts at the border for the things I'd overspent on, my American dollars were converted into Canadian dollars. Finally, everything was finished there, and it was time to get back into the truck. Then I wrapped my coat around me after being reminded that Canadian winters are cold. A little while longer and I'd be home.

Richard called again, and I smiled told him, "Yes, I made it."

Within 15 minutes of my brother Dylan's home, I called and asked him to get me a Tim Horton's coffee, and when I got there, I hugged them all and was happy. They noticed that something had changed, so I told them that my memory had come back and that I would be leaving Ex the next day. Charlotte told me that I could stay with them anytime to let it all out, cry or whatever.

I felt so happy. My first decision was made on *how,* and so now, my next would be on *what.*

Chapter 24

The Ending

As I drove through Toronto, I called Doreen, and she was home so my first stop would be to her house so I could drop my stuff off. She gave me a huge hug and the key to my first home. I was in awe! After a while, I took a deep breath and headed out to Beatrice's home. She and Jacob were both downstairs, and we all hugged. Ex was there, as well, and so I put my hand on his shoulder and told him rather dryly that he was looking much better. I was about to sit down when Beatrice asked me if I'd forgotten about her dad. No, I had not forgotten. Then I asked for some privacy to speak with him alone.

Before they went upstairs, though, I told them that I had driven by myself and that Danna had not come with me. Beatrice looked a bit stunned, and then I told them that I was quite capable of doing things. Jacob said that it was a long trip, and I said with a peaceful smile that it wasn't and that I enjoyed it. I told them that it's amazing when you have angels watching over you and faith. So they went upstairs after that, and Jacob went outside to unload the motorbike.

Then it began. I told Ex that I was glad he was breathing better, and then reminded him that he knew our marriage was over in Myrtle Beach. My life would be moving on without him. I asked to have use of the truck because it made me feel safer to drive than cars did, due to the fears brought on by the accident. He knew that, and so he agreed that I could have the truck.

Then he made a comment that caused me to stop and stare at him. "I thought we were getting along so well." I was stunned. It took me a minute to get the words out, but then I let him have it, "You know it's over. I told you it was over. I also told you that no one would ever again hurt me like you did. I remember things now. I remember everything!"

I could feel his eyes boring through me as I turned away and walked out of the room. I didn't care. I went outside and helped Jacob unload the bike, and wouldn't you know it? I couldn't find the stupid key! Beatrice's son unloaded the bins, and Jacob asked me how I got the bike loaded onto the U-Haul. I told him that some friends helped me. Then I hugged the grandkids and told them that I had to get rid of the U-Haul, and so I left.

I dropped off the U-Haul and then took the truck through the carwash as it was so dirty from the long drive home. Then there it was—the key. I phoned Jacob and asked him to meet me outside of Tim Horton's because I'd found the key. We laughed when he said that he was already at Tim Horton's, so I drove there and rolled down the window and gave him the key.

As I looked into his sad eyes, I knew that he already knew. So I smiled at him, and I said, "I love you, Jacob, and don't you ever forget it!"

Then I drove away and returned to Doreen's, also my new home, and I unloaded the rest of my stuff. Afterward, I sat outside with my cup of coffee to get a little rest, but that was short-lived because my phone began to ring. It was Lloyd. He was furious and demanded to know what was going on. So I told him, "Lloyd, it's over. Your father knew it Myrtle Beach, so he's not surprised. Besides, my children are both divorced, so don't you judge me!"

Then Lloyd asked me if he could come and see me the next day and I told him to come. "I'll explain it to you in person, but not on the phone." He had to get back to his meeting, and so we said goodbye, but not before I told him that I loved him.

When I got settled in, I decided to go over our bills, and was shocked at how they had piled up! Something inside me was beginning to open up, and I realized that we couldn't afford any of the stuff we owned. We had bills for everything and no money to pay them with—bills for lawyers and doctors, and for things we'd purchased. That's when I realized that it was me who'd signed for everything and that it was me who was responsible for paying for everything.

I used to be an office manager, and I used to clearly understand budgeting, and the process of spending and earning and balancing the budgets. But that was before the accident. So I sat there in awe going through the bills, and I discovered that without even realizing it at the time, I had signed for things and promised to pay bills. What made me so angry was that I'd signed these at times when I hadn't even a clue how to manage our finances.

Then the numbers began running in my head. Why couldn't I solve this now? Why couldn't I balance these things now? Confusion and anger set in, and the only solution I had was to sell everything! Sell the RV. Sell all of our possessions. Sell the lots—my beautiful lots. I closed the books and headed for the door, tears streaming down my eyes, "My beautiful lots."

The only way I could even try to grasp what all was going on was to go for walks—and I went for a lot of walks throughout my healing process. I tried hard to put the pieces of the puzzle together, but it was too difficult. I would look up at the heavens and say a prayer, "Lord, please protect my family."

I could not understand how, or why these things had happened and were even still happening. Sometimes as I walked, the tears would just flow down my cheeks. I felt lost and deserted and so helpless; yet, because I was able to just walk and talk to God about them, I would end up feeling so rewarded inside.

Dr. Corless had told me that I wasn't to jog yet, and I remember arguing with him and saying, "Don't tell me that." I'd try to jog anyway, and managed about 20 steps at a time. I might have looked hopeless to him and to everyone else at that time, but I would fool them all because I knew that one day—I didn't know when—but one day God would let me know when I could jog, and I *would* jog.

Chapter 25

New Beginnings

That night at the dinner table, Doreen pulled out a gift for me. It was a Pandora bracelet with a butterfly on it. I loved it, and it meant a lot to me because butterflies represent new beginnings. Doreen was supporting my new beginning. I told her that there were going to be nasty times ahead, but that I could handle them. She watched me and noticed a lot.

Lloyd came over the next day and just stared at me. "Okay, Mom, what's up?" So I told him that my memory had come back—all of it! I explained that it was a bit wild at times, but that I'd remembered enough to know what I was doing. Then I asked him if he remembered the beatings that he got as a child, and how I would intervene and how I took the swings that were aimed at him. I went on to tell him how his father had spent our entire marriage having affairs, even before the accident, and that I'd had enough.

I told him that I was no longer afraid of his father. I was no longer afraid of anyone. I went on to tell him that I knew about the neighbors, and how he'd hung around with someone who was supposedly a friend to both of us, and that I knew what they did together, how they were both guilty.

Lloyd watched me, and I knew that he was ready to either criticize me or defend his father. So I jumped on him first. "Don't judge me. You have been divorced twice."

Then he became quiet again, and so I told him about Beatrice, and how her father didn't want anything to do with her when she was born because of her handicap. I threw in that their father told me that if we divorced, he didn't want to have anything to do with Beatrice. Then I told Lloyd that I would also tell her the truth if she wanted to talk to me.

Lloyd needed to know that the reason I stayed this long was for the grandkids. They were of great concern to me because both of my own children were going their separate ways, and also because of each of their own troublesome marriages. I told him that his life now is because of the verbal and even physical abuse that he got as a child and that I had been faithful to his father all my life. I made sure he knew that the only reason I stayed in this marriage was that I was scared for the safety of him and Beatrice.

Lloyd was a bit stunned, and he didn't say a lot. But I had a lot to say. So I told him that I wanted everything sold. "Your father has agreed that I can keep the truck because I feel safe in it, as I have surgeons that I have to see, all in downtown Toronto."

Then I asked him to explain to the boys whatever they needed to know, and that I would not lie to them. I have never lied, and I didn't plan to start then. When Lloyd left that day, the message to sell everything was on his mind. I had made it clear that everything had to be sold, and even though he said he'd help, I know that this was something he was not expecting.

The next day, I visited Dr. Corless, and he was happy that I had made it home. "Yes," I said with a smile. He looked back at me and told me that I looked really good for the very first time. So I told him that it was because my memory had returned and that my marriage was over. He said that it was a gift from God. I knew it was!

Yet, there was still so much circling around inside my head, and I had to get things done. When I told him of all I'd been through with Ex, he insisted that I get blood work done, and then he said that I should have had it done years earlier. Then I told him that I couldn't go back; I could only go forward, and so I would do the bloodwork now. Dr. Corless gave me a hug and said that he knew I'd be okay, that friends had helped me with walking. He also said that my husband was responsible for his own actions, not me.

The next day, I called Jacob to have breakfast with me so that we could talk before he went out west again. I wanted to tell him that I would only talk to him about things that have happened since the accident, not before. I wanted him to know that before the accident is their father's and Aunt Beatrice's life.

Jacob was sitting in a booth when I got in the restaurant, and he appeared as if he had a huge load on his shoulders. I walked over and gave him a big hug, and said, "Thank you for coming," and then told him that I loved him. What I would tell him would be the same story that I would tell all the grandchildren. I wanted them to know my story, and I promised to answer all their questions honestly. "This is the only way that I've ever done things in life, by honesty."

I went on to explain to him that since the accident, I had been very sick, and Jacob remembered that I was, as they all did. I told him that I didn't have much hope in the doctors, but that I knew one day I would be okay. I also reminded him that I'd always had unconditional love for all of my grandchildren and that I loved each one of them so dearly.

He watched intently as I went on to tell him that during approximately the first five years, there had been a time when both of my children were getting divorced. My heart had been for the grandkids who were all crying and upset with the stress of it all.

Yet, I had so much to be thankful for because it was the kids that helped me to reconnect my math by teaching me to use the calculator. I said that through that, I was able to give them the times tables. I told him that when the kids weren't around, I worked and worked hard at everything so I could learn to walk, talk and even go to the bathroom.

I told Jacob that his Papa had always been unfaithful to me in a huge way. "So, I made a choice to protect you and show some stability in my grandchildren's lives." I told him that his Papa knew in Myrtle Beach that it was over between us, and now I know for sure that my job was done. The grandkids were all adults now.

We talked about the meaning of love. I told him that you can say, "I love the look of the ocean or of a dog," but being in love is very different because then, you love from your heart, soul, and spirit. I told him that then you're willing to sacrifice whatever it takes for that love. Then I said that there was a lot of history that I couldn't disclose to my grandchildren because it does not concern them. "Betrayal is huge, and he did that to me."

Jacob looked at me, and his face was sad, but he was holding it all together. I asked him if he had any questions, and he asked if there was another man in my life. My answer was, "No. I have never been unfaithful to your Papa ever in my life, and that is the truth." Then he said, "It's hard, Nana." He didn't expect to hear this, and he said there are always two sides to every story. I agreed with him that there are.

But then it became easier to tell him that when I saw them in Myrtle Beach, I realized that they were all grown up and that my job to protect them was finished. I let him know that it was during that time that I was happy for the first time in a very long time.

No more pretending. No more fear. It wasn't going to be easy, but it was time for me to move on. I reminded Jacob and all of them that at Myrtle Beach I saw us as one big family that had finally grown up. Now they could each live their own lives.

There was a lot of emotion that day, but I gave Jacob a big bear hug and a big kiss, and I told him that I loved him. Then we said our goodbyes, and there was peace in my heart because I knew that he would be okay.

Chapter 26

The Final Straw

The next step in my plan was to tell the other two boys and Lloyd. I took them back to the same restaurant and started the talk all over again with them. Lloyd came first, and we had a cup of coffee together. Then the boys came, and I asked Lloyd to please go to another table because I wanted this discussion to be just between them and me.

Marky laughed and said, "Yay, I love it already." Then before Karl even sat down, he said that he knew why I did it. I was stunned. "Did what?" I asked him. He just answered as if it came naturally to him. "You did it for us all, those years you gave up for us, Nana, and so don't deny it."

I almost fell over. They were smarter than I'd given them credit for. I told them that I'd only explain things from the accident on, not before. I mentioned the words *betrayal* and *adultery* and went through the word *love*. Then Marty said with a big grin on his face, "Nana, you never cease to amaze us! You're still teaching us and will always teach us."

After that, I asked them if they had any questions, and just like Jacob, Karl asked if there was someone else. So, just as I told Jacob, I said that there was no one and that there had never been anyone in my life except for Papa. Then I told them that I knew Papa had often told people that I'd been unfaithful, and that I had fooled around with every man in the U.S. "But that's a lie. I have never been unfaithful to him."

Then one of them said that they knew it was the other way around. I was proud of them for defending me, and then they said that I had taught them so much. So I asked them what they'd learned from me, and their answer brought joy to my heart. "Respect, manners, work ethics, honesty, love." They said they wouldn't be here today if it hadn't been for my sacrifices.

That made me very happy. Hearing their answer was the best reward any Nana could get from her grandkids. Then I told them that this situation was between their Papa and me and that he is and always will be their Papa. I told them that they were to always show respect to him no matter what and that by doing this, they would be the bigger person.

Then we talked about other things, and I told them that everything had to be sold and that bills had to be paid. I also explained that I had a lot of surgeons to see in Toronto and that surgery would be booked for me. I invited them to come and see me anytime at Doreen's home because it was now my home.

When we left the restaurant, I really felt good because I was finally able to get the truth out there to my grandkids. They understood it, and they accepted it, and that was so encouraging.

But I still hadn't heard from Beatrice or from her kids. I thought that I would need to give them time, and so I gave them a few weeks. Then I called Patricia and Sylvester and told them that I wanted them to have the windmill and flagpole. I knew that my mom would have loved it and that they would take good care of them. So they came and took them away, and then shortly afterward, Lloyd and the boys came with Ex. I told him that we needed to do this fairly and keep the grandkids out of it. I reminded him that this was between the two of us and that it's up to Ex to do that, as well. He agreed, and so I kept the truck, and he kept the RV.

Soon it was April 14th, and the results from the bloodwork came in. It was not what I had expected, not even what I would have guessed, and the results devastated me!

I had Herpes 1 and 2. I was in shock! So much so that I went to another clinic and had more bloodwork done just to be sure. It cost me $170, to have it done, and the blood samples were sent to British Columbia to double check due to my thyroid issues. I was so upset and immediately got the forms from city hall to file for divorce.

A few days later, I asked Ex to meet me at the coffee shop. We sat down, and I gave him his stuff from the safety deposit box. He looked bewildered, and then I told him how angry I was that he had given me Herpes. I demanded that he was not to contest this divorce for all he'd done to me. Afterward, all he could say was that he was sorry.

Sorry! I was livid! He was unfaithful and gave me Herpes and all he could say was sorry? I felt so dirty inside. Then I remembered all the yeast infections and cold sores that I'd suffered through for all those years. He had been with whores, and I, his wife, got Herpes from it. This was the end of him. Yet, it was just the beginning of an emotional roller coaster ride.

I called my brother and asked if he knew of a lawyer because my will was to be changed immediately. My name would also be changed back to my maiden name. I didn't want anything that belonged to this man. Before long, I was on my way to Niagara Falls, and I got my will changed and my name notarized. Then I filed for divorce.

Soon I'd undergo more surgery, and neither Ex nor Beatrice and her kids would have anything. Lloyd's boys would get whatever I had left, and so I visited them when Trish was there. I told them about the will and that I'd changed my name, and told them what was expected of them.

The boys just looked at me funny when I told them that I was proud of them. I couldn't say a lot because it hurt too much, even for me. After I left them that day, I went and changed banks and then prepared myself for surgery.

When I saw Lloyd and told him, his response was, "He just keeps on giving, doesn't he?" So I asked him if he would look after my stuff and just split everything fifty/fifty. That took a toll on me in more ways than one.

I anxiously waited for the BC report right up until May 16th, which was my surgery date. In the meantime, I had an endless list of things to do. With the help of Lloyd, Doreen, and the boys, we emptied the trailer, and then Lloyd drove it to a dealer to be sold. I gave most of the stuff to the boys, some to Lloyd's partner and to Lloyd. Afterward, I was totally exhausted.

Lloyd was working with one shoulder, and I had a torn shoulder, and patience was running out. Then I saw Lloyd and Karl trying to get the small fridge into the truck, and I just lost it. I pushed them aside and did it myself. We just piled the rest of the stuff into the truck and took it to Beatrice's. I told Karl to drive the truck, and I'd drive his car, and that's when Doreen mentioned that I can't drive the car.

Words were flying, and I told them that no one was going to tell me what I could or could not do. Silence crept in, and we all left for Beatrice's. I hated driving the car, but it's amazing what you can do when it feels as if the sky's falling down on you and you need to take back the control.

I made it to the boys' home, and Tricia greeted me and said, "Way to go!" We ended up having a nice visit, and I was able to calm down a lot, and as well, we restored our friendship a bit. So, some good things came out of the day.

Every time I had to go to Toronto, I would continue on my way to Niagara Falls and stay at my brother's. Lloyd was selling stuff, and the boys were working hard to help him. Ex had to go to Service Ontario to change the ownership of the truck into my name, and he was not happy about that at all. But he got a car given to him by his sister, so he had a car.

I was very edgy as I waited for the results from all the bloodwork to come in. I had to force myself to focus because my head kept spinning like crazy at times. At night, I'd listen to country music to relax because I didn't want my brain to crack up. So much new information to take in! If it weren't for Doreen and Philip, I don't know what I would have done.

Chapter 27

The Last Closure

Mother's Day came, and it was rough for me because my mother wasn't there. What hurt me the most, though, was that I was not wanted by my own kids. Nothing new. I just had to learn to live with it, and that wasn't easy. But my grandsons called and one granddaughter texted me, so that was good. I ended up going with Doreen to Montreal to visit her mom, and I had a good time.

One day shortly after that, I got texts from my young granddaughters that said they wanted to see me. So I picked them up from school on their lunch break, and we went to a restaurant. The first thing they did was compliment me on my new purse and Bluetooth. I looked at them and said, "Okay, enough is enough." Then I explained the same thing to them that I had to the boys earlier. Right away, the oldest girl said that while visiting their dad, he had told them that Papa had been unfaithful. I told them that yes, it was true.

Then I told the girls that I wanted to be honest with them, but before I got too far, one of them asked me if their Papa had ever been mean to me before the accident. I told her this conversation was only from the accident on and not before. Then another one asked if I'd had an affair with men. How did I know that was coming? Then I was asked if I was looking for a man now? So I told them all the same things that I'd told the boys. Then I said that whatever happens in the future, I don't know. Only God knows. Then we finished our meal, and I took them back to school.

I thought I was ready for everything, but I should have known that my daughter would hold a granddaughter against me. It was her birthday on May 3rd, and she was turning six years old. I didn't hear a word from her, and I couldn't see her turning six. It didn't seem fair to me at all, and I was very upset about it.

So then I got her phone number from a friend, and I called my granddaughter. I wished her a happy birthday, and she was polite, but then became quiet and handed the phone to her sister. Her sister told me that her birthday was yesterday, and my heart fell to the floor. I felt terrible that I was late. But I tried to sound cheerful and said that it was better late than never. However, the truth is that it hurt in my heart and soul because I did not like that I had missed it.

I had to drive to Niagara Falls again, and I fought to keep focused. The brain was spinning, and the pain in my head was terrible. I was terrified of suffering a setback from all the stress. I picked up my will and then went for fish and chips with my brother and Charlotte that evening. While there, I checked my messages to see if the lawyer had called because I was to see him on Saturday.

The lawyer hadn't called, but there was a message for me that I wasn't prepared to hear. The blood results had come from BC. It was confirmed—I had Herpes. I threw my phone down, grabbed my smokes and with tears rolling down my cheeks, excused myself and said I was going outside. "The test came back positive for both." My brother's facial expression was awful. He was angry. But I wanted to be the one to kill Ex.

I stood outside alone, and a million thoughts raced through my mind. I forced myself to focus, and then returned a few minutes later and prayed that I wouldn't lose my speech. I did not want this devastating news to set me back on the progress that I'd worked so hard to gain.

We ate in silence and then returned to their house. When we got back, Charlotte told me to cry as much as I needed—and so I cried, and I cried. She assured me that I was not alone and that I had family that cared.

In the middle of the night, I sat out in the truck and cried my eyes out. I wanted my mom. I wanted a friend, anyone who could help me. Charlotte was good to me, but she couldn't help me. No one could. I felt defeat slowly creep in. "Please, God!" I would never have believed that one person could cry that many tears.

My life at times seemed like an endless rollercoaster ride. So many issues to deal with; so many ups and downs. I had to get back to my plan, and the next step was to tell all of my brothers and sisters the whole truth. I needed to put some closure to some issues that were buried really deep. No more protecting anyone. I had worked too hard to quit or to give up now. God had given me the strength to keep pushing, and so that's what I planned to do.

The look on their faces when I told them was very sad, but they assured me that they just wanted me to be happy and that I would always be their sister. They all said that they wished I would have come to them sooner. But I told them that I couldn't as I had a duty to my kids. But now, they were old enough, and I was moving on.

I told them that it wasn't going to be painless, but it would be much easier now that I knew my family would still be there for me. I knew that the time had come for me to begin tearing down walls, little by little, and with my faith, I knew it could be done.

Yet, even in saying this, it had its moments.

Chapter 28

Shoulder Damage

May 16th, 2016 came, the day of my shoulder surgery. It was in bad shape, and it scared me. But I knew that like everything else, I would survive it. There was too much on my mind to worry about it, actually. The will was done, and I knew that there would be a major outbreak because of it.

Richard became a true friend to me, though, and he constantly checked up on me. This was the support that I wasn't used to and that I never expected. But I loved it. Doreen was amazing, too; she never left me. She even explained to the doctors that I could have a seizure if they didn't explain to me exactly what they were doing during the surgery and that it was because I was a brain injury survivor.

After that, the room was flooded with doctors. I had to keep telling myself to focus. Focus! My physio and Tao Chi instructor had taught me to go inside myself and focus. This became easy for me when I had to learn to ignore Ex.

Doreen did not leave my side while I was waiting to go into surgery. I wasn't used to that, and it felt so strange; another emotion that was confusing me because I had always done it by myself. Now, there was a person with me who cared. Wow! Was this normal? I was called tough because I could climb that mountain alone with my faith, but this time I had support, and it made the climb so much easier.

Finally, I was in the surgery room. I could feel the needles going into the base of the brain and down the spine. I focused on where all the feelings were. I called it *prickliness* going from one place to another. I felt it from the front to the back and through the whole shoulder blade. This was all new to my brain, and I had to keep following where it went and know when it was gone. It felt so strange.

Someone was telling me to move my fingers, and of course, I was moving them. But then I looked to where I had put my left arm, across my belly, and it was gone. Then I looked to the left and there it was, all stretched out. That was weird, and I said so, only I used a swear word without thinking, and then said, "Oops," and the doctors just laughed.

Then the mask went on my face, and I had to breathe in lots of oxygen. But I quickly took it off and told them to just knock me out. They laughed again and said I had a sense of humor. We tried again, and I asked God to let them do their thing and to help me recuperate. That's when I began to relax a bit and forget everything.

The next thing I knew I was waking up! It went by so fast, and it seemed so easy. But I wanted to get out of there. I told one nurse that I wanted to go home right then, and she said that I couldn't go yet, that I'd have to stay for at least an hour since I'd just had major surgery.

I looked at her and said, "Nurse, I have had so many things done to me, so trust me, I am fine. I can climb this mountain, too, so just get me to the next room so I can get ready to go home." She tried really hard to persuade me to stay and rest, but I didn't want to, and I let her know it. So, I won that case, and 15 minutes later, I was off to the next room. This group of nurses, however, was a bit harder to persuade, but I still did it.

Then I got to the last room, and Doreen was waiting there for me with a nice cup of coffee. She left me there while she went to get a wheelchair for me. Meanwhile, a male nurse came in to help me get dressed, but when he saw me, he said that he'd go and get a female nurse to help me. So I just laughed and said, "Listen, young man, I lost my dignity a long time ago." So, he stayed and helped me to get dressed.

My brain was racing, and all I wanted to do was get out of there. I couldn't move my one arm as it was limp from surgery, so the male nurse helped me get dressed, and he even did the buttons up for me. I was laughing and asking where Doreen was with that wheelchair. Then, low and behold, she came through the door and rolled one in for me.

So I climbed into it and was ready to go, but was told that I still had to sit and wait ten minutes because while checking my vitals, it was discovered that my blood pressure was low. So I told them not to worry, that I had a fix for that. I knew that if I had a smoke and my coffee it would bring the pressure up by ten points. So I did.

Doreen waited so patiently for me and told me that all the family and friends had been texting me and sending me hugs. That was so encouraging to me, just knowing that my new family and friends cared so much. So we said goodbye to the hospital staff and headed to the car, and then we were soon back at home.

I wasn't feeling too bad then, but I knew that once all the meds wore off, I would be in pain, and in even more pain once I started to do exercises with the arm. But I also knew that I would do those exercises anyway. It was not my character to skip over that stage just because it would hurt. Then I was told that I needed to return in ten days to get the stitches taken out. That was the easy part, and I knew that I could do that.

165

However, it wasn't easy getting to that point because the very next morning I had to take the sling off and start exercising. Doreen had made everyone's favorite breakfast, and we sat at the table and enjoyed it. But it came as a huge surprise to the boys and to Doreen when I left the breakfast table and started the exercises on the left shoulder. To me, this wasn't an option, and so I pushed beyond the hurts, but it paid off.

The doctor took the stitches out ten days later, and when I showed him what I could do, he was amazed. He said to continue with the exercises, but no lifting at all. Then he said, "I mean it, Marjorie! There was a lot of damage, not just two tears, but floating bones and a lump on top." How I had put up with it for so long was amazing to me, and doing everything that I'd done was even more amazing.

My answer to it all was faith. When your brain isn't working normal, you just tell it you're doing it anyway. I could handle that. The doctor laughed when I told him this, but was quick to warn me again to not lift anything and to just do my exercises for the next five weeks. I told him that I'd be careful not to lift anything, and I really was going to try. Besides that, I had lots of other stuff to do to keep me busy, anyway.

Chapter 29

Family Memories

I left the doctor's office and continued on to Niagara Falls to see my lawyer. I needed to start work on the separation agreement right away. Ex had decided to take over the banking and threatened to cut off my medical assistance, and everything else that could make my life miserable. Well, that wasn't going to happen!

I had lost my temper with Ex about three weeks earlier during a telephone call when he demanded to have half of my personal finances. He wanted half of my pension, which was my RIF and which should have been $90,000. But it was now only $38,000 since I had to cash it in to cover medical expenses after *he* spent all of the insurance money from the car accident for his own expenses.

Regardless, he kept insisting that he was entitled to half of everything and that he was entitled because of all he'd done through our life together. And that's when I lost it!

Half of all he'd done for me? Was he out of his mind? He had been unfaithful throughout our marriage! This man had given me a sexually transmitted disease! He'd spent all of *my* money on his own desires, and now he's saying that he wants half of what he'd done for me? He could take the whole disease, after all, he'd earned it!

I could not contain my words, and I let him have it. I screamed at the top of my lungs, "How dare you!" Then I ran off a lot of choice words and ended with telling him that famous two-word phrase that was becoming a natural one for me every time I talked to him.

Doreen was upstairs in the shower, and she could hear me through the sound of the water. She came downstairs and tried to comfort me, but I just wanted to be alone. So I went to my room and cried for hours afterward. Then I swore that I would never again allow myself to be lowered to his level because it hurt me so much to be like the devil.

But then I began to think about what he'd said about the RIF, and it triggered light bulbs to go on in my head. His sister worked in the bank and had looked at my account. So I had to wonder, "How did he know how much money was left in my RIF?"

Family and friends from Canada and the U.S called quite frequently to see how I was doing. It was so nice to talk to friends—people who just wanted to be a "friend" to me and not take anything from me. Their support was what I needed. It helped me to see that not everyone in my life was out to get me; some of the people in my life really did care, and it blessed my heart so much.

Five days after the surgery, I drove to Marmora to talk to my family. I had already talked to them on the phone, but not in person. First stop was to the grave site to see my sister Audrey and her husband, Dan. I couldn't contain myself, and I cried with so much emotion when I realized that I hadn't remembered Dan dying three months before the accident. Once I had settled myself down, I got into the truck and drove to see Leon.

He's the minister in the family, and I had always teased him. We got along well, but today was different. I told him about the disease that I have now and how that changes my life forever. He said that he knew Ex was cheating on me and that he wanted me to be happy and content with life. He said that when one door closes, another one opens, and I agreed with him.

This was a brother who carried a heavy load for many years. After the accident, he was always looking out for me and helping wherever he could. At the same time, he was taking care of Audrey as the battle with cancer began to win over her life. Leon never complained, never pushed us away, never criticized us, and was never ashamed of us. He was always there, and his love never changed toward Audrey or me. Looking back, I realize how blessed I was to have Leon as my older brother.

Next, seeing my sister Nene, I sat on the couch with her as we talked and cried and shared sister secrets. These secrets will never leave that room, but they will always be special to me. No matter how hard life gets, I will never stop loving them all. Nene was very fortunate and married the love of her life, and is so in love with him. She told me with heartfelt compassion, "It will happen to you, too, Marjorie."

My next visit after leaving Nene's house was to Patricia's and Sylvester's. That was a more comfy spot for me because they already knew everything. It was good to see them again. It was good to laugh.

The one place yet to visit was Audrey and Dan's old home. Their daughter Wendy lived there now and had often asked me to come and visit, but I had never been able to face her before. Today, I felt that I could, so I called, and she said she'd be home after school. So I drove to her house, and as I did, more memories began coming into my heart and soul.

Wendy's younger sister answered the door, and it was like a load shedding off of me as I stood there. Yet, as a memory of Audrey came to me, it brought me so much pain. I asked her to have a smoke with me so that I could relax, and she was crying as she tried to light them. There we were, both of us leaning on canes, and me hurting so badly with my one arm wrapped her shoulders. We stood by the sliding glass door and looked at the lake. It was so peaceful.

Then I remembered the day Dan died. The ambulance had just left, and Audrey and I both cried as she talked about the suffering of her loved one. All these years had passed by, and I had forgotten all of this. But God gave the memories back to me so I could get closure on all of it.

I needed to see their bedroom, and so Wendy showed me, but it didn't give off the memories of Audrey and Dan as I thought it would. It was Wendy's son's bedroom now, and it was decorated with joy, warmth, and love. Tears rolled down my eyes, but they were happy tears.

Wendy and I had a good talk that day, and I told her how I missed all of this. But then we turned it into laughter so that our memories could be happy ones, as well.

That was the end of the family memories. It was done. Another wall had come down. There were still a few to go, but I was working on them, one wall at a time.

Chapter 30

Endless Threats

My next stop was to Lloyd's with the rough draft of the separation papers. When he saw them, he asked me where I got them from, a computer or Charlotte? I told him that I had got them from a very reliable friend. Then he shrugged at me and said it was all garbage and not even legal.

That's when I let Lloyd have it, too. I told him that it was a starting point and that I was tired of being threatened; that this had to be done. Lloyd didn't seem too concerned about what I was going through, and instead just kept going on about the stuff he was going through with Beatrice, and with selling the tools. He said that the whole thing had driven him to the point that through anger he yelled at his father and told him to grow up and stop listening to Beatrice and to his sisters. However, this time I really didn't care.

But then, on the bright side, Lloyd told me that he'd been able to sell a lot of the tools and lumber to my brother and that my brother was also helping Lloyd to sell the other stuff. I felt good that at least things were getting done, but at the same time, Lloyd really hurt me that day.

I told him that I was really struggling with the Herpes that his father had given to me. His response was so cold that I was stunned. "Oh, Mom, just get over it." That's when I lost it with him. "How dare you say that to me!"

Lloyd was acting as the mediator, but I knew that something else was going on. With tears dripping down my face, I told him stories of abuse, and his partner was stunned to hear them. Then I told him that I never wash only half a floor; I do it all. I made sure he heard me when I said that I wanted it done. I made it clear to him that Ex would never control or abuse me again.

Lloyd's partner's dad was in the backyard smoking, so I went out to join him. He saw how upset I was, and was very comforting. He said that I had every right to be that way. I didn't like putting Lloyd in the middle as it was, and I mentioned that to him, but he agreed it was the only way. Then I told him that there was not much left of my life, that they'd either taken it all or blown it all and that I just wanted to move on.

He really did understand me, especially when I said that my job was done, my health had returned, and I still had my faith. Surprisingly, so did he. He said that my life has changed and that it would be different now, and that with meds I would live a full life. Then he said that if someone loves you, it won't matter, and he added that it's a hard pill to accept and a shock to your system. I agreed with him.

After calming down, I went back into their home and told Lloyd to get it started. He said that he would make a list of everything and divide it in half. I told him that while he would do that, I would get a lawyer. Lloyd agreed, but I had this feeling that there was something else that Lloyd wasn't telling me, and it began to really bug me.

But the day had been long, and I was worn out. I got to recognize the humming inside my head and the weird sensations that followed when the brain had had enough. So I got into my truck and headed for home, and on the drive home, my thoughts began to drift back to the beginning when I first learned to deal with the different brain sensations.

I was so grateful to the therapist for teaching me all along what the brain sensations are and how to deal with the body. Dr. Hamilton tried her hardest to get me to change the word *accept*, but to me, that was giving in. All the different things going on, and she understood that it was normal.

Another thing that kept coming to me were those long hallways. When I saw one, I wanted to run down it; it seemed to draw me in. I'd feel pressure on my forehead that was so weird, almost as if something was pulling me. I remember telling the doctor in the Hamilton Brain Injury hospital this, and his response was to just be a good girl, and I would get out of there. I will never forget that. Then I remembered the male nurse being so interested in what I was saying. Funny how I thought of those things on that drive home.

By the time I got home, I was exhausted. During dinner, Doreen and Philip were like angels watching over me. I could ask them any kind of question and Philip would always answer so wisely, which is just what I needed to hear. He'd say, "When people do wrong to you, God looks after things. He will guide you." That made me feel so much better. It seemed as if I really was closing doors and tearing down those walls.

During the next week, I saw Pastor Doug. He helped me like no one will ever know. We talked about talking to the family and the grandkids and telling them the truth. But then I told him that I was finding it really hard to forgive Ex, although I knew that I wanted to do it. Pastor Doug said that wanting to forgive him was the first step and that God would help me. He said that for me to move on, I would have to release that forgiveness and leave everything else to God. I told him that the kids don't know about my infection, and I know they have a right, but it hurts so much to tell them. I told him that this was my stumbling block, and he prayed for me. I felt so much better after that!

Afterward, I told Pastor Doug that I'd been going to church on Sunday's and that the music was so moving. It was during those times that I'd see people's faces. Pastor Doug said that it was the Spirit helping me to deal with things now, and with things to come.

A short time later, Lloyd called to say that he'd sent some spreadsheets to me. I read them and told him that his father was to pay for the meds for my STI. His response was unbelievable. "Mom," he said, "he told me that he got tested and he just had cold sores on his lips." Then Lloyd added that I must have got it from someone else.

That's when I lost it with him. "Did you see the blood report? Don't you see what he's doing? He gets even any way he can. I have been faithful, Lloyd, all of my life, and this is what I get for it? He turns my kids against me? This has been a threat hanging over me all of my life!"

Well, not anymore!

Chapter 31

The Truth Hurts

My young granddaughters wanted to see me again, and so I arranged for a time when I could pick them up that would be good for all of us. But they kept changing the times, and it was about the third or fourth change when they sent one last text to me and said that this was when they wanted to meet and that they didn't want to discuss the time anymore. This last time that they'd mentioned was final. They as much as suggested that I should just do it when they wanted, and that was that!

This upset me! Their lack of respect offended me along with their bad manners and lack of reverence, and not just to me as their Nana, but as an adult. So I spoke with the boys, my grandsons, and asked them if they thought I was overreacting. Both of them were as shocked as I was over the girls' actions, and they said that they wouldn't dare talk to me that way, that the girls were totally out of line and rude.

That's when I thought to myself, "It's time you all knew the truth once and for all." This was the last straw! I was in my truck and cried all the way home. Doreen listened to me as I told her what had happened with the girls. She seemed almost surprised when I told her that I was going to tell them all the truth. Then she asked sheepishly, "Are you sure you're ready to tell it all?" Yes, I was ready, and I told Doreen that it was time to tell it all.

Meanwhile, my head pounded so badly that I had to put ice packs on it to calm it down. I knew that I needed to get control over this headache, but even more so, over the situation with the girls or else I was going to be in really big trouble. After lying quietly on my bed for a while, the pounding began to subside. I was finally able to think more rationally about what I was going to do and how I was going to tell my grandkids the truth.

But before I knew it, Doreen came to me and said that she had done something that she'd sworn she'd never do. I stared at her in awe as I tried to figure out what she was talking about. Then she told me. She had called the girls and said that she was going to pick them up at a time that she'd given to them, and that she would bring the girls to visit me here at home. Then she asked me if that would be alright. I was too worn to argue with her, and so I told her that it was okay with me.

I didn't have the strength or the words to explain it properly, but I knew that I could turn to God for help. "Dear Lord, give me the strength." Then I curled up like a baby on my bed and sobbed. These very loved ones, these precious granddaughters that had helped me to regain my life, had just torn my heart out. I was shaking, and it seemed as if this emotional overload was shutting my brain down again. This was too much, and I knew that I couldn't handle it anymore.

But there was little time for self-pity because within half an hour the girls were there. Doreen had them sitting on the sofa, and I joined them and sat in my rocking chair. They were very quiet and watched me carefully as I told them that I loved them. Their eyes sparkled, but that soon disappeared when I told them how much they'd hurt me. Then I said, "Okay, this is the final report on why Nana changed her name back." Then with tears streaming down my face, I took a deep breath and told them why.

They needed to know that their Papa had given me a sexually transmitted disease that's called Herpes 1 and Herpes 2. I was very blunt and told them that I had no idea which female hooker it was that I got it from and that at this point, I didn't care. "I'm learning to deal with it. There's not much else I can do. I can't change it, and yes, I'm angry for a lot of reasons. This changes my life drastically, yet Papa denies it. Of course, someone who's as guilty as he's been all of his life *will* deny it."

They stared at me with very sad eyes and confused faces. This was a lot for them to understand, and the girls stayed huddled together on the couch. It was very likely that they didn't really know much about Herpes and sadly, I was too upset to explain it to them. I had to tell them what was on my mind, and why things were the way they were. I wanted them to know that this was really between Papa and me, and that he was still their papa and that they shouldn't change that. "This issue is between Papa and me. It's not about you girls." They said they understood.

Then I reminded them that the way they had treated me was very hurtful and that I never wanted them to hurt me like that again. One of them said that it was not meant to be that way. I wanted this to be put behind us, so I asked them if they were hungry. They said they were and so Doreen brought them some fruit trays that she'd put together for them. They began to enjoy the treat, and that's when Doreen reminded us that it would be a short visit. This was actually the first time that they'd been to my new home, and I was glad that they were there because at least now they knew where I lived. I took them to my bedroom and put Youtube on the TV so they could watch my favorite music video that I listened to all the time. It was called *Humble and Kind* by Tim McGraw. They liked it, and so I played it again and told them to listen carefully to the story in the song because they needed to hear the words.

It wasn't too long afterward that it was time for them to leave. We exchanged our hugs and kisses and goodbyes, and then they piled into Doreen's car so she could take them home. I stayed behind and sat out on the back deck. I was so uptight that my body ached all over. I was so caught up in my own issues that I hadn't noticed just how stressed and worried Doreen was about me, or that she'd called for Philip to come home.

A short time later, they both joined me on the deck and asked if I was okay. I said that I was, but that now I was concerned about explaining this truth to my grandsons. I was worried about how they'd receive it.

I knew that Karl already knew it all, so it was just the other two that I had to deal with. Not too long before this day, I had to drop something off to Lloyd, and Karl was there and greeted me when I pulled into the driveway of their home in Oshawa.

He opened the door to the truck and asked me what was up, and I told him to give the parcel I had with me to his dad. But then he said that he wouldn't move until I told him what was wrong. He said that they all knew something was wrong, but they didn't know what it was. Karl wanted to know right then and there. So, I asked him if his dad had said anything to him about me, and he said no, that his dad hadn't said anything.

Karl stared at me with a very concerned face and said, "Nana, you have never lied to us before, but we notice that something is really wrong. There is something that you're not telling us, and I'm not letting you go until you tell me." Tears began to stream down my face, and I begged him to just let me go, that now wasn't the right time, but he insisted that now was the only time.

This wasn't going to be easy, so I sniffed and wiped away the tears as he stared at me with his big sympathetic eyes. "Okay," I said. "I'll tell you under one condition. You have to promise that you will not say one word about this until the time is right. I'll let you know when that time is." He sighed slightly but promised.

So I told him that his Papa had given me Herpes, and his face raged red with anger. He called his Papa a few choice names as he clenched his fists, and he told me what he'd do if his partner did that to him. I didn't want him to react to this sudden emotion, and so we just talked it out for a while until I saw that he was okay. Then he commented that the final piece of the puzzle was in place.

He hugged me, and that day I saw an emotional side of Karl that I'd never seen before; a caring heart that I'd never noticed. I was glad that I told him, and I believed him when he said that he wouldn't tell anyone. He kept his word about that, too.

But the task was still there for me, and now I had to tell the other boys. So I texted the boys to come over and asked them to pick up a pack of smokes for me. Surprisingly, they got there in about five minutes. Then they anxiously sat on the sofa, all of them including Karl. Then I said, "Karl, I am relieving you of the secret that I had asked you not to reveal. You cannot hold that anymore in your heart."

Marky commented on how unfair this was for me, and that they knew something serious was going on. I gave them the same speech that I'd given to Karl about the importance to be sexually safe because it can happen at any age. After that, I asked them if they had any questions and then reminded them that he was still their Papa and that I knew this news would likely change how they felt about him. But I also reminded them of how important it was to not hold grudges.

Karl said that it did matter, and of course, I knew it mattered, but I told them that they were old enough to handle this news now and that they needed to decide for themselves how to deal with it. I was proud of them and told them so. I tried not to cry, but tears welled up and managed to slowly drip down my face anyway.

The boys would do what was right for them, and in my heart, I knew it. I had done what was right for me by telling them the truth. Once everyone knew the truth, my own personal healing would begin. Up to this point, everyone in my family knew the truth—everyone except for Beatrice.

Chapter 32

Moving On!

When I had decided to end the marriage with Ex, we agreed to split our personal possessions in half and then sell everything else and split the proceeds from those sales. The lots that I'd so enjoyed were included in the things to be sold. Lloyd said that the realtor had an offer on them, and so I drove up to Peterborough to talk to Lloyd about the offer.

We were in the restaurant eating breakfast, and Lloyd said that the potential buyers had offered less money for the lots than what we were asking for them. This hit me a bit hard at first as I was hoping to get the full asking price for the lots. So, it was a bit disappointing. For a second, I thought about countering the offer to get more, but I didn't want this dragging on any longer. I just wanted everything sold so I could move on with my life.

So, I agreed to it under one condition, and that was that there would be a 30-day closure. The buyers accepted it, and I was on the road to another closure in my life.

The deal would close on July 4th, and I was excited. However, there was a lot of work to do in the meantime to get the clean-up done on both of the lots. On my drive back home that day, the good news ran over and over in my thoughts. Even though we got less than what I'd originally hoped for, things were finally beginning to fall into place.

Soon this would all be behind me, and I would be able to finally begin to relax. That's when I remembered that I had talked to Lisa a few days earlier. Things were lining up, and it was almost time for me to go for a visit with her. So, I stopped at the travel agency to see what was available.

My first impulse was to ask the lady there if she had anything available on September 9th. Her answer astounded me! That particular day was the cheapest day of the two weeks, and so I told her to book it. I felt so happy because this was going to be my vacation when all of this nonsense was over with. I had something awesome to look forward to, and it was going to be good.

Not too long after that, the agreement regarding the marriage separation between Ex and I was finally finished. I didn't waste any time, and so I got into my truck and drove right away to Niagara Falls to give it to the lawyer. He would draw up the legal separation papers, and things would be in motion. I just wanted this whole thing with Ex to be over so he could be out of my life forever. There were so many sad things in my life that needed to be turned around so they'd be positive, and this was a good first step in making that happen. It would be a tough go, but I knew that I could do it with God's help.

I drove back home with my papers in hand, and with my heart feeling good. Things were finally beginning to happen legally! Lloyd came over shortly after that, which was a bit of a surprise, and he wanted to read the legal Separation Agreement. After scanning it quickly, he glared at me and said it was garbage and that it wasn't done right.

Very calmly, I looked at Lloyd and told him that it was drawn up by a top representative lawyer. Then I told him to go to the last page, and he saw the lawyer's business card. He clenched his jaw and said nothing more.

So right there in front of Lloyd, I signed my copies and told him to take the copies to his father to sign. Doreen had been sitting nearby watching, and she told me later that Lloyd's countenance was cold and hard. But I didn't care. I wasn't worried or afraid anymore. "Water off a duck's back," I said.

The next morning, I got a phone call. The papers were signed! Once again, I didn't waste any time picking them up, and then I drove off to Niagara Falls to get them to the lawyer. Finally! No more threats! No more bullying! Life was becoming great again.

Things should have been looking up for me, but legal papers or not, they didn't always turn out the way they were supposed to. The bike got sold, but I didn't get my half of the proceeds as it was agreed that I would. Not only that, but Ex kept the entire income tax refund. Somehow, he managed to keep a lot of the money that I was entitled to through the sales of our things. I was beyond the point of letting it upset me, so I accepted the way it was and tried to carry on.

My concern was getting my health and my brain back up to par. For the last couple of months, my lips had been very sore and had broken out, and on top of that, it had hurt very badly to urinate. These torments had to end, so an appointment was booked with Dr. Corless. He was an amazing support for me, and my visits with him were always enjoyable because if anyone had an answer, he did. He wanted me to go on antidepressants, but I didn't do it because there were so many different drugs in my system already, and it just didn't want any more.

I had been slowing gaining my weight back, and on April 1st, I was 95 pound. By June 1st, I was up to 110 pounds and holding. Doreen can be credited for that because when you're around her, you eat. She'd make me eat and then force me to get on the scales.

But there was still one loose end to connect before I could truly rest, and that was Beatrice.

I had called Beatrice's partner and asked him if it would be possible for me to see my youngest granddaughter for the first time. He said that it shouldn't be a problem, and so we arranged for me to be at a particular McDonald's and at the arranged time. I was there with bells on. I sat in the parking lot and waited patiently—excited, nervous and even suspicious of how this little get-together would turn out. All I could do was hope for the best.

Then I was shocked! All the granddaughters had come, and so had Beatrice. I was only expecting to see the youngest granddaughter with Beatrice's partner. I picked up my little granddaughter and twirled her in the air, and we laughed together for a few seconds. Then I put her back down and stared at Beatrice's partner. "Why didn't you tell me that she was coming, too?" He just shrugged and said that she said she wanted to come, too, and so she came.

We went inside and sat down in a corner booth and then got some food to eat. The girls enjoyed it, and it was fun watching them. But then I thought to myself, "Stop delaying. Just get this over with." I couldn't figure out why I was torturing myself with this unnecessary worry. It was time. So I told Beatrice that I wanted to tell her something and that I wanted her to listen to it all, and then afterward, she could ask all the questions she wanted to ask.

Then I told her everything from the time of her birth, through the accident, and right up until my memory came back. She just sat there staring at me and didn't say a word. I thought I was getting through to her, but then when I was finished, she shocked me. "So you just left him to die?" I wasn't expecting that response from her, so after a heavy sigh, I told her that this was not my doing. He had chosen that for himself.

I told her that it was me who had suggested to her father to go and live with her, to get to know his daughter because he wanted nothing to do with her all of her life. I stressed that I thought he needed to do this while he could. I told her that he didn't want to but that I felt he should.

Then I made sure she knew that when she was growing up, I was the one that did it all and that he did nothing. All he ever did was complain about her. When I was finished speaking, I thought for sure that she'd have some kind of an emotional reaction, but it didn't seem to make any impression on her at all. So, when there was nothing more to say, I left. I had told her the truth and what she did with it was her problem. But for me, I now had some peace.

My confidence was finally coming back. I had been trying to stay in tune with my brain, and sometimes I didn't understand what I was doing, but I knew that I had to learn new ways again to get through the emotional trauma and the pain. I needed to slow it down at times and tell myself to relax. I had to learn and learn all the time to continue to regain what I had lost. I thanked God continuously for allowing it to all come back to me, and to keep me from getting upset with the unhappy memories that came with it.

Then came another visit with Pastor Doug, and I told him that it was over between Ex and me forever. He knew that it was over as we'd talked before about it, but this time I told him everything, including the disease that he'd given to me. He sat there so solemnly as I went on to tell him that I had spoken with my kids and with the grandkids and that I had explained to all of them why it was over. Then I told him that I had reminded the grandkids that this issue was between their Papa and me and that they were all to still love and respect him as their Papa. Then the tears started to flow again when I told the pastor that telling them this hard truth was the most difficult thing that I ever had to do as a parent or as a grandparent.

185

Telling Pastor Doug the truth was the right thing to do, and I told him that. He agreed that the truth will always set you free, and the fact is that it did make me feel free once I'd told everyone. Then came the task of forgiving them all, and I knew that one day it would happen, but I had no idea when. The pastor said that I would know when the time was right, and so I had to just wait for that time.

The following Sunday I went to church, and it was a beautiful service. The music was so moving, and it made me feel at peace. But then suddenly, on my way home, I got a feeling as if something had just been released inside me, and I knew this was what the pastor was talking about.

The next Sunday, I called Beatrice. She said that there was mail there for me and that she would be home around six if I wanted to come by and get it. That was good with me, but when I got there, low and behold, she wasn't there. But who was there to my surprise, was Ex.

I very proudly walked up to him, and he wanted me to sit beside him on the bench. I said, "No, thank you. I am here to forgive you, because, for me to move on, God says I must do that. I must forgive you. So I just want you to know that I forgive you for what you did to me during our marriage. And now I'm moving on."

Then he said to me, "I don't know where you get those stories from." There I was, trying to get closure and do it peacefully, but the way he said that just caused me to lose it. I was so angry with him, and I started to shout at him. "How dare you sit there and lie! I have proof that you strangled me and punched me. There was a witness to it all because I went to the doctor's when my throat was so sore and he saw the marks on my neck. You were the meanest person on this earth. How dare you sit there and lie to me! I am done." Then I stormed away, got back in my truck and left him sitting there.

I went to the drive-in restaurant and got a cup of coffee and then sat there alone in my truck in the parking lot. I was in awe. How could a person sit there and lie to me and deny everything when he knew as well as I did that it all happened? I stewed over it for a long time, but then after a while, it didn't matter anymore, anyway. Who cares what he thinks? I had done what I needed to do so that I could get the closure and move on with my life. So, that was exactly what I planned to do—move on with my life. Thank you, God!

Chapter 33

Time to Heal

The next day, I returned to Beatrice's to pick up my mail, which I knew would be a cheque for me that was reimbursement for my payment to see Dr. Hamilton. But Beatrice didn't want to give it to me, so I ripped it out of her hands and told her to leave my mail alone. I didn't want to come across as wanting to start an argument, so I took a deep breath and then suggested that we sit outside. She agreed.

But as soon as we got out there, she called her brother. I looked at her and called her a rude so-and-so, and was so upset that I told her I don't have a daughter, and that I couldn't believe any person could be so insulting to their mother. I told her to get a hold of her father and tell him to quit driving around the block so he could get back and sign my cheque.

That was the last time that I spoke to her. She had crossed the line too many times, and I was done with her nonsense. She had told people, including my friends, that I had Alzheimers and Dementia, and she even tried to get the boys involved. Well, that was it for me. No more.

July 1st came, and everything was cleaned up on the lots. Lloyd and I had taken truckloads to the dump the day before, and the lots were ready to go. When it was time for me to leave for the last time, I turned and looked at the lot that I'd once called home. I would miss the peace of the trickling waters, but it was time to say goodbye.

I wiped away a few tears and then got into my truck and headed out to Marmora to visit my sister Nene. There was going to be a family reunion the next day, on July 2nd, and many members of my family were staying there for the celebration.

The reunion was amazing! Everyone had a lot of fun, and I know that I had a lot of fun, too. It was not only Canada's Independence Day, but it was mine, as well. I enjoyed myself because, for the first time in a very long time, I was free. So every minute of that reunion was exciting and special to me. Charlotte was up to no good as usual—in a fun kind of way, though—and I had to do shots. It was the first time in 25 years, but it wasn't a problem. Then I got soaked with water when my niece dumped it on the wrong aunt. It was cold, and I was wet, but it was a lot of just pure fun.

On July 4th, which is the American Independence Day, I felt that it was mine, as well. This was extra special because I'd finally seen the lawyer and signed all the papers for the sale of the lots, and all I had to do then was wait for the check. This was my personal Independence Day.

When the check was ready, I picked it up and met Ex at the bank. My insides shuttered when I saw him because he gave me the creeps, but I ignored him, stayed focused and stuck to my plan. First, I paid off the debts that we had accumulated and then split what was left over with him. That was the last time that I ever saw Ex. My plan was complete. I now had closure on the past. It was time to heal.

Over the next few weeks, I spent most of my time alone doing a lot of deep thinking. The only ones who I actually talked with were Doreen and Philip, and that was because I lived with them, and the boys because they still came over to visit me. I was so blessed because Doreen and Philip had been so good to me.

I will never be able to properly express how grateful I am to them for coming to my rescue with guidance, love, and understanding at the lowest point of my life. But I knew that I couldn't stay with them forever; the time had come for me to move on and get my own place.

Then I called Charlotte, and she and my brother were excited to have me come and live with them. I always felt so content and happy there, and I knew this was the right move. So I called Lloyd and told him that I'd soon be moving. He was really surprised and asked what I was up to, and so I told him that I was packing up my things and would be leaving in about an hour to my new home in Niagara Falls.

He was not happy with me, but his boys came and helped me anyway. They knew that no one else had come to visit me for a while and that it had been very hurtful to me. People can be so uncaring—especially family.

By August, I was settled in my new home in Niagara Falls, and for the first time in a very long time, it felt as if I had family around me. They accepted me and wanted to be with me. We'd laugh and talk and go out for coffee together. It was truly a great time in my life.

My September vacation was drawing near, and I was getting excited. In just a few weeks I'd be in Louisiana, and I could hardly wait to get there. I'd drive back to Doreen's home where my boys would pick me up and take me to the airport. That way Jacob was able to use my truck for a few days before he returned to Alberta.

Finally, the day of my vacation arrived, and I was so excited! This was the beginning of a new life for me, and I loved it. The excitement of seeing Lisa and her family was making my brain go into overdrive. This was all new to me, and so I had to learn a different way of traveling amid all the chaos as it seemed almost overwhelming to me at times.

I hated how chaos had so easily messed with the walls around my ability to know what I could and could not do. But now, things were changing; chaos was dwindling.

No longer would I get embarrassed to ask for help; those days were over. Things really were changing because now I felt that if I needed help, I could and would ask for it. It was much easier for me to just ask for help than it was to get so confused that it became a heavy burden to re-focus.

Finally, I arrived in Lafayette, Louisiana! Lisa was there waiting for me, and from the getgo, we were laughing and talking. She took me to the motel at Breaux Bridge, and I got checked in. I hadn't slept for 24 hours, and I was quite exhausted. But who can sleep when huge loads have been lifted off of you, and your heart and soul are clear? Not me. Yet, once I was settled in and relaxed, I began to feel the tiredness in my body, and that night I slept like a baby even though it was really hot in the room.

The next morning, when we were downstairs having breakfast, I noticed how friendly the people were. The smoking area was different from any that I was used to, as well. The people were pleasant to be around even though many of these dear guests had lost their homes during the floods, and had since been living in the motel with their children. It was heartbreaking to learn all that they had gone through, and all that they had lost.

Yet, I seemed to fit in with them, and so we talked and laughed together. The feeling of the people was amazing; everyone had some kind of hardship that they were enduring, and yet, through it all, they were still able to laugh from their hearts. It was good to tell my story, too, and not have anyone criticize me or brush me off. We became a group of people who could laugh and shoot the breeze together. I was soon known as the *Canadian Cajun Girl*, and friendships between us began to develop.

One of the reasons that I'd gone there was to find myself, and so when Lisa was working, I'd either stay in the motel room by myself or go for my walks. Some walks were very early in the morning, and others were late at night. It was just too hot to go walking during the heat of the day.

When Lisa was free, she'd take me sightseeing. We were in the heart of Craw Fish country, and the Cajun language seemed so funny. If I didn't understand it, I'd say to let me try again, and then we'd all laugh. It was like being a young girl again, and since we were all girls, we'd have fun. We celebrated at Lisa's house, and we'd laugh from our bellies and act foolish, dance to music like college girls, and talk about everything.

I told them that new beginnings were starting there, and through it all, I found myself. Finally, I knew who I was, my own individual who would never be ashamed of being me. It felt so good to say that for the first time. What a breakthrough! I was free to do whatever I wanted to do. I even accepted the invitations to go out to dinner with a few different gentlemen. Dinner was as far as it went, though. I was beginning a new life, but I still had my morals.

The one thing that I desperately wanted to do was to go dancing. So on Sunday night, we went dancing. Kayla was the designated driver, and Lisa and I danced and laughed so much that I will never forget it. Lisa met a friend that night, and now she is so happy, and I'm really happy for her. Just to hear her happy voice was warming to my heart. She truly is a wonderful lady.

As I watched her, I thought about our future and pictured the two of us sitting in rocking chairs and saying, "Do you remember when we went dancing that night?" When we returned to the motel, even the staff was laughing with us. Everything seemed funny, even the silly things that girls do, like giggling as we say, "I have to go pee."

It's not fair how time goes by so fast when you're having a good time. My last week there just seemed to fly by. I met my friend Richard, and we talked and talked. It was heavenly to just be able to say how you feel without being judged. I really to needed talk to him about someone who was so dear to my heart, my sister Ruthie.

Why Louisiana for my winter getaway? I'd spent the two weeks there in September of 2016 because I believe that something told me to go and be with a dear friend who was very sad. So I went. The spiritual part of me knew that this was where I wanted to come for the winter. I don't know why I knew that, but I did.

Yes, I had planned to go back very soon. Hopefully, it would be for two months this time.

Testimony #5

What kind of girl am I?

My good virtues:

I'm Honest. I believe in trust, morals, and 100 percent loyalty, especially to the person or persons I love, when that love is returned to me.

I'm caring. I wear my heart on my sleeve.

I'm committed. I'd work side-by-side with my partner in life.

I'm faithful. I'm true in every aspect of my life.

I'm sincere. Life is precious to me. I believe in faith, in the Spirit and in God above.

I'm happy. I believe in laughter, smiles and free well-being.

I'm thankful. Every day I wake up and can walk and talk, I am so thankful.

I'm a friend. I'm totally honest with people, and I'm trustworthy.

I'm a lady. I dress like one, act appropriately when and where needed, but in my heart, I can still chuckle at some people without them knowing it.

I'm strong. On the outside, I appear strong, but on the inside, I can melt or cry and bear all the emotions. But I won't say anything even though I'm learning to open up more.

The other side:

I can cuss. When I'm with my family, I can have a few drinks and laugh with them. And Heaven only knows what I might call a sister or brother, but it's done in fun.

I'm scared. I still don't ask questions all the time. I'm still reserved, but I'm learning to be stronger and more open.

I'm optimistic. I know that we all have pasts that we want to forget, and I want to know that it happened, but not let it rule who I am. I want to always look to the future for better things to come.

You could add more to my list, be it good or bad, and I now know that I can handle it because I know who I am. I'll never be in bondage to people again.

This is me, my life all wrapped up in a nutshell.

... Marjorie Coens

Chapter 34

Leaving the Past Behind

Back in Canada, and on my way home to Niagara Falls! But my first stop before that was to the eye doctor in Toronto. It was a dreary, rainy day, and very different from the weather I'd just enjoyed in Louisiana. I knew that I wanted to get back there as soon as I could.

After that, I drove straight home and couldn't wait to unpack. Unfortunately, I had to go to the bathroom very badly, and without thinking, I ran up the stairs and burst into the bathroom. I was startled by Charlotte who suddenly jumped out of the shower and scared me half to death. We had a few laughs over that incident, that's for sure.

My brother is a man of few words, and his face told me that he was glad I was back. That was very heartwarming. However, I didn't intend to stay for long, as I was going to return to Louisiana for the winter.

There was a lot to do in the meantime and only three weeks to do it all in. It was going to be another busy time for me, and so I went into high gear to arrange and prepare for everything that had to be done. The truck would get a complete overhaul because I planned to drive it there. It got new tires, an oil change, and the transmission was serviced so that everything would work perfectly before I was to leave.

On top of that, I had to drive to Oshawa to get my supply of meds for the winter. Once that was done, I would be all ready to go.

I met Lloyd at a restaurant for breakfast, and he said that I looked different, and then asked me what I'd done or who I'd met in Lafayette. He seemed stunned when I said that what happens in Louisiana stays in Louisiana. He looked at me strangely, and I told him that it was the place of new beginnings for me.

Then I told him that I had found myself and that I planned to go back to Louisianna for the winter. Afterward, we said our goodbyes, and I headed out to Walmart to pick up my meds along with a few other things.

As I pulled into the parking lot of Walmart, a text came in from my granddaughter. She asked where I was and I told her. Then she asked if it was the Walmart by her school and I said that it was. So we got together because it seemed right to me to give it another try. But this was the last try. I didn't want another conflict, but it happened. I had to keep telling myself that I was the new and improved Nana, that my purpose on this earth was to help people, not hurt them.

On my drive back home, I pondered my feelings of being back there again in Oshawa, and for the first time, it didn't bother me as much as it normally did. I was stronger because I got to know who I was then and who I am now. I had no regrets.

I got to Charlotte's just after she'd returned from her shopping spree at the market again. I laughed and asked her what she was doing to me as I stared at bushels of tomatoes, peppers, and apples. Then we sat and peeled all ten bushels as we listened to country music in between the chatter and laughter. It was really amazing and something I'll never forget. I was happy and free.

As I peeled those fruit, I remembered the time when I couldn't even hold an apple, and when I couldn't even get it to my mouth to take a bite. I remembered the tears and the struggles of trying to hold one apple. Yet, I didn't give up. It hurt, but I diligently did my aerobics to the music to help heal my body, and now I was able to hold and peel those apples. I had come a long way, and I was very proud of myself.

My nephew was getting married about one week before I was scheduled to return down south. All my brothers and sisters, and Karl, Marky and Darlene came. I had no idea how the day would end, but it started out good. I had shots with the grandboys, and I took part in the dance game, and it was a lot of fun. There was a lot to drink—beer, shots and then water. I would get off the dance floor and drink water. I remember commenting that the water tasted horrible, but I was thirsty and drank it anyway.

As the night went on, I began to feel the effects of all the drinks, and I hit the point of no return. It was time to go home and soon I was struggling big time. My sister helped me upstairs and gave me a bucket to put by my bed, just in case. But I insisted that I wouldn't throw up and pushed the bucket away.

The next morning I was up by six, showered and ready to tackle the day. I woke everyone up with smiles, and they were all stunned. That's when I learned that they had added vodka to my bottles of water, and yet had still made it out alive. I think I passed the Niagara Falls family initiation.

The grandkids came by and said goodbye to me and wished me a safe journey. Karl told me that he loved me and that I had surprised them all with so much laughter. Little did anyone know that as soon as they all left, I would go back to bed to get some sleep.

The week passed by quickly, and the night before I was to leave, the gang came over and wished me well and hoped that I'd have fun. Wow! That was so nice and so unexpected. It was Friday, and so of course, the dinner was fish and chips. I left them all drinking as they waved goodbye to me. It was time for me to head back to Lousiana for the winter, back to my new home. It was as if someone inside me was saying, "This is where you have to go."

When I got back to where I'd been staying, at my brother's home, I loaded up my truck and then crawled into bed. As I was drifting off, my mind kept trying to remember if I'd packed everything. It was important to me that I didn't forget anything. Then after about two hours of sleep, I woke up and saw that it was 1:30 in the morning. Time to go! So I jumped into my truck, stopped at the coffee shop to pick up my large coffee, and then headed for the border.

When I crossed the border, I sent messages to all the people that I loved so dearly and told them that I was heading for a new life. My heart was filled with excitement and hope. There was so much to live for now; so much to look forward to and it thrilled me to no end.

I drove from one state to the next. My goal was Nashville that first night, but I felt so awesome that I kept trucking. The weather was perfect, and I listened to music and talked on the cell phone as I drove. I arrived in Grantor, Mississippi around 5 p.m., and I was really tired. So I booked a room at the Hampton Inn. After a quick shower, I called a few people and then crashed for the night.

The hours of sleeping sailed by, but when I stirred early in the morning, I knew that it was time to get back on the road. It was about 5:30, and it was still dark outside, but I was anxious to continue on my journey. The inn didn't have their breakfast menu ready then, so they gave me two bags of breakfast-on-the-run.

199

It didn't take long to get onto Interstate 55, and there was no traffic. It was great! I was trucking and eating and having a great time. I'd called the day before to reserve a room for me, and they said there would be one available for that morning at 10 a.m.

However, when I got there at ten, they said that there was no room available until three in the afternoon. There wasn't much I could do, so I tried to relax as I texted a few friends. It was warm outside, so I went to Cracker Barrel to get familiar with things.

How was I supposed to fill in my time? I went to Lisa's house as I had her address in Garman, and I surprised everybody. After a while, I headed back to the motel but stopped off at Walmart first to get a few groceries. This place was new and should have been appealing, but it didn't feel right. When I got back to the desk at the motel, I wanted to pay them for the full two-month stay, but the computer would only accept one week at a time.

Lisa and Kayla were trying to find a place for me, and many of the places were very expensive, so I had to figure things out. I finally got settled in my motel room after I'd brought it all in and put everything away. I was exhausted, but I did it. It was a bit of work, but worth it. The best way to success is to have faith, and the best thing to say is *thank you*. Then I put on a pot of coffee, but I sure wished that I could have had one from Tim Horton's. However, that was a luxury only available in Canada.

About an hour later, I got a call from Lisa. She said that Kayla's mother and step-father had a nice trailer that wasn't being used right then and that they'd be happy to rent it to me for the remainder of my stay there. This was very exciting, and I told them how grateful I was, and that I looked forward to staying in their trailer.

Unfortunately, the week at the inn was a rough one for me emotionally. A million thoughts ran through my mind. Did I do the right thing in coming here? The boys' father was leaving for Greece for two years. I constantly questioned myself where I'd gone wrong with my life. After a while, I began to feel very confused and almost stressed.

First I thought I was right, then I questioned if I was wrong. I was beginning to feel frazzled and worried that those walls would start coming back up. I didn't want that. After a while, though, my thoughts settled down, and I felt that I was where I was supposed to be. But that was short-lived because the news quickly found me that Ex had broken the Separation Agreement.

He was deducting $200 for his funeral expenses. The worst part was that Lloyd agreed with him by saying that I got the RIF. That really hurt more than he realized. He was sticking up for something that was against the law. I mulled everything around inside my head for quite a while. The bottom line conclusion was that I was an adult—and their mother and they were the children that I have protected all of my life. Children are supposed to honor their father and mother according to the Ten Commandments. My children weren't.

That's when I decided that since I was the mother, I was not going to accept their offenses anymore. No, this was my time. I had no idea what was in store for me, but I would deal with whatever came at me, one day at a time. It felt so good to get my spirit back.

So, I closed my eyes and begged God not to let them or anyone drag me down again, to keep me strong. That's how I ended the rough week at the inn. So, when Sunday came, I packed up my things and moved out of there and into the peaceful trailer.

Chapter 35

Welcoming Changes

Looking at the trailer brought tears to my eyes. It was so beautiful! Kayla and her daughter were working hard to clean it up when I got there. The best way I can describe this trailer is to say it was home. I knew I'd be happy there. I felt something so....so positive in that trailer. It was as if this new life really was beginning to happen for me.

I helped with the cleaning and enjoyed every minute of it. It wasn't work for me; it was more like moving forward into something far better than I'd imagined. It was meant to be, and it gave me hope. I laughed when I discovered that I'd brought my bottle of Vim (bathroom cleaner) with me. Who takes that on vacation? Everything was beginning to line up, though. After a full week, I had cleaned and reorganized everything so that it felt like home to me. I was so happy.

The landlords in my new home were awesome. They were two of the most friendly, helpful and caring people that I'd ever met. There was something about them that I couldn't quite put my finger on. I had this gut feeling that there was something special about them. I couldn't understand what it was at the time, but I couldn't shake the feeling.

Lisa and I got together often, and we'd talk and laugh and carry on like a couple of teenagers. We made plans for the Christmas holiday and for places we wanted to visit, but I wasn't sure how all of it would fit into my tight budget.

I didn't want to crush Lisa's excitement, though, so I told her that I'd go one day at a time. She was happy with that! Our friendship was special and almost unconditional. We could talk and complain and laugh together, and give each other our heartful thoughts and opinions. The best part was that we always listened to each other.

When I had arrived at the trailer, I had texted my friend Richard so that he could know where I was living. He was another friend who became very special to me, and our friendship grew stronger every day. We'd text each other whenever one or the other of us would go out so that we could know that the other one had arrived safely. Then we'd text again to say that we had got back home safely. It was so comforting to actually have a friend who cared whether or not I got to where I was going safely. Perhaps this is why I treasured his friendship so much.

I went to dances with Lisa and her new friend, and we always had so much fun. It really warmed my heart to see that Lisa was so happy, especially with all that she'd gone through. The joy on her face told me that something special was happening to her. Then, I'd join in with the dances and try to learn their way of dancing. That was a challenge! It was like learning to dance to the old way of jiving.

It was so much fun for me to be out with my new friends and enjoying life. It seemed so natural to them to want to include me in things that they were doing. I wasn't used to that, but I loved it. Yet at the same time, I also cherished the time when I could sit at home alone and relax.

Often at night, I would look up at the stars and at the moon and then beyond that and into the heavens. I'd say, "Lord, help me with what I am supposed to do." I loved my new life, but I felt deep inside me that there was more purpose for me being there than just to have fun.

On November 6th, I attended the bachelorette party for Kayla and Brook. I'd been elected as designated driver and photographer for that event, and it was a lot of fun as I listened to their stories and took their pictures. The love flowed between Kayla and Brook as they drank their brains out—a figure of speech, of course. Then Kayla and Lisa would dance together, and Brook would drink her drink while she was there. It was amusing to watch them tease each other about it afterward. No anger or hostility, just fun.

While the bridal couple did their thing, Lisa and her friend danced the night away. There was a lot of joy and love and laughter in the air that night, and I took pictures of all four of them throughout the evening. It was a lot of fun for me, and it also gave me such a warm feeling to be part of this precious family for this evening. When it was over, I drove them all home in my truck, and we laughed all the way there. Afterward, I texted Richard to let him know that I was home.

The wedding was three days later, and it was very simple, yet, filled with love and promise. Again, my heart was ecstatic because I felt as if I was part of their family. It was such a rewarding feeling. The bride and groom said their vows by the pool, and wouldn't you know it? The weather did not co-operate! It was cool, so everyone had to wear jackets. But then, that's just par for living in Louisiana.

The dinner was delicious—sweet potatoes, potato salad, rice, and Gumbo. What a wonderful time we had together that day! The night ended early, and I was home by eight. That was fine with me as I needed the rest. Such a simplistic wedding and yet, so awesome! It was an honor to be part of this special day and with these special friends.

Things seemed to go along great as I enjoyed this new life with my new family and friends. Unfortunately, I got sick from the burning of the sugar cane because of my allergies. I feared that they'd really do me in, and they did.

So, I laid quietly in my bed for a few days, trying to recover from this unpleasant episode. Of course, suffering from allergies had always been somewhat normal for me in the past, so I just accepted it. But I also took advantage of it because while I was there alone, I did a lot of soul-searching.

Richard called me on the third day because no one had really heard from me for a couple of days, and he said that I sounded awful. I tried to joke with him, and so I asked, "Do you really think so?" So he came by and brought me a nasal rinse machine, and once I was settled in with that, he scolded me for not letting anyone know that I was sick. Of course, when Lisa found out, I got another scolding from her, as well. But it hadn't occurred to me to tell anyone. I was so used to just taking care of myself and not asking for help that it never crossed my mind to say anything to anyone.

Oh yes, things were changing! There were people in my life now who actually cared about me. I loved it, but it was new to me, and I almost had to focus on it so I could realize that it *was* normal for this new life. After that incident, I had to phone my landlord and tell her whenever I was not feeling well. A whole new attitude came upon me. I was not afraid to tell them how I felt. I was not ashamed. I didn't feel mocked or humiliated. I loved my new life!

For years I'd struggled with words, and the hum in my head never stopped but got worse when I was tired. Headaches struck like a drum beating down on me making it difficult to focus, let alone speak or try to think about things.

I called the pharmacist back in my hometown in Canada and asked which antibiotics should be taken for what issues. I'd brought them all with me and didn't want to take the wrong one, and once I learned which one to take, I took it. I promised Richard that if I did not start feeling better within 48 hours that I'd get the shot that he'd told me about. Low and behold, by the next day I started to feel better.

However, I also began to worry that it would trigger the infection that I have with me at all times. Things such as a cold, or stress, or getting run down was always a trigger that activated the little blisters. I did get a few, but I had the meds with me, and I knew what to do. So thankfully, I was okay as I had caught it in time.

While this new life brought me more joy than I had ever imagined possible, I still had some days that brought me down. One of those days was my granddaughter's birthday. I thought of our last visit and of her texting me and telling me what and when I couldn't handle anymore. I had blocked her and her mother, but as a mother myself, I know that you never lose the love that's there for them. I knew that one day we'd meet again, even if it was in Heaven.

It wasn't easy for me, but I forced myself to get out whenever I felt depression or sorrow beginning to set in. This time I went shopping and bought some makeup. It seemed to be taking a long time to adjust to this new life because it was just so different, so wonderful. But then I realized that finally, I was beginning to feel like the real me. To top it off, my internet came that week, and I felt connected again. Sometimes living in the country means that things are limited, yet they were slowly coming together.

This was my Louisiana home!

Chapter 36

That One Special Friend

The week of November 27, 2016, began painfully for me. My foot was killing me, and I wanted some slippers to keep my feet warm and comfortable. It was still a new thing for me to ask people for help as I was accustomed to doing for myself whatever was needed and whenever it was time to do them. So I got in my truck and drove to Lafayette in the rain and bought a pair of slippers that were warm and cozy. Unfortunately, the pain in my foot was caused by a bunion that had developed. So while I was out, I went to Walgreens and bought a toe separator. Those two really helped.

When I returned home, I tried to get some rest. But the internet service was not working properly, and so I spent the next three hours on the phone trying to get internet service. So many hassles and roadblocks, but I wasn't going to let them stop me. I knew what I wanted, and I didn't plan to give up until I got it. It's the way I did things now, and it seemed as if I had to often fight for everything that I wanted.

The next day, Monday, was my granddaughter's birthday. I sat there and stared at the rain as it poured down and splashed on the window panes. I rarely drifted back into my past anymore, but even so, at times I'd think about my family and friends back home that I still loved. I said a prayer for her and listened to some uplifting Heavenly music. Often, the best way I could deal with things that I couldn't control was to sit quietly and let the music do its thing.

Richard came over during the day on Tuesday, and we had a relaxing and comforting visit together. It always gave me so much joy to spend time with him. However, later that night after he'd gone home, I had difficulty sleeping. I woke up with a weird feeling, and it was as if someone was there with me. Then on the Wednesday and Thursday nights that followed, the same thing happened. I opened my eyes and squinted at the clock. It always showed the same triple numbers each night. I tried to focus, but I had no idea why I was waking up like that.

Then on Friday night, I didn't want to sleep, and I was wide awake most of the night. I had weird feelings and, of course, I would get up and make myself a cup of coffee and have a smoke while I stared up at the stars. People should really try that because before they'd know it, they'd be looking at the heavens and feeling as if someone was listening to their thoughts.

The following Saturday night, I woke up at 3:33 a.m. again, but this time, I said, "No way," and turned over and went back to sleep. Strangely though, I woke myself up at around 7:30 from all the crying that I was doing. I had no idea why I was crying; I don't remember dreaming anything. I just remember waking up because I was crying so hard.

So, I got up and blew my nose, but I was still very tired, and then climbed back into bed to sleep a little longer. Before long, though, I was living my whole life all over again. It was flash after flash of recaps. I couldn't stand it!

I needed to break this feeling, so I got up, made myself some coffee, and then took my smokes and went outside. After a while, this urge came over me to type, and so I went back inside and sat at my computer. I wasn't sure what I'd type, but it soon all came to me, and I dove right in and typed faster than my brain could handle it—the words just kept coming.

There was no desire in me to do anything else except type, and after three and a half days, I had written a rough draft of my life's story. I typed whatever came to me, and even though it seemed like a lot that I'd typed already, I knew I missed many details. But something compelled me to keep writing my thoughts down, and so I did. I had this unbelievable feeling as if there was a spirit inside of me doing it all for me.

Unfortunately, shortly after that typing spree, I wasn't feeling well, and I just wanted to stay at home by myself and rest, not be out with people. However, Richard came over and brought some movies for me to watch. He even bought me a blue ray DVD player to watch the boxes of movies on. This made my life a little more interesting as I was lying there in my bed trying to get healthy again.

Before I knew it, Thanksgiving Day had come, but I was still too sick to go to Lisa's, so she brought a delicious dinner to my home. I felt bad that I couldn't go there, but our visit together was awesome and very special to me.

The thoughts kept coming to me that I should write a book, and the more I thought about it, the more real the concept seemed to be. It occurred to me that to write a book of my life would be something that I really should do—that I really needed to do. I'd written so much of life down already, and yet it wasn't clear why I'd done that. Perhaps it was time to think very seriously about going all the way with it.

It would be easy to get a testimonial from Pastor Doug at the Embassy Church. I felt more encouraged all the time to do it. I had to do it. So I reviewed my earlier notes and began to feel truly inspired to share them. I really believe that the whole reason I was compelled to write everything down that had happened to me over the years, was because I was supposed to publish my story in a book to share and encourage others.

Shortly afterward, I was back in Louisiana, and Rick visited often—and I call him Rick now instead of Richard because we had become very good friends at that point, and I felt that I didn't need to be so formal with him anymore. It was truly encouraging for me to have a friend like Rick who just loved me for being me.

In my heart, I felt as if there was someone or something that was drawing us together to be special friends. It was wonderful, too, because we had so much in common. Before he left from one of his visits, we agreed that on Christmas Day, he'd come over and cook the dinner. I thought that was a great plan, and I couldn't wait for the day to come.

I went to church in Lafayette, and the music was something that would draw the inner soul to Heaven! I thought of my mom on that Sunday and how she was likely dancing to the rhythm. Whenever I felt stressed, I always turned to my music to help me relax.

By the first week in December, I had written in the first story of how God with His Spirit and His angels had given me a gift. This excited me to want to continue, and I began to focus more and more on writing my own story. Every chance I got, I added more notes to my collection, and the story began to come together.

Rick knew that I was writing this, and so the time came for me to send what I had written so far of my story to him. It was important to me to get his view on it at that point and to see if I should keep going. He knew some of the issues from me talking to him about them, so nothing was really shocking to him as he reviewed my notes. But wow! He loved it and was so proud of me for doing it. That really encouraged me. I planned to show it to my family and friends here, but it was as if someone was telling me to wait a while yet. So I kept it to myself.

My story was finally done; at least I thought it was, and I felt good about it. It was time to send it to some friends and get their feeling of it. The feedback was overwhelming! They all agreed that my story needed to be told, but how was I going to do that? I didn't know how to write or publish a book; yet, it would all happen in the spring of 2017.

My new friend Crystal would help to make it happen. I had met her in August of 2016 when I was still in Oshawa, Canada. I actually met her through my son Lloyd. She was a financial consultant, and he was working with her on a particular project. I had some money that I wanted to invest, but I had no idea how to go about doing that, and so Lloyd suggested that I meet Crystal and let her help me.

At the time, I didn't really want to meet anyone, and I was still struggling with getting people and relationships straight in my head. On top of that, I wasn't sure that I really wanted to trust or even work with someone that Lloyd was referring me to. I wasn't sure that this person would work in my favor under the circumstances.

But I called her to set up an appointment anyway, and I had a busy schedule so I told her that I'd meet her the next day, which was Saturday. It didn't really occur to me at the time that she might have weekends off, but I insisted, and so she came to the office, but she had her son with her. He was adorable, and after a few minutes, it began to click in that this was not really a work day for her. I began to realize that she actually had plans with her son for the day.

When I look back now, I see that I'd been rough with her when I sat in her office with my arms crossed and the Bluetooth in my ear. I just wanted to get the appointment over with and get out of there, and sadly, my attitude was a bit sharp towards her. After a few minutes, she let me know that she'd gone out of her way to be there just to help me, but that if I didn't want her help, then that was fine, too.

That was not my expected response from her, and it made me feel a bit guilty for my harsh attitude towards her. So I asked for another appointment during working hours this time. She was fine with that and agreed to another day. That made me feel better because I had a hunch that she would be the one who could help me when the time was right.

Meanwhile, back in Louisiana, it was Christmas Day, 2016. As promised, Rick came over and cooked up a delicious steak dinner! But of course, my air conditioner broke down and so we both shared the discomfort of spending the day together in my over-heated and stuffy home. But it was okay because we were together.

We enjoyed our meal, watched a movie and laughed a lot. Something special was exchanged that day. I was able to be myself, and he was able to be himself. No more walls; no more trying to impress. We were two good friends that loved to be together. He gave me a beautiful necklace with two hearts joined. We had connected!

I didn't go out to celebrate New Year's Eve that year as I wanted to end the 2016 year at home quietly and by myself. My life was finally coming back, and I was content and happy. Oh, this was home! My inner peace had opened a whole new book of life for me.

Something inside my heart said that this was why I was in Louisiana. It was because of the love of a friend who could puncture a small hole in the wall of my heart and allow me to feel the reality of being able to love a man again. My heart had opened up to that one special friend.

Testimony #6

While I was an advisor at a financial firm in July of 2016 Marjorie had come in to see me. Lloyd and I were working together, and he had suggested that I meet her as she had some money that she wanted to invest, and had no idea what she wanted to do with it. She called me on the phone and said, "Okay, let's meet," and under her breath, she muttered, "Let's see what my son has for me this time." I responded and said, "Not a problem. When would you like to come in?"

She quickly added, "Tomorrow morning at 9 a.m." I replied that the next day was Saturday, and then there was silence for about15 seconds. Then she replied sharply, "Yup, I know that. I will see you then. Goodbye."

I hung up and shook my head and said, "What just happened?" I was not planning to work on Saturday, and I had my son Nolan with me. I called Lloyd and asked him, "Um, is your mother always like that?" He laughed and said, "Get used to it."

Then I advised him that I would have my son with me that day and that I was not going to call her back to tell her as her tone pretty much scared me. He could tell her, as he was the one who'd set me up with her. I kept thinking, "What have I got myself into?" So, Lloyd let her know it was my day off, and that I was coming in as a favor to him.

I did keep true to my word. I came to the office, and I did have Nolan with me. Marjorie was completely fine with that, and in fact, Nolan took to her right away.

I started to go through the process of who I was, my background, etcetera and tried to get her to open up and tell me what it was that brought her in that day. But she refused to answer. Instead, she sat there with her arms crossed and a Bluetooth device in her ear. What an attitude! Again I was thinking, "What the heck!"

I kept trying to talk to her and discuss finances with her, and so I got out the paperwork that I needed for my compliance, but still nothing. So I closed it. I looked at her and said, "Marjorie, you are here for a reason, and I am trying to help you. I can not and will not help you if you do not want it. I have my son here on a Saturday morning, a time that you made on my day off. I am being very honest with you, and I want you to be honest with me. Do you want and need someone to help you? If yes, then I will help you, and you have my word that I only work in your best interest."

She was totally taken by surprise, and then sat up and looked at me. I was sure that she was going to yell and then leave. Instead, she told me what she needed and then booked a second appointment. After she left I contacted Lloyd and asked him, "Did I do something to upset you?" He chuckled and said, "That's my mom, and I love her."

Thank goodness that second appointment went so much better. That is when she thanked me for being honest. I told her that once she becomes a client of mine, it is a lifelong process. I will be there in the good times, the bad times and everything in between. I have kept my promise.

You meet people in your life that truly make you take a step back and say, "My god, how did you ever make it through?" Every day when I see Marjorie, she is smiling and laughing, and I get a message that says, "Let's see what today is. Good morning, Happy Friday!" She does it just to spread some sunshine around. I think about how many people get that and smile.

The woman that came into my office two years ago was so hurt inside and so fearful to express any emotion that she came off as ruthless and pushy. All along, she was just someone who needed to be accepted and know that someone was going to look out for her, even if only for her investment.

I have grown a very strong bond with Marjorie, and I love her like she is a second mother to me. She gives me trouble, pep talks and is always there if and when I need her, just as I am for her. I am truly, truly thankful to God that He has honored me by bringing Marjorie into my life.

. . .*Crystal*

Chapter 37

Following My Dream

The next day, I was having fun as I phoned everyone I knew to wish them a Happy New Year. I stayed home with some friends and vegetated as we chilled and enjoyed the day together. That was a lot of fun and a great beginning to a new year. I know that I struggle at times, and I know that I will always struggle, but I also know now that I am able to move on and enjoy my life in spite of it.

I chatted with Pastor Doug again, and he gave me the encouragement that I needed. I even kidded with him and said, "I need all the help I can get." We both laughed. It was so good to talk to him again and to know that he was still supporting me, even from so far away.

My friends Danna and Bill came to visit from a small town in New York State called Tupper Lake. Bill had to go to the hospital in Houston for a series of exploratory tests to find the answer to his own health issues. Yet, while they were there, we had a wonderful visit and enjoyed so many laughs together.

Rick came and made a delicious meal of homemade spaghetti. Danna and I were impressed, and she said, "One meal we don't have to worry about." Bill was in a teasing mood when Rick came, and of course, Danna got things stirred up about hair coloring when we get older. That really sent some words flying in the air, but all in fun. The four of us had a really wonderful visit, as we talked and laughed and ate together. It was such a fun evening.

Then, after Rick left, Bill sang an old-fashioned boyfriend-girlfriend song to me. It was so funny! The three of us just sat around and talked and laughed together.

It was around this time that I was in contact with an author who I'd sent my story to for his opinion. This isn't the same author who would write my book later on, though. His response took me by huge surprise when he said that my story must be told and published. I began to think that maybe my published story could help someone else who has suffered a brain injury and encourage them to never give up. I called my friends to share the good news, and they said, "You go, Girl! Keep at it."

Of course, I had to call Rick and tell him to come over because I had something to show him. I was so excited! I felt like a dancing girl, jumping with joy and acting silly. When he got there, I jumped up and right into his arms, and I told him excitedly, "I did it!" Rick was laughing as he looked at the email from the author, and he congratulated me.

That was enough to get my writing juices flowing. It gave me the incentive to do it, and before I knew it, more thoughts began to stream in. My brain was going in full circles, and it was time for me to get a writing pad and start writing things down. At this time, I wasn't totally dependant on my computer as I used to be because now I could actually hold a pen and write. It was wonderful to be able to do that and for me, so much easier.

I needed to refresh my mind so I could get a general idea of how books were written, and what words the authors used. I wanted to get the feel of how to write a book that would encourage others to want to read it. So, I did what all good authors do and began to read novels. The ones that really gave me insight were the true stories of Native-Americans back in the 1700's, of how they lived and suffered. It was amazing how drawn I was to these stories.

Some nights, I would read and go to sleep, but it was as if I was living their life with their sad and happy times. I was drawn into the lives of the characters, and it made me want to know about them. Their spirits, faith, and worships were so similar that people don't really even know it because we all believe in the heavens up above.

I came to Louisiana and learned so much. I found who I have always been, and to my surprise, I discovered that I never lost my inner soul and heart and spirit. They have always been right here.

Soon it was Valentine's Day, and it was a beautiful day. Rick brought me roses and my favorite candy. We had become best friends who were helping each other through bad moments and sharing the joys of the good ones. At least that's what I told myself.

It had been a while since I had talked to Lisa, and it was good to hear her voice when she called. She was still happy, and that made me happy. She also knew me and knew that I had to do this my way, and she knew why I didn't go out much. Meanwhile, Rick came by weekly to see me, and our friendship grew even more.

I took a trip to Rockport, Texas and planned to stay for a week. I'd saved up enough money to go there, and that took a while to get together. Ex had been taking money off of the alimony to pay for his funeral, and so I had to get after Lloyd to start paying it back. Soon he was paying it back, a little bit each month. It was something, and I really did appreciate that.

Lloyd and I either talked or just briefly chatted at times, and he said that if he had it, he would pay it all back. But then he added that he knew I was not in my right mind at that time. Well, he was right. That's the past, and I was no longer there. I was moving on.

When I arrived in Texas, it was awesome to see my friends again. I was in the place where I'd met my aerobics teacher and first learned how to give up my cane. I believe that God sent me there as she was everyone's angel. But being a sergeant, she'd push us all past our limits. I was following my dream then, and I am still following it now.

I stayed at my friend's house, and it was great. It felt as if it was another check off of my list of accomplishments. I thanked all of those dear people who helped me along the path to recovery.

My Louisiana family made me promise that I'd text them when I arrived in Texas and when I would be leaving. That is a sign of a loving family and true friends, and it gave me a feeling of security. I enjoyed the visit, but after only four days of being in Texas, I returned home—can you believe that I now call Louisiana home? Rick came right over and said that he thought I'd stay there for a week, but I told him no, that I wanted to come home.

Then came my birthday. How do I explain it? First thing in the morning, Rick phoned and sang happy birthday to me. It was so sweet, and it melted my heart and made me laugh. He had to work that day, but he called a few times throughout the day, and each time he said, "Happy birthday," it was special. I wonder if he'll ever know just how precious that was to me.

Lloyd called to wish me a happy birthday—and so did the boys. Wow! Then my brothers and sisters began to call, and all of my friends. It was so unexpected, and yet so wonderful to know that they were thinking about me. I thought it would be a quiet day where I would stay home alone, but it turned out to be a really special day. To my surprise, it didn't stop there, either.

Rick came over the next day, and we celebrated my birthday again. It seemed as if my special day would never end. I needed a virus scan put on my laptop, and I had to ask Rick to do it because I struggle with that hugely as it's way too confusing for me. I am not ashamed to admit it anymore, either. So Rick did it for me, now I have a virus scan on my laptop.

I went to the JC Penny store, and when I entered, they gave me a scratch ticket. So I looked at it and scratched it, and then the lady said that I'd won the big one. I had won a hundred dollars to spend in their store. What a great birthday gift! So I spent the hundred dollars and bought a purse, wallet and two tops, and it only cost me $1.08. I was so happy as I said, "Happy Birthday to me!"

I phoned my friend Danna who was in Florida and told her what I'd got and about the sale that was on at this store. Then Bill looked up the JC Penny store there, and low and behold, they were not having the same sale in that state. This gave me full bragging rights. We laughed so much, and if anyone were watching, they'd think that Danna was right there with me. We were both just a bundle of joy that day.

My landlords became good friends of mine, and we would visit at least once a week. If they didn't see me puttering around the community or in my yard, then they'd check in on me. That was so sweet of them, and I felt so honored to be thought of like that. Again, nothing I was used to in my old life. They knew that I was writing, and they'd encourage me to keep going, as well. Sometimes she would look at me, though, and say, "You're tired, Girl."

Oh yes, I was tired all right, but I was on a mission, and there was no stopping me. Thoughts would come at me at all hours of the day or night, and I'd write them down. Every thought and every detail was a part of my life that needed to be in my book.

Every day Rick and I would talk on the phone, and we would text, "Good morning" and "Goodnight" to each other. We'd remind each other of something we had to do, or when it was meal time. I truly looked forward to every minute that I could spend with this man, even if it were not in person.

But then, sometimes I'd worry about when I'd have to return to Niagara Falls, and just how much I was going to miss all of my family and friends in Louisiana. Most of all, my heart ached for how much I'd miss Rick. I knew that I would have to go back to Canada, but I also knew that in October I would return to this place that I call home.

There is something magical about the spirit of angels, and the love and peace that is all wrapped up, guiding me through the good times and the bad times. I don't look at the negatives anymore. I focus on my positive thoughts. As I look at my page on Facebook, the internet social media of the world right now, I can see where I began and how far I've come. I know who I am—and I like myself!

Chapter 38

Chronicles of a Survivor

The dreaded time came, and I had to leave Louisiana and return to my home in Niagara Falls. My stay this time would be focused on getting my story written and published. Then I'd be back in Louisiana with my book in hand. I was excited about what I'd done so far, and I thought it was complete. But as I thought more about it, I knew it really wasn't. The story has yet to be told of how I tried to get to where I am to be in life—and it's an amazing story.

I drove from Niagara Falls to Oshawa and met up with Crystal to talk to her about my story. She seemed to be very interested in the prospects of my book and gave me a lot of hope that it could happen. I knew that somehow, she would be the one to make it happen. She invited me into her office that wasn't only very lovely but also huge. We chatted for a while, and she really encouraged me that I should do it.

There was still so much to write, and Crystal allowed me to work on my writing project there. I was so happy that I had a place to actually sit and write. I got my own little space where no one bothered me, yet there were people all around. She said to take all the time I needed to write my story. Sometimes I had to pinch myself just to make sure this was real. Not only did I get all of my writing done while I was there, but Crystal introduced me to many new people.

It was too much for me to drive back and forth from Niagara Falls to Oshawa every day. I was so thankful that Doreen invited me to stay at her home at night so I wouldn't have to do the long drive every day. That allowed me to spend the full day at Crystal's office with everything I needed to write my manuscript. It was no easy task to write that, either. In fact, I found it very complicated at times.

Focusing was the key that helped me get the times and dates in the right order. So much information floated around in my thoughts, and it was a real challenge to get it all out and onto paper so that it made sense. At times my thoughts started to mess with my head, and so I had to follow my heart because I knew that it would let me get the truth out and onto paper.

I called up LuAnne while I was there because I knew that she could help me. She's another dear friend who's more like an adopted sister to me. Our friendship was reunited in about 2007 after being separated since the accident. I'd known her before the accident, and we had apparently been very good friends. But after the accident, there was no memory of her for a long time, and then when I could remember her, I wasn't able to remember who she was, just that we had been friends. Then one day I was thinking about her, and I had a drawing to go and see her. So I did.

On that day, I shocked her when I just showed up at her office. My hope was that we could get together for lunch, and so I told her that. She wasn't sure, though, and I could sense that she felt awkward. After all, it had been a long time since we last talked and a lot had happened since then. I didn't even look the same as I did back then, so I don't blame her for being hesitant. However, we made it for another day. This boldness to step out and do something that was outside of my personal comfort zone was something that I wasn't used to— yet I did it.

We met for lunch, and we had a good first visit together. LuAnne knew that I struggled with my cognitive skills and such. Back in 2007, it was still quite obvious in my speech and in my walking. Yet, we talked and laughed, and rekindled our friendship that day. I told her that I was about to head out to Texas so we wouldn't be able to get together for a while. She was okay with that.

Then every year after that and around the same time, LuAnne and I would get together. I invited her out to the lots, but she never came. I tried not to take offense, and instead just put it on the back burner and chalked it up as she was too busy to try and understand what I was going through. On the other hand, perhaps she just felt uncomfortable being in the presence of the man that she knew made my life miserable.

We'd meet up each year and go to a restaurant to eat and spend time together. Each visit got better and better, and with each one, I was more advanced in the healing process. This not only made way for a better visit with her, but it also helped LuAnne to understood my issues a bit better with each visit. Our time together would be filled with chatting and laughter as we'd talk about all the old memories—both good and bad.

LuAnne remembered it all, and this was good for me because I needed her to help *me* remember. I knew she would take the bull by the horn and help me find what I was looking for. We listened to each other's thoughts and ideas, and it brought back so many memories that had been locked up in the back of my mind. Memories of our working days together and the days of laughter that we'd shared, as only sisters could. I never imagined that the heavens up above would send so many angels to guide me, and yet there I was, reunited with another dear friend who was a good part of my past and would always be part of my life now.

Earlier, when I was in Ontario in April of 2016, I had called LuAnne and told her that I had left my husband. Then I told her that my memory had come back. She was glad for me and said she couldn't wait to see me again. So during the time that I was working on my book in Crystal's office, I called LuAnne to tell her that I was back, and we made arrangements to get together for lunch. This time I told her the truth about the nasty things my ex-husband had done to me. She was very upset because she had no idea of the horrors that he had made me suffer through.

There was such a sense of release for me once I told her because now she knew the truth. I didn't have to hide my pain from her anymore. After that, we enjoyed a great visit together, and when it was over, she gave me a big hug and told me that she was happy I finally got my memory back.

It was amazing to me that after all the years we were separated, in the end, we had never lost our connection in spite of the lost time due to the accident. This makes me ask, "Why was that?" For the first eight years after the accident, I didn't even remember her. Then one day, she flashed across my mind, and I just had to see her, and it was if it took only a very short time for us to get right back to where we left off.

I remember now that we used to work hard, but we also laughed hard, too, and we'd debate seriously about many things. My work relationship and my friendship with LuAnne was something that Ex never liked. But now we can both look back, and smile and laugh. It was good to have her back in my life again.

Every morning when I was back in Ontario, I'd wake up to "Good morning" texts from Rick. Then shortly after, he'd call me, and we'd talk. He would always give me a feeling that would make my heart shine and convince me that it was going to be a good day.

I remember one time when we were driving from one city to another that he told me it was his job to watch over me when I was traveling. I was so touched with the feeling of security when he said that. It gave me the courage to keep going—and to get my story done.

Since I was so close to Oshawa where my boys lived, I dropped in for a visit, and once again, they brought life back to me. I remembered back to the time when we could laugh, and I'd say, "Hey, guys. Please get along."

They were young men now, but I could still look at them and learn so many hidden stories of the love and the adventures that they took me through during that time of recovery. I couldn't tell them why I was in Oshawa at that time, though, and it hurt a bit. So, I'd make up excuses and tell them that it was because of doctor's appointments, which was partly true because I did go to see doctors there.

The visits were short, but their mom Tricia knew the story. She empathized with me and said that it must be hard at times, and it was. But just being able to share with her some of it was a great feeling to me. She remembered and said, "Oh, yes. That is so true." Tears would trickle down her face, and I'd say to her, "It's okay. I'm back now."

When I'd meet with Pastor Doug, it was always very helpful to me. I'd go to church, and the music would inspire my soul and spirit. I'd say to myself, "Keep going, Girl. Don't stop. More lessons, please." There was so much to teach and learn.

Facing the difficulties of where I could stay, and the cost factor of driving back and forth was wearing me out. I was on a limited budget that got strained when I had to stay in motels or eat in restaurants. I blew my budget so many times, and then I'd spend the next while trying to get it back on track. How I managed to do that, only God knows.

Many times I had to remind myself that my purpose for being there was not to visit but to write my book. So I'd drive to Crystal's office every day, and I'd sit at the desk and focus hard as I tried to get it all down on paper. But I would always text Rick when I was leaving and then again when I arrived. Then he'd call during the day just to talk, and he'd make me smile. It was so good to hear his voice as he gave me that daily nudge of encouragement to keep going.

I knew I'd be there for a while, and I didn't have any designated place to stay during my time there. The traveling was getting to me, and so I began to worry about how I could keep it up. Finally, I broke down and told Crystal, my lovely adopted daughter, about my concerns. I don't know what I was hoping to get from telling her, but regardless, she was already a step ahead of me.

Crystal told me that her friend Vickey, another friend who turned out to be my angel in my time of need, lived nearby and had an extra bedroom that I could stay in if I wanted it. That was perfect, so I accepted the offer and took the room, and thanked Crystal. She is a very busy lady, and yet, she overflows with so much kindness and compassion that there really aren't enough words to describe her.

The world seems to go around fast at times, and we can't keep up with it. But I know that if we help one another, the journey will be so much easier. I didn't have any money to pay for the room, but what I could do was offer my cleaning skills in return for the room. This plan worked out perfect for both Vickey and me. I had been taught to clean the old-fashioned way, and that was getting on your knees and washing the floors by hand. It's the best way to clean floors because then you get the corners and the baseboards clean, and you can do a lot of thinking at the same time.

Having extended family all around was wonderful. There was my newly adopted daughter Crystal, who's now my manager, and Doreen, LuAnne, and now Vickey, as well as Donna, Effie, and Mirka. Yes, I was blessed. Staying at Vickey's was really amazing, too. We had such peaceful talks in the sunny backyard that I will never forget.

I was able to see my now adult granddaughter who had a full-time job, so I called her, and we met up before she left for work one morning. She was full of questions, but that's only natural since we hadn't spoken in a year. So much had happened in that time, too. So, I was cautious for that reason—there had been no contact from her, not even a text.

My goal was to not allow myself to get hurt again, and even though I still loved her, I didn't want to push our relationship. However, that didn't seem to become an issue anyway because after that initial visit, a week went by and I hadn't heard from her. I thought it was a bit odd, but I waited to see if maybe she'd just been very busy and not able to call. So I waited a while longer, but still no response.

Finally, I sent her some texts to see why I hadn't heard from her. However, she didn't call back or answer any of my texts. I wanted to get together again in the morning before she went to work, but there was no response from her. Weeks went by, and she never got back to me.

So I went into her workplace and saw her, and I made sure that she saw me. Then I said to God, "Please give me the strength to do what I have to do." Then I ignored her. Oh, that did hurt, but I had to teach her that you don't treat people like that. She was a bit upset because I had left and then texted me. I told her that I would pick her up after work and we could go for dinner. I didn't know why she'd ignored me, but I thought things had turned out for good.

However, when I picked her up, she got into the truck and called me a rude nana. I let her talk on, and then my words came out. "How did it feel to be ignored? Not good, is it? Well, little girl, you and your family have ignored me for almost two years. I have tried every which way I possibly could to talk to you, but nothing!" I impressed myself that I could tell her this and not stumble over my words as I had done with her and her family years ago.

Then I took a deep breath and said that going to Louisiana last year was something that I had to do to find myself and that I did find myself. Then I smiled at her and said that it was a good feeling, too. She sat there quietly as she watched me, so I added, "But you need to treat others how you would like to be treated." She just looked at me and didn't say anything at first.

Then she started to open up a bit after that, and she talked about her mom and her sisters, and how I ignore them. My defenses were up, and yet I stayed calm as I told her that my door has always been opened to them, but only to the good, not to the bad treatments from them. After a while, we were both more relaxed, and we actually enjoyed our visit and our meal together.

She asked me about God. The simplest thing that I could tell her was to look up at the clouds and talk to Him, and then say, "Thank you." I told her that He would hear her.

Afterward, I drove her home, and I really hoped that this would be a new beginning for us. I hoped that this lesson of treating the family with disrespect and the feeling of being ignored in the way that says, "You don't exist," would help. I hoped that maybe later in life, some angel might show her the light.

Testimony #7

I first met Marjorie in the winter of 1991, when we worked in the same building but for different employers. We talked and enjoyed our conversations together, and became good friends. After the company she worked for moved to another building, we stayed in touch and started getting together more often. We even brought our two families together at times, but mostly, it was just the two of us getting together for some great chats and good wine.

As deep as our conversations got, I always knew she was keeping something hidden from me. I often asked her about it, and sometimes she would open up a bit, but then she'd stop herself.

When her 25th wedding anniversary was getting closer, we met after work one night, and she told me that she had to stop being friends with me. I also knew she had to do this, and I told her that I would always be there for her. She hugged me, and it was a very strong hug. I respected her wishes and did not contact her.

In December of 1998, Marjorie called and said she was leaving her husband after the holidays and that we'd talk then. Then, I heard about her car accident in January of 1999. I was worried and called the house, but never got a callback.

Then in 2007, Marjorie showed up at my workplace. She told me that she had to come and see me. Again we hugged, and then we met a couple of days later for lunch. My heart broke as we talked.

She was in pain and broken. She only had bits and pieces of her past, and I noticed some of her comments were very wrong. But I did not correct her. And as well, she was still with her husband.

We met several times over that summer before she and her husband headed south for the winter. However, we got together every time she was in town. She was always inviting my husband and me out to see them, but I found excuses because I knew she did not remember.

I was so proud to share her journey back to finding who she was, is and will be. Her memory was returning slowly in 2013, and every time we got together I saw that she was getting stronger, both physically and mentally. Then I got a call saying, "My name is Marjorie Coens, and we need to meet." Over the next year, her memory came back more and more, and this time when she had questions, I responded to them and told her what she used to do and be.

Marjorie called me from Louisiana one time, and I told her, "I have my Marjorie back." She responded, "I remember. I am back! And I wrote a book." She said, "I just sat down, and it flowed out of me." I told her that it is a story that needs to be shared.

Since that day, Marjorie has only continued to amaze me. I watch her grow as herself and as the woman she is, and I am so grateful that she allows me to share her journey.

She is my sister from a non-blood line, and I will always love her and be here for her.

...LuAnne

Chapter 39

Settling Issues and Going Home

Crystal became ill, and when I learned that she was in the hospital, I got worried about her. From what I'd gathered, she may have had a stroke on her left side, but the doctors confirmed later that it was a severe Migraine. Wow! I was so glad to hear that and glad that the grand opening of her new office that she was so excited about would not be postponed.

When I went to see Crystal at her home, my heart ached for her. She was bent over, trying to walk with a cane and didn't have a clue how to use it. I was quite surprised that no one at the hospital had bothered to show her. After giving her a big hug, I looked at her and smiled, but inside I was crying out to God. "Give me the strength to be tough with her. She needs to know that I can help her, but I don't want to lose my adopted daughter in being tough with her."

Teaching someone you love is not only hard on them, but it's hard on the teacher. Crystal was dragging her leg and pulling herself with her good arms. Memories of the past flooded my thoughts. I wanted so badly to help her, but I wasn't sure where to begin.

After I'd helped her to sit down, I went into the hallway to be alone for a minute so I could call Rick. I told him about Crystal, and he said, "Girl, you are the best person to help her. You have done it, so go help her." I told him that I would do it. Such a good friend! He always gave me words of encouragement, and yet always with compassion.

So, I sauntered back into the room and put my hands on her shoulders and looked her in the eyes. Then came the first drill. "Stand straight!" She looked at me with her sad eyes and said, "I can't." Wrong words! So I told her, using my own selection of a few choice words, that there is no such word as *can't*. Then I showed her how to hang onto the cane and said, "Look at your left leg. Look at it! Make it lift!"

She looked up at me as if to say it was impossible, but I knew that look; I'd already been there. So I told her, "Look at the leg." Then I put my hand where I wanted her to look, and she very slowly moved it the right way. She was amazed and filled with hope. A little more practice and I knew she'd be walking again.

The next challenge came when I saw her trying to climb the stairs. I stopped her and said, "Oh, for Heaven's sake! You're going to kill yourself doing it that way." Then I took her cane into my left hand and put my right hand on the railing. "This is how you climb stairs," I said. Then I climbed a few steps to show her.

After that, I showed her how to use the same idea to come down the stairs. When it was her turn, she put on a big smile and then did it. I knew she was going to be okay because I was going to be on her case all the time until she was healed and walking normally again.

I returned to the office later on that day, and that's where I met a young man named Brian Kennedy. He was a paralegal, and I had no idea why, but there was something about him that drew me to him. We got along, and I just let my feelings go and waited to see what was in store for me.

Everybody was working hard and trying to get things done for the big opening. I took the simple job of putting labels on water bottles and of course, of cleaning the floors, tables and whatever else needed to be done.

The summer rolled along, and I was wearing out. I'd kept myself constantly busy doing different things, helping Crystal get well, cleaning for Vickey and writing my book. My brain was buzzing, and my body felt as if it couldn't do even one more thing. My days seemed long, and when I'd get back to Vickey's, I'd go right to bed because I needed to rest.

While the full days kept me busy from morning to night, it was the realization of not speaking to or seeing my daughter that hit me the hardest. I had tried everything in my power to break down the walls and to be a mom to her, but the walls were higher now than ever. There was nothing that I could do; it was up to the heavens above now.

I thought things were getting better with Lloyd, but when he came home for a vacation, it was not pleasant. On top of that, I had been busy going to the Union Hall to learn my legal rights and try to deal with the almost hostile threats that had been handed to me over the last two years.

Rick would call when he was at home, and every time I talked to him, my insides tingled with happiness. This was one thing that really bothered Lloyd, but I didn't care. I was moving on with my life, and even more so now than ever. My children were adults, and I knew in my heart that I had taught them right from wrong the best way I knew how.

As for my grandchildren—well, Lloyd's three boys anyway—they still showed respect to me, and if they needed help or if I needed help, we were there for each other. For that, I am eternally grateful.

When I needed some legal advice, Brian turned out to be another angel to guide me on my journey. I showed him the manuscript that I'd written about my life, and he said, "Wow!" He told me that it was good and to keep going, and that was a real encouragement to me.

I'd been extremely busy that summer between writing and seeing people, and going from one hurt to the next and putting out one flame after the other. Yet, I still didn't know what the One above had planned for me.

So many thoughts rattled around in my head. Why was I so tired? Where do I go to live? I felt as if I'd been abandoned by my own children and that hurt me badly. Then I'd tell myself, "Marjorie, stay strong! Climb that mountain, keep smiling, keep listening to the music, enjoy your extended family." Likely, the only reason I'd made it that far was because of Rick's faithful daily texts and his cheerful phone calls that brought joy into my life. He was the strength that I needed every day and that I depended on.

One evening, I'd taken all that I could, and I broke down and cried like there was no tomorrow. That's when it occurred to me where *home* was, where the ones who loved me were. I cried because I wanted to go home to Louisiana!

So I called Rick, and I told him that I needed to come home. He understood what I was going through and what I needed to do, but he told me that I needed to stay here and get things cleared up first. He was right. I knew that once I had all the loose ends tied here with family and things, and my book set in motion, that I could return home. But the wait was very hard on me.

Writing my story became a struggle. It wasn't coming as easily to me after a while because it was harder to focus as things were not connecting in my head. My life that summer was busy and demanding because of so much that needed to be done. There were a few times when I had short circuits and lost control of my speech.

One of these times was when I had hired an editor to help me with my story, but mutual differences occurred that caused me to go in a new direction of the editing provisions. It became a brain overload, and I had to take the winter off to regroup and to find a new editor for my story, which I did.

Sharon had become my new financial advisor at that time as Crystal felt it was best to have someone else represent my financial interests due to a conflict of interest. I was in a meeting with Crystal and Brian Kennedy, the legal representative about my concerns for an editor. However, the intensity of the meeting caused me to leave the room because I was losing control of my speech and balance.

Sharon saw me staggering out of the office, and she wanted to call 911 as she thought that I'd had a stroke. But I told her, "No, no! Help me downstairs for a smoke. I need to get away for a minute and try and focus." I was in trouble, and I knew it. I just hoped that the smoke would do its thing.

Sharon helped me get outside, and we walked over to the blank wall so that I could stare at it for a minute. I knew in doing that I would be able to focus. Then I turned around and leaned against the wall and stared up at the sky. Slowly, I started to come back. After a few minutes, I explained to her what had just happened.

I wanted to stay at the office, but I knew that I wasn't Superwoman; I did have my limits. I'd been down this road before, and I knew what was ahead if I didn't get away immediately and get home so I could lie down. Enough was enough, and it was time for me to go back to Vickey's and some rest.

There were times when things just didn't go the way they should have gone, and the stress was more than I could handle. After a few minutes of being back at Vickey's, I sent a text to Rick, and he responded by calling me right away, and he sounded really upset.

It just took one word not pronounced correctly, and he knew that something was wrong. However, he got a whole slew of wrong words and almost panicked. I had sent him a voice text on my phone, but the auto voice that's known as Siri didn't translate the words as I had keyed them in, so the message that Rick got was rather confusing. No wonder he was upset! I'd be upset, too. But at least I got to talk to him, and that made me feel good.

It was the end of August, and I had many friends then who were always there for me. Vickey was an angel sent by God who was a great listener. We had a lot of talks and laughs together, and I knew we were friends for life. I met one of her students who was from another country, and she was a sweetheart. We had many healthy talks about life. She was so enjoyable.

Of course, there was Crystal. She had regained her health and had moved to her new home. After a week, I stayed with her and helped her unpack and clean. Then on September 15th, I packed up all of my stuff that was at Vickey's and moved it to Crystal's home in Oshawa. This is where my head office would be while working on my book. I'd only be there a few weeks because I planned to leave for Louisiana on October the 12th.

Then I decided to return to my brother's on October 1st to stay until it was time to head down south. His home was close to the border, and it meant a lot less driving through Canada to get to the border on my day of departure. That way I could actually be on my journey down south much sooner.

My sister Nene and her husband were also there, and we had a lot of heart-to-heart talks. Things seemed to go rather smoothly, but the day before I was to leave, there was a terrible thunderstorm, and the bang of the thunder blew me into another short-circuit!

My nephew caught me and knew that my speech and movements had been impacted. He held my hands and kept talking to me as he encouraged me to stay calm. Finally, I came back—my brain came back. It never really left as I knew what was happening; I just couldn't respond coherently because I couldn't talk properly. Then my brain began to spin faster and faster, so I decided to lie down and rest.

The family knew that I was leaving the next morning, as I was already packed and ready to go. But for whatever reason, I felt that I needed to leave early. In fact, when my brother and his wife came home from the dance lesson and bar around 11:30, I gave them a hug and set out.

By 12:05 I was at the border, and it took a while to get through customs as I had six months of stuff packed in the truck. The weather was nasty in Ohio with torrential rains, but I was able to follow a transport truck for miles with the four-way flashers on. Then around 6 a.m., I finally called Rick, and he was so surprised at how far I'd driven.

At 9 a.m., I was entering Kentucky, and I hoped that the rains would be over. My goal was to get to Nashville, but with the clock going back an hour, I headed to the motel in Memphis. As I was driving, I was on the phone with Rick and was caught up in the excitement of being with him, and I missed the cut-off. I was so tired, and I needed to rest. However, turning around to get to that cut-off was not an option, so I kept going.

It was around 4 a.m. when I saw the Hampton Inn and pulled in. I got a room and then went to the restaurant across the street as I was as hungry as a bear. Minutes later, I was soaking my tired legs in the tub, but it was a short soak as I was afraid of falling asleep in it. Next thing I know I was in bed sleeping. But I was up again by 5 a.m. and back on the road, and the next six hours just flew by. I was on the phone talking and laughing with Lisa, and checking in with Rick.

But as I got closer to Baton Rouge, my phone stopped working, and I panicked. I could not make this trip without my phone. I told myself to keep driving, that maybe there were no towers. Then finally, the phone was back up, and I was on it and talking with Rick. I felt quieted again. He said that he would pick up milk and water, and I could tell that he was excited that I was almost there. He had bad news, though, and would tell me later. But just knowing that he was healthy was all that counted in my book. I believe that everything has a reason or a purpose and that we don't always know what God has in store for us.

Once I pulled into Arnaudville, Louisiana, I looked for my key and there it was. I unset the code and opened the door. Home at last! The first thing that caught my eye was the vase of roses from last Valentine's Day that Rick had given to me. What a welcome that was! So perfect.

Then there was a noise outside, and so I turned to look out the door and saw a man stepping out of his truck. Rick! I burst through the door and ran to him and jumped into his arms. What a sweet moment that was! We were both so excited to be together. The last six months had seemed so long, and now we were in each other's arms.

I didn't even realize that he was on his cell phone at the time, but we didn't care—well, I didn't care. Then he smiled at me. Oh, that smile! It lit up my heart and soul. How I had missed his heartwarming smile!

He ended his conversation with his sister on the cell phone and told me that the house of his poor mom had exploded not that long ago. He said that there was so much to do to help her. Over the last two years, I had often asked if he'd called his mom and if she was okay. There was something, but I didn't know how to explain the feeling.

Rick carried everything in for me, and I was almost stunned at how much I had managed to pack into that truck. But as we unpacked, out came his birthday gift—A&W root beer, and mugs. Rick loved them, and that made me happy. Yet, there was so much to do, and I didn't know where to begin. But it didn't matter because I was home, and with the man that I loved.

Chapter 40

The Miracle of a Gift

Rest? Sleep? What was that? I was flying high and constantly telling myself, "Focus, Marge." I had so much to be thankful for that I hardly knew where to begin. I had my life back, and I thanked God for getting me home safely. Not to mention that I was spending time with the man that I loved, and with his four adorable puppies that touched my heart with love and joy.

I was able to organize all that I needed for my stay there; things like getting the internet hooked up, and buying groceries, and handling the excitement of my new extended family. Yet, that first month was a bit rough in some ways, though, because the phone system did not work properly, and I had to have patience when explaining what was wrong with it to the customer service people. That was challenging, but, oh the internet man; he was so helpful, and the customer service was excellent.

It was the time of the Canadian Thanksgiving, and I was not with my family. I felt alone at times. Yet, it was all worth it because I'd look up at the stars at night and every morning before the sun came up, and I'd say, "Thank you, God. I am blessed." Because I really was blessed.

The weather is so different in Louisiana. When the weatherman predicts flash flooding, mother nature doesn't fool around. It was so depressing when it rained, and I never knew what to do—cook or clean.

Time was flying by, though, and I didn't want it to be over. At night it felt as if there was something around me, and I'd wonder what was next for me. I'd tell myself to have faith, and it would come. But time, what was that when you are alone? I didn't want it to slip by; life is too short.

One day I noticed that Rick was in pain, and I was worried about him. Yet, talking to him always lifted my spirits, and of course, I understood pain. I was so thankful that he was going to get an MRI and see a specialist right away. I told him the experience I'd had and how long I had to wait to get one, and he was amazed. Yet, regardless of the pain, we both endured, and we both enjoyed each other's company, laughter, smiles, and friendship more than ever.

Rick's family really got into the celebration of the American Thanksgiving, and I was so glad to be part of it. We were going to Rick's daughter's home for Thanksgiving dinner, and I was really excited. Lori was going to put on a delicious meal, and I couldn't wait, yet, I was really nervous because this was all new to me.

Both Rick and I were filled with excitement and love as we set out. However, the funny thing was that we had to return to his house a couple of times because we kept forgetting things. I laughed to myself as we went over the list again of the things we were to bring. We had the tables, the chairs, the two turkeys, the fruit tray, and the cooking utensils. Finally, we had it all and got to Lori's house.

I'd never had deep-fried turkey before, so this was going to be another new experience for me. When we got there, I was greeted with hugs from his family and from all the grandchildren. Wow! There was just something so special there. So much love! I felt so free and so welcomed there, and Rick made it so easy for me to get over the jitters. He was beside me and a perfect gentleman at all times, and when he wasn't right at my side, he was always within eyesight.

There was, of course, a time when I had to be out of his sight, and that was to go to the bathroom. It was a small, but cozy room with a sign of rules on the wall for the kids. It made me think back many years to when my own kids were little, and it filled my heart with joy. But that joy soon ended when I was about to leave, and the doorknob wouldn't turn.

I tried several times, but it wouldn't work. Was this a new handle that worked differently? I knocked on the door and called out, but no one heard me. They were all enjoying the sun outdoors and setting up the deep fryer and barbecues.

I had to get out! "Think, Marjorie! Think!" Then it occurred to me to call Rick on his cell phone, but he didn't answer. All I could do was leave him a message and hope that he got it sometime soon. But I couldn't wait, so I texted him—and still no answer.

Stress began to set in, and I didn't want that. Then I thought that sooner or later, someone would need to use the bathroom, so I would eventually get out. I tried to relax, but I felt the anxiety coming on. I had to focus, focus, focus!

Just as I was about to scream, I called Rick on the phone again, and this time he answered. "Hi, Hon. What's wrong?" I was so relieved, and then I told him not to laugh or say anything, but that I was stuck in the bathroom.

That's when I heard a burst of laughter on the other end of the phone. I felt so foolish. But it turned out that they all knew that the door wouldn't open. They just forgot to tell me. Then I heard the click of the bathroom doorknob, and Rick's granddaughter opened it and smiled. How can you not smile and laugh with a child?

Rick told me that he wasn't able to answer the phone sooner because he had his hands busy with preparing the turkeys. But when I came back outside, he stopped what he was doing and quickly put his arm around me. I felt safe again, and I felt great throughout the day. It was amazing! I was eating and talking and laughing with all these strangers, yet they didn't feel like strangers at all.

It was as if I'd been there before; as if I was meant to be there. So much laughter, love, and hugs to go around. I was very grateful to be able to share the U.S Thanksgiving with Rick's family.

The day had come and gone, and not too long after that I called the Brain Injury Association in New Orleans. This is an organization that helps people with brain injuries to come together and talk about it, learn from each other, encourage each other and also finds outside help for their recovery. The people come together as a support group called the Amaze, and they discuss all different kinds of situations and talk about ways to overcome them.

I was very nervous to attend at first because it meant speaking out about things that I'd kept hidden for so long. It meant being among people and trying to learn things, while at the same time, trying to encourage others. Yet, I felt confident because it was as if an angel was guiding me and telling me not to let a gift of hope and survival go to waste. I came to understand the feeling that I had, and that it was inspiring me and giving me a purpose to reach out to others and to help even one person if I could.

My aim was to share with others that they are not alone, that they need to believe in themselves and follow their heart, soul, and spirit, and that God would guide them through the hell of pain and confusion. This was when I knew for sure that it was time to tell my story so that I could help others overcome their own battles.

The first meeting was set for December, and I was too nervous to go alone so I asked Rick if he would like to come with me. He said that he would and that it was a given that he'd be with me anyway. Little did he know that to me, this was amazing. Why? Because I'd never had the support and care of a man, who wanted to understand me and know what I was going through. It was then that I knew that he really did love me for who I was, a brain injury survivor!

Those of us who suffer from ABI (Acquired Brain Injury) are often looked down on. Many of us have not been accepted in this world as people who have suffered through an unfortunate trauma and who have acquired a brain injury because of it. They don't realize that we are still people with a heart who can still love and laugh—and cry. Many of us hide, and others are just shunned. I had believed that this was just the way everyone felt about us.

But now—wow! I was so happy. I had flutters in my stomach. This was the real me, and Rick was supporting me 100 percent. I was in such awe that if I'd had the chance, I could have made a list of feelings that I didn't even know had existed.

God had sent me a man to be my strength and my support; a man who had the heart to help others. I remember that I looked up at the sky again and said, "Thank you, God, for sending me a man to be beside me and to work with me to help other people." I had been given a new life to be able to recognize and encourage the true feelings of others and to be able to give them the guidance they needed.

While I was waiting for December to roll around, I had to keep myself busy. So, I decided that the best thing to do was to make a "Must Try" list. This was a list of things that I'd like to do that I'd never done before. As it turns out, there were a lot of very versatile things that were written into that list.

Rick was happy for me that I was doing this, but at the same time, he was very nervous that I might get myself into something that I would not be able to handle. So I promised him that if a situation came up that I couldn't handle, I'd go to the truck and sit there and relax with some quiet music.

The first thing on my list was target shooting. I was excited to learn this, but I knew that I would not be able to handle the noise. Sharp, loud noises still sent my head trembling at that time, and it was something that I had yet to overcome. The earplugs went in my ears and then the earmuffs were placed overtop of my ears. However, I could still hear the noise, and that was the problem. There was no way to totally block out the loud noise, so I knew that I'd have to conquer this first or I wouldn't be able to do it.

So, while Rick was getting the guns ready, I did my usual focus therapy. He kept looking over at me and checking on me, but I was okay. It took every inch of my body and brain to do it, but I did it. I was able to overcome the noise. Of course, Rick was an awesome teacher. He was patient, and he gave me confidence. That is something that is so lacking in this society, and something that is not in the science textbook of teaching for medical professionals.

Another feather in my hat! I had an amazing day that was filled with fun and laughter, and all while learning to do something that I'd never done before. Afterward, we went home and rested. The day had been so much fun, but it had drained me.

Yet, somehow, just knowing that I did it, made me feel great about myself. There aren't enough words to explain how my new accomplishments made me feel that day.

As we sat outside to rest later that afternoon, I looked up into the clouds, and once again, I told God, "Thank you."

Chapter 41

Doors Were Opening

Finally, it was December 4th and time to visit the ABI support group. Rick picked me up, and we went to his house where he'd prepared an awesome chili for the Christmas potluck dinner. I relaxed with the puppies for a while before we headed out, and that took my mind to a different place.

We arrived shortly afterward, and I was so nervous! Meeting new people was very difficult for me, and I had to keep reminding myself to relax and to just be myself. I remembered back to the days before the accident when I used to hold office meetings and how easily it had come to me. I knew that I could do it again, too.

We were immediately greeted by Paul who was in charge of the program. He was friendly and encouraging, and he took us to be seated with other brain injury guests. As we sat together, we listened to a young man go back in time and tell us about his accident. He let out all of his emotions, and it brought out the emotions in all of us. I was so proud of that young man for being there and for taking this step in healing.

There was a speaker there by the name of Brandon, and he explained his type of therapy to everyone. I was in awe! I looked at Rick, and I said, "That's what I had!" I was so excited to hear all that he had to say, and I looked forward to getting together with him later and just talking.

When it came to my turn to speak, I was introduced as a Canadian, and I was welcomed into the support group. I began to relax, and I felt as if I fit in with everyone. It was all very friendly. At the first intermission, I went to Brandon and told him my story, at least a broad view of it. He said that he would call me later about it. Meanwhile, I didn't say a lot at the meeting, but I did listen, and I did observe a lot.

Paul made everyone feel welcome. There was no fancy dress code; people just came as they were. "Just be yourself" is the best way I can describe it. Everyone was just themselves, and they wore what was comfortable. It was a very free and friendly atmosphere.

When it was over, we packed up our things, and Rick drove me back to my home. But it was on that drive to my place that he remembered he had not given Jolie, one of the puppies, her needle. He was upset and worried, and I just wanted to cry. So I prayed during the whole trip home that Jolie would not have a relapse in her condition. It was such a relief when we got there, and Rick said that she was okay.

The next day I was relaxing at home, and I thought of the hustling and bustling of everyone in Canada getting ready for Christmas. They'd be tackling the cold weather and the snow, just as I had done for so many years myself. But now, things were so different for me. December was a month of joy in Louisiana. It was peaceful, and no one was going crazy about shopping and decorating. Not yet, anyway.

On Sunday mornings, I'd go to the 9 a.m. church service. There were more; in fact, it was hard to believe that there were actually three services in the morning. But I didn't care that it was early. I looked forward to the music because it gave me that lift as if someone up there was watching over me. After church, Rick and I met up with Lori and her family, and oh the feeling of love that flooded my soul. We hugged and talked, and the kids just melted my heart.

Not too long after that, I met with Paul again, and the meeting was so good! We talked and laughed, and he said that they had prayed for an angel to come and help them and that I was sent to them. Suddenly, I felt as if I were part of it. I wanted to help. This was the place where I knew I should be. We had a few meetings that month, and we talked about strategies and different ideas. Then Paul told me that I was to give a speech at the January meeting.

This didn't really surprise me, but it did make me a bit nervous. I had my work cut out for me, and I knew that I could do it. I called a few friends and asked for their help, so with the aid of LuAnne and Doreen, I had it all done by the time it was required. It was a lot of work, and trust me, I looked over what we'd written many times, and I read and reread, and added words, and went back in time from the very beginning. I wanted it to be perfect. But it was so very draining.

This was the first time since the accident that I would actually step out and talk about my issues publically. I told my extended family about it, and they were all happy for me. I even called Brian Kennedy, my lawyer back in Oshawa, and he said that this was awesome. I was truly encouraged that so many of my friends were fully supporting me, and speaking words of encouragement to me.

Yet, even with all of this amazing support, I was still nervous. So many doubts popped into my head that I began to question my ability to do this. For the next month, I tried to envision how I would present my story. Would I start at the beginning? Or should I start at the end and go backward? I tried to picture how I would say it. How much should I say? Then I was concerned as to how I would dress for the occasion. I wanted the people to feel comfortable with me, and at the same time, I wanted to be comfortable with myself. I wanted to do the best job I could to reach people with my message.

As excited and nervous about my presentation as I was, there were still other things on my mind that I couldn't shake. When you've been hurt in the past, you find yourself on guard all the time—and I guess I still guarded my heart. I'd spent so much time with Rick, and I was in love! But I didn't know how he felt about me, and my heart, brain, and soul went into overtime worrying about it. I was getting scared of what his answer might be, and I just didn't want to get hurt again. So I wasn't as open with him as I wished I could have been. I still needed to protect myself.

I was getting really close to Rick's family, as well, and I loved them unconditionally. That was another big part of my concern. I was worried about the relationship between Rick and I because I could not handle any more losses, and I'm not just talking about losing Rick. I mean falling in love with his family, as well, and then losing them. I just couldn't handle that. I didn't know what to do.

Rick and I had spent a lot of time together, and I was getting to know this man inside and out. We'd talk about life, our pasts, our children and our hopes. Things were getting personal. We were close. We loved each other, and we even told each other that, "I love you." But to me, saying "I love you" is very different from saying, "I am *in* love with you."

My feelings for Rick were very obvious to me in my heart. I knew how I felt about him. I was in love with that man. However, my worry was how did Rick feel about me? Did he love me or was he in love with me? I really needed to know this. I could not and would not allow myself to go through anymore hurt.

Christmas was almost here, and we had a lot of family events planned. It was exciting, and I looked forward to them all. But it was on December 19th that things changed for me. It was a day that I will never forget.

As I sat alone that evening, pondering over the many things that were going on in my life, including Rick, my phone rang. It was very unusual because no one ever called me at that time of night. But it was Rick. "Marjorie, do you love me?" I thought I was going to faint! My heart pounded as I told him how I felt. "Rick, I am in love with you."

There was a short silence, and I held my breath as I waited for his response. Then he said with a soft voice, "Marjorie, I am in love with you, too." My heart skipped a beat with joy! All fears were put aside as I smiled inside and out. God had answered my prayers. This was a new chapter in both of our lives. Rick had punctured the wall of my heart, and he was in love with me!

Christmas shopping that year was my best experience ever. I bought gifts for Rick's family and had such joy doing it. It's amazing how much greater life is when you know that the man you're in love with is in love with you, too.

The Spirit of Christmas was back in my life! I enjoyed walking around leisurely as I thought about what memorable gifts I could buy for them from Rick and me. I had this feeling that giving gifts was something that was inspired from above, and that the joy that comes with that giving is a gift in itself.

Waking up on Christmas morning, and getting hugs and just being together with breakfast all made for me was the best gift of all. I'd never spent Christmas Day like this before, and I loved it. I had a truly joyful day at Lori's and Charlie's home with family all around me. There was almost more laughter and food than I could take, but I enjoyed every bit of it. This was how Christmas should be. It's how I'd always imagined and hoped that it would be for me one day.

While driving home that night, Rick and I were talking, and I opened my heart and said that it was sad that the only kids I'd heard from on my side of the family were the boys. Rick responded with his heartwarming smile and said that now I had a new family. That made me so happy, and I agreed, "Oh, yes." This new family just filled my heart with love and joy, and I was very happy because of them.

The few days that followed Christmas were wrought with bad weather, and of course, I was out of milk and a few other groceries at that time. I intended to go out and get them, and mentioned that to Rick when I was on the phone with him. However, he did not want me to drive. He told me that often, when it rains like that, the roads would get washed out, not to mention that it was really cold out there.

He knew that I was determined to get these groceries, and wanted me to go to the local store instead of driving the long distance to the one I wanted to go to. But I said no, that I'd go to Beaux Bridge. Of course, the man was in protective mode, which I admire, and asked me again not to go.

Finally, I got the nerve to tell him my fear. I told him that I don't go to any store where my phone does not work. If I had a short circuit, no one would understand, and I would be put in an ambulance, and that alone would set me back a few steps. None of this would be necessary, especially when I knew what to do to control myself. But it would happen because no one around me would understand it.

Admitting that was not easy for me, and the next thing I knew, he called back and said that he was on his way to get me and would drive me to the store. I was in tears that he would do that for me. It was just part of having someone love me that was still sinking in and amazing me.

Explaining the fears that were still locked inside me was hard because I'd guarded them with my own way of handling different situations. Things change when you come back as a survivor. You learn different ways of doing things; you're always afraid that people won't understand you.

We got the groceries and then walked around a bit. I'd been suffering from headaches that had lasted for the last several days, and I'd pushed them aside. On this particular day, I planned to stay at home in my pj's because it was rainy and cold outside. Weather change was always a big factor that brought on the headaches, pain, and an overall feeling that was not good. But I forced myself to say that it was a good day anyway, and it turned out to be just that.

Then came New Year's Eve day, and I spent it with Lori and Charlie's family. What a great way to end the year! Everyone was together, laughing and playing darts. It was another focusing job for me, but the laughter, food and just being with a family that loved me was the greatest gift of all.

However, the northerly winds whipped down, and it was cold. I sent messages up to my family in Canada and jokingly asked them to stop sharing the northerly winds. Laughter is good for the soul. I'm not sure if they thought it was funny, though.

After eating, I went with Rick to his home, and it was so nice! There was a log burning in the fireplace and soft music playing. I sat on the sofa relaxing with two of the puppies, and Rick had the other two puppies. I kept thinking to myself, "What more can a person ask for? I have peace, and I know the year has ended with smiles, love, and laughter." It had been a great year.

Chapter 42

Finding my Purpose

The new year of 2018 started off very busy for me. There was a lot of paperwork to get done for my upcoming presentation, not to mention everything else in my life. My daytimer was the most important thing to me. A lot of people use their phones for appointments, but with me, I find that by writing things down, it makes me use different parts of the brain. I have to do something physical and then focus, and this helps me more than just letting a computer do it for me.

Finally, the day came for me to give my first speech to the Amaze Brain Injury support group. But I needed to relax first, so I went to Rick's place and played with the puppies. I don't know why, but they could take my mind off of the things that were stressing me. They helped me to relax.

Rick had been busy in the kitchen making homemade soup for the potluck dinner at the support group. Before long, he had the truck all packed up with the video camera, food, and of course, me. Last time we visited the group, Rick had forgotten to give Jolie her needle, but this time we both remembered. So, we headed out to the Amaze.

I was so glad that Rick wanted to come with me. He encouraged me and gave me the confidence to take this opportunity and speak out to help others.

While waiting to speak, I had to focus a lot, but I was able to do it. Then came my turn, and while reading my speech I was really nervous, but Paul tried hard to make me feel comfortable. Comments were made afterward of how calm I appeared, but little did anyone know that my brain was racing almost faster than I could control it.

I tried so hard to sit prim and proper, but my back was sore. I think it's called the old-fashioned training of many years ago. "Keep your back straight, breathe and just do it." So, I followed that protocol and did it. I hoped that my message would be the beginning of a mission in my own life where I could help people, one at a time.

It was easier for me to read my speech than to just speak. Even so, everyone seemed to enjoy it, and it went much better than I'd anticipated. Rick was in the audience, and that gave me a lot of moral support. All in all, I was very pleased with how well my presentation went. But then, the question and answer time came...

...and I began to panic. No one could tell, but I was worried about what this stress could do to my brain. This was the moment I'd dreaded the most. What if I had short circuit right there in front of everyone? I wasn't sure if I could answer the questions properly or without appearing flustered, so I began to rehearse in my mind how I would answer them.

Rick picked up on the cues right away from my facial expressions and hand movements. He didn't wait to be invited; he just jumped up and came right onto the stage and sat beside me as he introduced himself.

I know that I didn't show how happy I was that he did this but that was because I was fighting my own little battle just then. But Rick knew, and he stayed at my side. He dove right in and started to answer some of the questions, and then helped me to answer other questions. What an awesome feeling it was to have him right there helping me!

January had lots of new beginnings for me, and the group was one of them that really blessed me. But it was also the month that I would begin the treatments with Brandon, the speaker who offered some therapies similar to mine.

We went through everything together. I told Brandon about the hums in my head that were very loud and almost like a hammer pounding at times. I explained the treatment that I'd received from my physiotherapist, and how I'd learned to relax and go within myself to just find a better place and feel what my body was feeling when the treatments would begin. I guess you could call it *self-healing*, and faith has a lot to do with it. Regardless, Brandon was able to really help me.

Without realizing it, Rick and I had started our own little ritual. Every Sunday morning, I'd go to church while he did his morning routine, and then we'd meet at 10 o'clock at the *I Hop* for breakfast. This was a place where we could just be us. We had no plans for the day and did just whatever would come to mind. Sometimes it was a movie, sometimes a drive. It didn't matter as long as we were together.

The month of January was filled with special dates that reminded me of things that had happened in my life and that I could never forget. I always wanted to remember these dates. It was the 3rd day of January that I had the accident, and it was the 10th day when my sister Ruthie was taken from me. Now I had new things to add. It was also the month of my first speech at the Amaze in Lafayette. It seemed that this month had always brought a lot of change for me.

My speech was videotaped and put up on YouTube, and the feedback from it was amazing! But that was only the beginning. I had another speech to give in February, and I had to get busy and prepare for that. This had been playing on my mind a lot. It was a request from Paul, and it was a very memorable one at that. It was about abuse.

The month of January flew by, and I couldn't stop thinking about my upcoming speech. But then, when I went to church on the 28th, there was a song that we sang called, *Faith in the Mountain*. I was moved by the words and by the music as it gave me the strength I needed. I was able to write my speech and present it without the help of my friends.

I believe that things happen for a reason, and there are times when you have to act on your gut feeling. During one of these times on the 31st, I got a new phone. Learning how to use that was anything but fun and games. It was like a little computer that I had to really study and learn to operate. It was a great challenge and took a lot out of me, but I stuck to it, and I did it.

A few days later, I got my medical alert bracelet. Then a few days after that, my little puppy Ringo was to have surgery. I knew he'd be okay. He was in my heart, too. The days seemed to go by fast at that point. There was never enough time to do everything that I needed to do.

Then it was the 2nd day of February, my daughter's birthday. I thought about her, but I did not text her. I had tried too many times over the years and had always been hurt. So I knew that to forget the pain, I needed to just keep busy, and there was no better way to not feel the hurt than to do something positive. So I went to Rick's and spent time with the puppies, and I had a great day.

Later that night, after Rick had taken me home and then returned to his house, I realized that I'd forgotten my iPad at Rick's. I was frustrated, but there was nothing I could do about it. I forgot about it, and that was that. Rick found it and wanted to bring it to me, but I told him not to. He asked why, and so I told him that in forgetting it this time and not having it for this night, I just might remember the next time to not forget it.

I really wanted to cry, but what good would that do? I went outside, looked up into the heavens and said, "Thank you for the day, God,." Then I went in and slept like a baby.

Soon I was back to working on my speech, and I was reminded that miracles do happen, and they never ceased to amaze me! I'd just started typing when I got a message notification that Brian had sent me a response from the last meeting with the Amaze group. I read it, and it touched my heart. I knew then what I would say in my speech.

I thought of my sister Patricia and what she and her family were going through with her son-in-law's sickness that took his life far too early. Wow, life is short! I knew what I had to say, and so I began to type.

I wanted it to be a simple message of how life can be cruel at times when you're living through it. I didn't want it to be a long, drawn-out message but the words kept coming. I'd thought a lot about what I wanted to say, but when it was time to relay the message onto paper, it got easier.

There are times in life when we all have questions: all the "What-if's," "Where am I going?" and "What's next in life for me?" I had asked myself these questions all the time, and now somehow, the answers were starting to come.

February brought Valentine's Day, and it had become a very special day for me now in so many ways. It was a day when I could really share love and laughter with the one I loved. The whole month seemed to flow with hope. It's called *spring cleaning* and *seed planting.* It was so different this year. Back at my old home in Ontario, it was always very cold this time of year, and often the ground was still covered in mounds of snow. But there, in Lafayette, the warm spring air just rejuvenated your whole being.

It's amazing how, at times—and it doesn't happen too often—I'd wake up at 3 in the morning from a dream or a vision, and discover later that day that Rick had also been up at that same time in his house. I wrote the vision down this one particular time so I wouldn't forget it, but I didn't share it with Rick just then. I will, though, one day when it's the right time.

Then one night, I got a message that said, "You know the time is coming near, 52 days away." I cried over that because I'd actually been thinking of it, too. I'd have to start packing soon and head back to Ontario. Then it really hit me that it was 30 days away, but he insisted it was 52. The reality was setting in, but when it was just 14 days away, Rick still said that it was only 52. He didn't want the time to end any more than I did. Yet, we could not stop the clock from ticking.

Seeing each other almost every day had been the joy of my life, and I didn't want it to end. Life is so precious and so short. Only God knows when our time is up, and the truth is that my life had really only just begun. I was not ready to have it end.

But I had to put those thoughts aside because the day had come for the Amaze open house. I was nervous about it, but I knew that I had a purpose in being there. I knew that if I could help even one person, then it would all be worth it.

Testimony #8

On your 65th birthday, I bet you would never have thought that you would be at an event speaking about your accident that happened so long ago and that almost destroyed your life. It is so ironic how life changes, and how it can make or break us. Yet, today here you are…

Today, as you look around the room and see everyone there, I want you to remember something that your mom said to you. "Climb that mountain, Marjorie!" You have done exactly what she has told you to do. Still climbing to go, but you are DOING IT!

I have seen you cry, I have been there when you felt like you had nothing left, and I have sensed in my heart your pain. I have seen the anger that has left you in despair to the point that you wanted to give up. But you have not done that. I have not met anyone that has been as determined as you, and that has survived what you have, and can still smile and continue to fight. And not just for yourself, but for everyone else.

You are here to help others. God gave you a second chance in life and a gift to spread the word to others about brain injury—and you are doing that. You are helping others and encouraging them, and if you can save even one life and prevent even one suicide, then you have done a miracle. God doesn't make mistakes. And that is why you went to Louisiana; that is why you met Papa Rick.

The woman that came into my office two years ago was someone who was so hurt inside and so afraid to express any emotion that she came off as ruthless and pushy. Yet, all along she was someone who just needed to be accepted, and who was looking for someone to watch out for her even if it was just for an investment.

I knew from the very first moment that you were someone special and that you were a person that was hiding in your own shell due to pain and hurt. It wasn't long before I knew that we were kindred souls and that we going to be connected for eternity.

Marjorie, you are an inspiration to so many, and I cannot tell you how very proud I am of you; how very proud we all are of you here. You are a part of my life, and you have brought so much joy to it, not just as a friend but as an adopted mom. I have adopted you as a mother, and the best part of it is that I GOT TO CHOOSE YOU!

On your 65th birthday today, and for every day, no matter where you are in this world, your family supports you, loves you, and is always here for you.

I want you to know, Marjorie, that I love you very much. I am rooting for you from Oshawa, Ontario in Canada with pom-poms and all. I can't wait to hear all about today.

I love you, Momma. Happy Birthday…hugs.

. . .*Crystal Clark*…aka…daughter

Chapter 43

My Life Has Just Begun

I don't know if it was a coincidence or not that the Amaze Support Group open house just happened to be on March 5th, which was also my birthday. Maybe the saying really is true, that God works in mysterious ways.

I woke up at 6 a.m. to Rick's beautiful voice on the phone. "Good morning!" Our usual text and phone calls of good morning, and we both knew that we were alive. What a great way to begin my day. I love it!

Lisa also called to wish me a happy birthday. Then I checked my Facebook page to see my morning exercises, and I was shocked! Wow! Birthday wishes by the dozens were rolling in and down my page. I even got one from a stranger—my daughter, as well as a text from Lloyd. That sure was a welcoming surprise.

Then my extended family sent their heartfelt wishes for me, and I was overjoyed. Rick texted me again, but this time he was playing a joke. I always say that it's okay to forget, that there was nothing wrong with that; after all, we were getting older. But I knew that he didn't forget so when he shouted "Happy Birthday" we both laughed.

All morning, the birthday wishes poured in, and many of them were phone calls. This really encouraged me, yet I was nervous because soon it would be time to leave for the Open House at the Amaze Support Group.

I arrived at Rick's around 3 o'clock, and changed my clothes and did my hair. I was wearing the white dress that I loved to wear. Meanwhile, Rick loaded up the truck with all the video gear. We had to be there by four, and I was getting a bit stressed, but I felt so refreshed when he told me that I looked beautiful. That compliment coming from him had so much meaning behind them. Wow! I felt so blessed.

While we were traveling to the open house, he said to me, "I know I'm going in the wrong direction, Hon. Sorry, I wasn't paying attention." Meanwhile, I was too nervous to notice, so we just laughed it off. But I couldn't tell anyone that. I had to be strong, and so I told myself over and over that I could do it. It wasn't going to be easy for me to relive each hardship of my past and tell how I survived each one.

Within a few minutes, Rick pulled into a bakery and went inside while I waited anxiously in the truck. Seconds later, he came out with the most beautiful birthday cake I'd ever seen. He handed it to me, and I was lost for words. Took the wrong direction, did he? We laughed and then continued on to the group. When we arrived, he parked the truck and then, like the perfect gentleman, he opened the truck door and said, "I'll carry everything in, Babe."

His arms were full of computer screens and everything else to go with it, and I carried in my cake. The support workers greeted me, and they all wished me a happy birthday. I kept smiling and trying to keep my composure, but inside, I was saying, "Okay, Girl. You rock. Just do it."

I asked which table was ours and this lady came to me and said that it was the one up front where the flowers were. This kind of special treatment was something new to me—but I was happy. I put the cake down on the table and then walked up to the front to smell the flowers. They were so beautiful, and when I read the card, the tears just flowed down my face. "With love, your family in Oshawa, Ontario."

This caused me to almost lose control of my emotions, so I had to tell myself to stop. Seconds later, I was surrounded by different people; some were vendors, others were the support group people. They all gave me hugs. Meanwhile, poor Rick was jumping all around as he hooked everything up.

Eventually, everything was ready, and the celebration began. Before I knew it, Rick leaned over and said, "You're up." I looked up and a man by the name of Kirk was talking and introducing me. Yes, it was my turn. I was nervous, but I watched Rick, and I knew I could do it.

Visitors were coming in, and I had the privilege of talking with many different people. Then a young couple, Nic and Ashley, came to me and started talking. I wasn't sure what they were saying, so I said, "Yes, I'm a brain injury survivor," and then started to tell them my story from the beginning. That's when Nic said, "You're the one that she needs to see." I wasn't sure what he meant, and then I saw a frail lady with a walker coming towards me.

I almost gasped because I saw myself in her in an instant. Then I leaned in toward her and asked her if it was too noisy in the room for her, and in her own way, she said that it was. She needed to get away from the loud sounds, and so I got up and walked slowly with her to the entrance where it was quieter. There were some chairs there, and I sat in one while we talked.

I had a picture taken of her while she walked there. This lady was Ashley's cousin, and it took a while, but we finally got her to sit in a chair beside me. I knelt down in front of her and asked her about the noise. She couldn't get the words out as she had a speech problem—one that I was only too familiar with—but she gave me the thumbs-up and looked at me and whispered, "I'm alive."

Suddenly, I was taken back in time with her; I was with her problems, and with not being able to walk or talk. The only difference was that this lady was not alone as I had been. She had this young couple to help her. I had no one. But I wanted to help her, and we spent the next hour going over difficulties and how I could help them. This was not easy for me. In fact, it was very painful.

My feet were killing me, and Rick brought me my moccasins to wear. My back was oh, so sore, and it felt as if knives were stabbing into it. Then my head started to pound with a headache that kept getting worse. I hurt all over, but there was no quitting now. I kept telling myself that I could not fail. I needed to focus and climb that mountain. I talked with many people that night, and when it was over, I was exhausted.

Rick helped with the cleanup and handed cake out to everyone, and he did it with a smile and with a caring and loving attitude. His back also hurt, yet he gave no thought to his own issues; he just kept going. I was so proud of him.

Afterward, he loaded up the truck, and we headed for his place. He wouldn't let me carry a thing in, and instead, told me to go in and put my feet up. So, I went inside. But I didn't stay there. I slipped out the back door to be with the puppies, and I lit a cigarette and looked up at the sky, and just as I always did, I thanked God for a perfect evening.

Finally, Rick had finished unloading everything, and the two of us were able to sit on the sofa with a nice cup of tea. That's when I got a message from Nic and Ashely. As I read it, tears welled up, and I could barely tell Rick about it. It was such a beautiful message!

I read it to Rick so that he could know what they said:

> *Marjorie, I can't thank you enough for taking time out of your evening to inspire Ashely's cousin. Thank you also for inspiring us. We all needed your incredible story. God is doing amazing things through you. Thanks for doing his work.*

With tears in my eyes, I asked Rick if he'd help me to respond as I was exhausted. He was tired, too, but he helped, and the words just kept coming. It was an amazing message.

The next morning, I finally read the message from Brian, and it was powerful! Brian was an inspiration to me.

Dear Marjorie,

> *I cannot express how proud I am of your endeavors and success. These brain injury survivors are extremely lucky to have such a great-minded individual like yourself to assist with their hard times. For many survivors, knowing another's story is what inspires them to make a change. But what you are providing is so much more than this. You are a textbook example of what good spirits, true dedication, and a strong mind will bring. Never give up*

inspiring; our world always needs more people willing to voice their story.

All the best,

Brian Kennedy

My time to leave this beautiful home behind for another season was almost at hand, but it was not over for me. My life had truly just begun. I sat there beside Rick on the sofa, and I was so thrilled. My life had never been so blessed. I had an amazing man in my life who loved me for who I was. As well, I had a new family who loved me, who listened to me, who cared for me, and who welcomed me in as one of their own.

But most importantly, I had a purpose. I knew that my job to encourage and inspire others with my message of hope was just the beginning. This is what God had called me to do—and He called me to do it in Lafayette, Louisiana, the place where my life began; the place that I call home.

Chapter 44

Being Thankful

I traveled a lot during the years of my initial healing. I knew that if I had been stuck alone in my home all winter, my progress would have been slow. I didn't want to be left alone in a house to just survive. I wanted to live!

The long winter months can be not only lonely but very depressing. I needed the aerobics to help bring back my motor skills, and my mental abilities. I needed to be able to sit quietly in a peaceful environment and read. I needed to become normal again so that my brain couldn't run wild and keep me in constant defeat. I wanted people around me to talk with and to laugh with—and to encourage.

Writing this story has put me through the memories of hardship, determination, and heartache. Like my mother said to me a few years ago, "You can do anything, Marjorie. Just climb that mountain." And so, I have done that.

I have endured so much sadness from my own family, being surrounded by manipulation, lies, and deceit. I have done my share of crying and felt my limit of hurt and pain. Yet, through it all, I forgave them, and because I forgave them, I have peace with God. I am able to live again.

Marjorie Coens

My family doesn't have to answer to me for their actions. But they will have to answer to God one day for the pain and the heartache that they put me through.

I am a brain injury survivor. An injury like this changes our lives so much, but when we get our health back, happiness is sure to follow. My angels have been around me and continue to help me deal with some of the issues that I still have, but I don't get stressed over things like I used to.

Now I have a new family and many friends around me now that love me, encourage me and support me. Because of them, I'm able to continue to keep trying, knowing that the healing of all different forms of life will take place.

Be encouraged! Don't take your brain for granted. It controls your body, but it's your heart and spirit, and your faith in God that has the greatest and higher power. We brain injury people are survivors in so many ways. Things that are so small and simple to most people become huge in our eyes.

But perhaps they really aren't so small; perhaps it's us being able to see the magnitude of how all the little things make up the big things that we take for granted. Don't let anyone tell you differently because when you look up into the universe and give thanks, then miracles do happen! Those seemingly little things will prove to be the foundation that our lives are built on.

This journey of life has been important to me because it has taught me that faith can move mountains. It has helped me to believe in myself again. Now I can share my story, and encourage others to know that if they have the will and the faith, they can climb their own mountain, too.

Special Appreciation to the Business Professionals who made the production of this book possible:

Crystal Clark
(Experior Financial, and Literary Agent)

An Executive Director in Oshawa. Crystal is who I placed my trust in for this very personal project, and she never let me down. She was the driving force behind getting this book done, from the onset through to the final printing. She researched everything necessary to ensure the success of Climb That Mountain for Heaven's Sake. I look forward to her continued collaboration as a powerful and enthusiastic agent.

Brian Kennedy
(Cause of Action Paralegal)

Brian is a paralegal whose passion and concern for people drives him to go the extra mile for each of the clients he represents. He uses his knowledge and abilities to provide the best possible advice and solutions for his clients. Brian is a very thorough and competent professional who was gracious in clearly explaining the legal process enabling me to write this book with confidence. He went above and beyond all of my expectations.

Steve Viau
(Freelance Website Developer/Designer)

Steve is a dedicated designer whom I worked with to create a book cover that clearly depicts both my story and my personality. He was patient with me throughout the entire process, never letting me make hasty decisions and providing honest advice about what was best for me. I appreciate everything he contributed and was fortunate that he also developed a website perfectly suited to my needs.

Trishelle Diamond
(Pearl Diamond Photography)

Trishelle is a professional photographer servicing the Durham area. When I told her that I needed a professional photograph of myself for my book and for promotion purposes, she was very gracious and worked with me to produce the best possible results. Her greatest concern was that I was satisfied and happy with my photographs. Thank you, Trishelle, for making my request a priority and for giving me a beautiful biography photo.

About the Author

Marjorie Coens is a brain injury survivor who almost lost her life during a car accident in 1999. However, through faith, determination and hard work, she has regained the fullness of her life and has written this book to share it with you. At the age of 65, most people are getting ready to retire, but Marjorie is just beginning to live.

Marjorie is an active member of the Amaze Brain Support Group in Lafayette, Louisiana, and has been invited to be a speaker at the upcoming Aspiring Speaker's Bureau. She has spoken at many conferences about how she got her life back and has also produced several videos on YouTube where she speaks about her healing and return to life.

Please visit her website at marjoriecoens.com and stay updated with all of her successes including future tours and books.

98470803R00178

Made in the USA
Columbia, SC
30 June 2018